龐 曾 瀛
Pang Tseng-ying

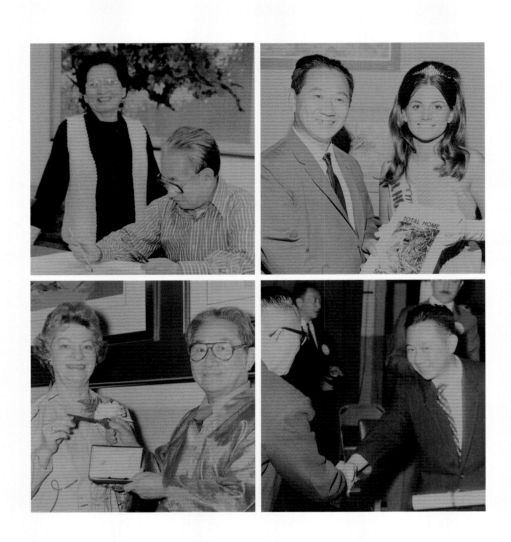

龐曾瀛
Pang Tseng-ying

大未來畫廊／策劃出版
Curator:Lin & Keng Gallery

藝術家出版社／編輯發行
Editor:Artist Publishing Co.

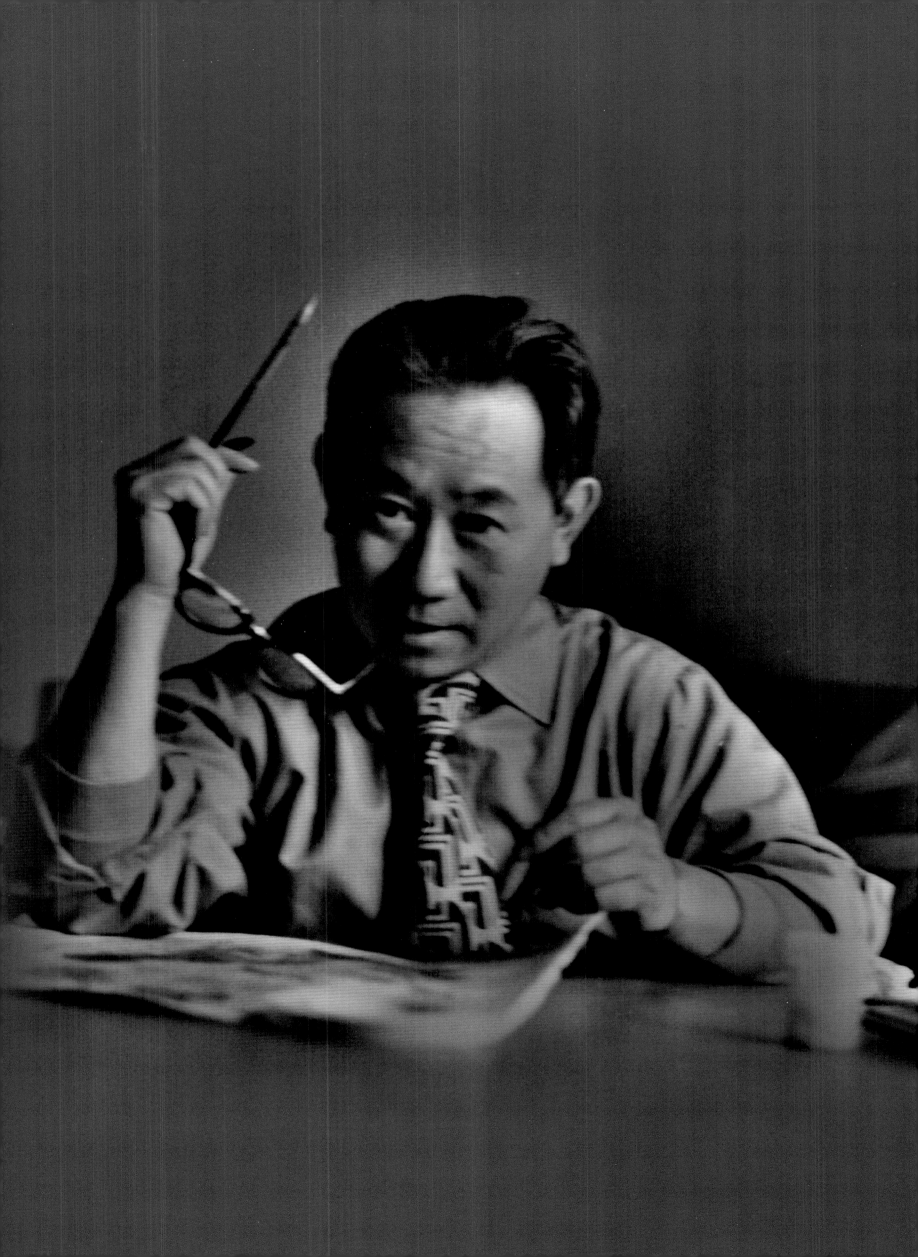

目 次

Contents

我們的龍頭老大
李德眼中的龐曾瀛

李德口述、王雅玲整理

龐曾瀛，一個讓台灣畫壇覺得些許陌生的名字，祖籍江蘇吳縣（蘇州），一九一六年出生於日本東京，成長於中國北方，一九四九年遷居台灣，一九六六年移民美國。一九九七年在美國過世。

「他是我們的老大，他是我們的龍頭老大」，這是李德談到龐曾瀛時的第一句話。當年李德與龐曾瀛、劉煜、張道林、劉予迪等五人成立「集象畫會」時，是以年齡排列的。龐曾瀛最長，生肖又屬龍，因此就成為他們的龍頭老大，大家暱稱他「老龐」。

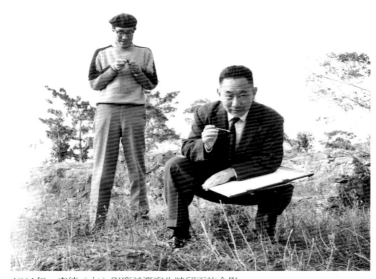

1961年，李德（左）與龐曾瀛寫生時留下的合影。
Read Lee (left) and Pang in outdoor sketching

老龐的單純與才華

「他徹頭徹尾是一個藝術家。爽朗的個性，不管在教學上或是與朋友交往，都是坦誠以對。當年我們是復興美術工藝學校的同事，後來又同時在國立藝專兼課。在復興，他教油畫、我教素描。在校長郭明橋帶領下，全校二百多名師生，擠在四棟破舊的建築物裡，弦歌不絕，打成一片，倒確實稱得上名副其實的『生命共同體』。」回想起過往點滴，李德對這位親切的同事、畫友，興起深切的懷念：「在校園裡常可聽到龐曾瀛對著遠方的校長大喊『郭……明……橋……』，或是喊我『老……李……』。有時大家也會吵架，吵架的原因都很單純，都是為了學校或是學生。」

「在繪畫上，我很羨慕老龐他那雙靈巧的手。有一天校方受救國團委託，在台北市敦化北路一棟教學大廈裡製作兩幅壁畫。校方指派老龐與我各帶領一組學生去工作，沒多久，他那一組很快就進入狀況，我們呢，笨手笨腳，弄得快累死了。平時在教學上，他也很能把握方法、成效的，他也常能激發起學生們的創意，因此學生們也都很喜歡他。要是我沒有記錯的話，有一件事也是值得一提的，記得他在藝專教畫期終評分時，他竟給全班學生同樣的分數（好像是一律八十或八十五分？），這也可看出他認為分數不能代表學問，他那率真可愛的一面。」

集象畫會

「復興和國立藝專老龐都是兼課，北一女才是他專任的學校，一直到移居美國才離職，他都住在永和文化街北一女教職員宿舍，在永和大街上也有他的畫室。而我，打從民國四十六年

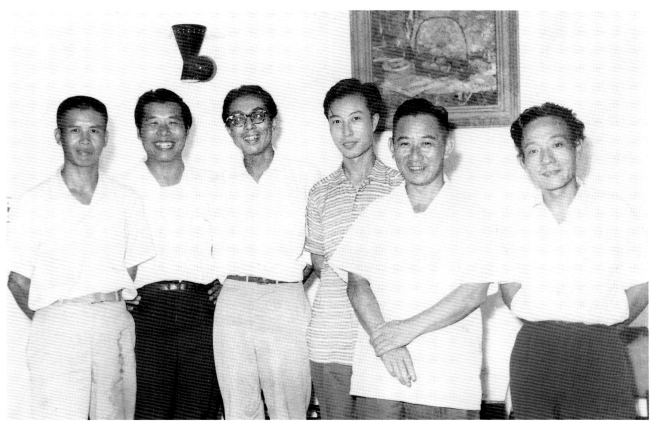

1961年「集象畫會」會員留下的合影，右起：張道林、龐曾瀛、劉予迪、李德、劉煜、胡奇中。
The members of Chi Hsiang Studio in 1961 (from left to right): Hu Qi-zhueng, Liu Yu, Read Lee, Liu Yu-ti, Pang Tseng-ying, and Chang Tao-lin.

（1957）起就住在永和。當時台灣最早的專業模特兒林絲緞小姐，也在永和設立舞蹈工作室，因此，我們也有了研究人體繪畫的機會。永和也變成了我們畫會活動的地區。接著就是民國五十年（1961）舉辦了第一次『集象畫展』。記得展出的前一天，我們把畫作集中在老龐的畫室，五個人聚在一起編目錄、畫海報、裝框、打包⋯⋯搞了個通宵。第二天雇了一輛拖拉車，連人帶畫一起去台北中山堂旁邊的『新聞大樓』佈置會場，說來這已經是快半個世紀前的事了。畫展期間，記得有一位在師大教美學的費海璣老師曾經寫過一篇畫評，其中他提到老龐的畫作非常突出，他用『惹眼』二個字來形容它。我還記得那是一幅在大片淺黃色上揮灑了一些黑色線條，流露出中國畫風線條之美的半抽象作品，那的確是很吸引人的。」

「這裡順便說一說當時所以有『集象畫會』的組成，是基於大家都從事純粹繪畫的研究，而又都有一份對現代中國繪畫藝術克盡心力的意願，而彼此畫風表現雖個個不同，但理念一致，因而命名的。集象首展以後，曾連續數次展出，而後又有胡笳與吳廷標兩位畫友的加入，由五友變成七友。當時有老一輩『七友畫會』，他們把我們稱作『小七友』，其中鄭曼青、劉延濤兩位前輩也住在永和，也常常有來往。如今老七友都已作古，我們小七友呢？胡笳早已過世，吳廷標失去聯絡，我們五個人呢？頭（龐曾瀛）尾（劉予迪）都先我們而去，留下來的張道林遠在紐約，在台灣就只有劉煜與我，人世無常，真是令人噓唏！」

美學與創作風格的轉變

談到龐曾瀛創作的路向，因為李德表示看到龐曾瀛的原作並不多，只好從畫冊上揣摩，他將作品略約分成三個時期來討論：

早期的畫，在一九三六年赴日之前，當時在中國大陸的美術教學，一般來說都以源自西方的印象主義的模式作為基礎訓練，當然龐曾瀛也不例外。同時「畫畫絕不是無條件的模仿自然！」這種強烈的創作的意念，也早就植根在龐曾瀛的心中了。一九三六年他到日本，我們想一想，當時的巴黎畫壇大致是超現實與抽象繪畫的天下，這股「前衛」風吹到東京，正是龐曾瀛所處的時空背景。而一九三六的次年（1937），中日戰爭爆發，一九三九年二次大戰啟端，在此動亂的年代，作為中國留學生的他，身份是很難立足的。但他就在這種景況下，吸取、磨練

1965年，在龐曾瀛（右一）永和畫室裡的一場餐會，與會的有劉煜（右二）、張道林（右三）、姚夢谷（右四）、李德（左一）。

A party at Pang's studio in Yonghe City (from left to right): Read Lee, Yao Meng-gu, Chang Tao-lin, Liu Yu, and Pang Tseng-ying

了他日後的創作能力。當時他的用功好學可以想見，這些從他那些早期的作品可以看出。

一九四九年龐曾瀛來到台灣，之後的十年間，到了一個比較完備的境地，這是指畫家的「心」與畫面的「形」結合得更適切。台灣在當時對外的交流是比較封閉的，生活是相當艱難的，而又經歷了輾轉播遷、戰時的動亂，這個時期反倒使他有了一個沉潛、省思、鍛鍊的機會，使得作者的精神生命與畫面構成的要求，增加了作品的內含與堅實度，這是龐曾瀛中期的風貌。

及至一九六〇年前後，也就是我與龐曾瀛相識的年代，龐曾瀛的作品從油畫轉變而為水彩及彩墨畫，這可歸作「晚期作品」。其間的原因，很難推斷，也許畫到這個階段，他發現他是比較屬於線性的畫家，毛筆、紙本比較符合他創作的需求。再是，一般來說，歷來出國深造的畫家，回國之後，總想找出一條融會中西、開拓現代中國繪畫的道路，龐曾瀛此時的作品，從早期西方的「面」的訓練而提煉出「線」，進而引用中國傳統的線條，也可說是順理成章的一種過程。為了塑造他自己的形式，又把國畫的蟲、魚、花鳥，將其符號化，靈巧機智地溶入西方的結構之中（此令我們想到克利）也是可以理解的。這種轉變的結果，使得原本大而化之的他，逐漸形成了細緻優美的「龐曾瀛風格」（此時李德不禁笑呵呵地開起老朋友的玩笑來，他說：這大概是蘇州人的個性使然吧！）這種龐氏畫風，到美國之後，發展得更為成熟。

最後的會面

一九七七年，龐曾瀛移民美國後的第十二年，李德去了紐約，龐曾瀛到機場去迎接了這位老友，而後一起前往馬里蘭州的住家，「老龐與他的夫人元美嫂（沈元美）殷切款待我，他們兩個女兒都已出嫁，寶貝兒子也不在一起住。寬敞的畫室，花木扶疏的庭院，二老生活得恬適愉快，我心中暗自為他們慶幸」李德說。一九八三年龐曾瀛回台，在國立歷史博物館舉辦個展，老友們再度相逢，這是「老龐與老李」最後的會面。

The Head of a Dragon, Our Leader and Elder Brother:

Pang Tseng-ying in the Eyes of Read Lee

Read Lee, Wang Ya-ling

Pang Tseng-ying (1916~1997), whose name sounds somewhat unfamiliar to the members of Taiwan's painting community, was a native of Wu County (Soochow) in the Jiang Su Province. Born in 1916 in Tokyo, Japan, he grew up in northern China, then moved to Taiwan in 1949 and later in 1966, emigrated to the U.S. There he died in 1997.

"He's our elder brother, our leader and the head of a dragon," is constantly Read Lee's first sentence whenever he talks about Pang Tseng-ying. When Read Lee, together with Pang Tseng-ying, Liu Yu, Chang Tao-lin and Liu Yu-ti first formed the "Chi Hsiang Studio," these 5 founding members were ranked in order of age. Pang Tseng-ying, born in the year of the Dragon on the Chinese zodiac, was the eldest. Naturally he became the group leader as well as the head of the dragon (Note: the Chinese character of his surname "Pang" contains the Chinese character for "dragon." Thus, he was nicknamed "Lao Pang or Old Brother Pang."

A Simple Talent — Lao Pang

"He's a 100% artist. He's always open, frank and cheerful. While teaching or dealing with friends, he's constantly sincere and straightforward. At that time, we used to work together at the Fu Hsing Trade and Arts School and concurrently taught part-time at the National Academy of Art in Ban Ciao of Taipei. At Fu Hsing School, he taught oil panting and I taught sketch. Led by President Kuo Ming-chiao, we became one family with 200 or so students and faculty members, though living and working in the old, dilapidated building, yet keeping on studying diligently and all mixing together, just like a truly 'community.'" In retrospect, Read Lee thinks fondly of this warm-hearted colleague and painting mate, indulging in the things past, "On campus, people could always hear Pang Tseng-ying shouting 'Kuo - Ming - Chiao' to the President who was still in a distance or 'Lao - Lee' to me." We did sometimes quarrel or squabble, but always for the good of the school or its students.

"I admire Lao Pang's dexterous painting abilities very much. Once, the school was commissioned by the China Youth Corps to create 2 giant wall paintings to decorate a teaching building located on Dunhua N. Road in Taipei. Lao Pang and I were assigned to do the job with each leading a group of students to be responsible for one of the wall panel projects. Lao Pang's group quickly got ready and started on the spot, while my group, looked so slow and clumsy, did not know where and how to begin work, and ended up exhausting ourselves to

death! Lao Pang was a methodical and effective teacher who could always excite and inspire the imagination and creativity of his students. Thus all the students loved him very much. If my memory serves me right, I still vividly remember an episode that is worth mentioning: in his days teaching at the Academy of Art, he gave all his students the same final exam score (it seemed to be 80 or 85 points). This obviously shows his sincerity and frankness as well as his belief in 'learning being not solely for earning high scores.' Such distinct traits made him so lovable on campus."

Chi Hsiang Studio

"Lao Pang's main job was teaching at the Taipei First Girls' Senior High School. He taught part-time at Fu Hsing Trade and Arts School and National Academy of Art. He kept teaching and living in the High School teachers' dorm on the Wenhua Street of Yonghe City, and had his own studio on the main street of the city. As for me, since 1957, I've been living in Yonghe. At that time and over there, the first professional model Ms. Lin Si-tuan set up her first dancing studio, so we were fortunate to have the opportunity of learning about human body painting. Yonghe City had, therefore, become the center for our painting club activities. In 1961, we opened our first Chi Hsiang Group Exhibition. I can still clearly recall on the eve of the event, the five of us placed and stored all the exhibits in Lao Pang's studio, squeezing up in there and spending day and night on cataloging, drawing the posters, framing and packing until the small hours of the open day.

"The second day, we hired a truck to bring the five people and all of the paintings direct to the site — Press Building located next to the Zongshan Hall in Taipei for preparation. It's a memorable event occurring about 50 years ago, nearly half a century from now! During the exhibition, Prof. Fei Hai-chi, who taught aesthetics at the now National Taiwan Normal University, wrote a comment on the paintings. He commended highly Lao Pang's paintings for their being very conspicuous; he even used the adjective "eye-catching" to describe them. Among those paintings, I remember one is a semi-abstract painting on which some dark lines were freely and facilely sprinkled or splashed with ease on a large light yellowish patch, revealing Chinese traditional painting style which featured beauty of lines or strokes.

"Also, I'd like to tell the story about the origin of the Chi Hsiang Studio. It was formed based on a goal of pure painting studies as well as an earnest devotion to promoting modern Chinese painting art cherished and pursued by all five of us. With a common goal and common belief, despite diverse images and styles that each was good at expressing, the studio was so named.

After the debut, a series of shows followed with two more painters, Hu Chia and Wu Tieng-piow, joining in. Thus, the five-friends club evolving into a seven-friends one. And since there was already a "Seven Friends Studio" comprising senior painters at that time, ours were thus called "Junior Seven Friends." Among the seniors, Cheng Man-ching and Liu Yen-tao, also resided in Yonghe, had developed friendship with us. Now that all of the seven senior painters were no longer living, how about the junior seven ones? Hu Chia had passed away and we had lost contact with Hu Tieng-Piow. And the other five? Both the head of the Dragon, Pang Tseng-ying and the tail, Liu Yu-ti had died, leaving me and Liu Yi in Taiwan whereas Chang Tao-lin is residing in New York. Well, how sad it is to witness the changes of life! And that is how life is!"

Aesthetics and Transformation of Style in Creation

When it comes to Pang's creative style, Lee emphasized that, due to his limited contact with Pang's originals, the following analysis is based more on the works listed in the catalogue. Pang's art career can be generally divided into three periods:

Pang's early works done before 1936 prior to the departure for Japan were generally originated from Western Impressionism model on which the mainland China art education was based. At that time, deeply rooted in Lao Pang's mind was a strong desire for creation coming from the idea of "Painting is absolutely not just an unconditional imitation of nature." His 1936 arrival in Japan, as we could figure out, allowed him to immerse in the atmosphere of the avant-garde style in Tokyo's art circle, influenced and swept by the combined trend of surreal and abstract painting which was permeating the art world of Paris. The next year (1937), with the breakout of Sino-Japanese War which ignited World War II, as a student from mainland China, Lao Pang found it especially hard for him to establish himself in society. It was under the difficult circumstances that he worked hard to absorb and became tempered to develop and hone his creative skills for later use. One can imagine how hard he had been working and studying during this period by looking at his early paintings.

In 1949, Pang moved to Taiwan. In the following 10 years, he was afforded a relatively ideal painting environment, where he was able to more properly combine the 'heart' of a painter with the 'form' of painting. At that time, as Taiwan was relatively isolated, international exchange was hard to make and everyday living was rather difficult, in addition to the tumultuousness resulting from WWII and the withdrawal of the government from mainland — all of these difficulties might easily dampen one's spirits. However, they offered Pang, instead, a

great opportunity to concentrate, meditate, reflect and take tests alone. Thus, he was able to bring his life and spirit into the picture to deepen the essence and strength his works. This is the special feature of his style as seen in his middle period works.

The period from 1960 and on marks the so-called "Later Works Period," covering the years during which Pang and I got to know each other. Pang's works had undergone a transition from oil painting to watercolor and colored ink painting. It is quite hard to infer the reason for his change of style and path. Maybe in his later works, he became aware that linear expression was more in line with his disposition, and that brushes and paper were more fitting for his creative needs. Furthermore, the painters studying abroad generally tended to ponder a way to combine Eastern and Western cultures to explore a new path for modern Chinese painting. In this period, Pang's works followed a matter-of-course process to transform from the employment of 'planes' based on his Western art training to the refined 'lines,' and further to the traditional Chinese lines. And in order to create a form featuring his individual style, he turned the insects, worms, fish, flowers and birds often seen in traditional Chinese paintings into symbols, and then deftly and smartly incorporated them into the composition of a Western painting (this reminds us of Klee's works). As a result, a casual painter as he usually was turned into an inventor of the meticulously refined 'Pang Tseng-ying Style' (upon this Lee broke out laughing, and began to make fun of Lao Pang, "this change was probably attributable to Pang's upbringing in Soochow!") This style of Pang's later evolved into a mature one after he moved to the United States.

The Last Meeting of Each Other

In 1977, the 12th year after his emigration to the United States, Read Lee traveled to New York and met by Pang Tseng-ying at the airport, then proceeding to Pang's house in Maryland. "Lao Pang and his wife Shen Yuan-mei showed hearty hospitality to me. Both of their daughters were married, and their only son was away. He had a wide studio and a courtyard full of flowers and trees luxuriant but well-spaced and tended. The couple indeed enjoyed a happy life in the comfortable and quiet environment. I rejoiced very much in their good fortune," says Lee. In 1983, Pang returned to Taiwan for a solo exhibition held at the National Museum of History. All of the old friends again met together. It was the last meeting for "Lao Pang and Lao Lee." (translation/Morris Huang)

龐曾瀛藝術思維演化
從中國現代畫到現代中國畫

曾長生

中國現代畫抑或現代中國畫

遠東地區均曾受過西方列強殖民主義的影響，其藝術發展在二十世紀前半葉都經歷過西化與現代化的洗禮與掙扎。現代主義強調的是個人自我風格的展現，在以儒家思想為主流的東亞地區人治社會中，現代化精神有其偏限。

在中國現代繪畫發展初期，像劉海粟、高劍父、林風眠及徐悲鴻等民初遊學過日本及法國的知名畫家，在他們接觸西畫之前，大多已畫過一段時間的國畫，因此由國外學得洋畫後，都企圖以西畫理論和技法融進國畫裡，而創出所謂「以西潤中」的新國畫。而近代的台灣畫家，在面對舊美術與新美術的選擇時，則全然拋開了傳統文化的羈絆，而投入學習新法的路徑，終身鑽研西洋畫的素材與技法。日治時代的台灣畫家尊崇石川欽一郎，肯定「帝展」與「台展」的權威，並堅持追求印象主義和野獸派的繪畫風格。這段時間留學之後居留海外的藝術學子不多，像常玉、潘玉良終老巴黎，朱沅芷病逝紐約，何德來長居日本，他們是中國現代畫歷程第一批取經的孑遺者。他們的偉大犧牲，寫下了第一代海外華裔藝術家的悲歌。至於較具成就的趙無極、吳冠中、丁雄泉、朱德群……，則是在抗戰結束後，才出洋考察或展覽的，並在歐美羈留下來。

龐曾瀛（1916～1997）曾親身參與台灣五〇及六〇年代現代美術運動，一九六六年移居美國，大多數旅美華裔藝術家對他的大名均耳熟能詳。龐君是在大陸養成中國書畫教育，在日本奠定藝術創作的理念，在台灣思考現代繪畫的真義，而在新大陸創造出獨特的繪畫風格，並獲得歐美人士的普遍肯定。他的作品可以說是成功的東方與西方藝術結合的範例，他為西方抽象繪畫開闢了新的領域。

一九五四年，當龐曾瀛在紐約舉行他的海外首次個展，藝評家顧獻樑曾如此表示：「龐君從畫史所獲的心得，可以說是中少外多，那是中國油畫家和水彩畫家的共同點之一，他們大多數完全或不完全的一致忽略自己的畫史，往往近於全盤西化，

1961年，一次在歡迎畫家郭柏川於台北開畫展的聚會上的合影。右起：顧獻樑、龐曾瀛、曾培堯、郭柏川、沈元美。
On the welcome party for Kuo Po-chuan's solo exhibition in Taipei, 1961 (from left to right): Shen Yuan-mei, Kuo Po-chuan, Tseng Pei-yao, Pang Tseng-ying, and Ku Shian-liang

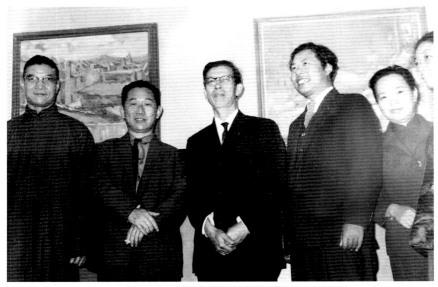

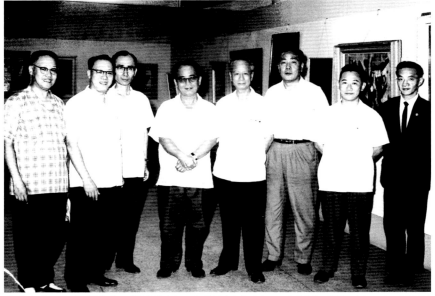

集象畫會1961年畫展時，龐曾瀛（左二）與袁樞貞（右一正面者）、劉煜（右二）、吳延環（左一）合影。

Wu Ting-huan (first on the left), Pang Tseng-ying (second on the left), Liu Yu (second on the right), and Yuan Shu-chen (first on the right) on the 1961 Chi Hsiang Group Exhibition.

1962年第十屆南美展時的一張合影。包括：顧獻樑（右一）、龐曾瀛（右二）、郭柏川（右五）、梁又銘（左二）、梁中銘（左一）。

On the 10th Nan-mei Exhibition in 1962: Liang Zhong-ming (first on the left), Liang Yu-ming (second on the left), Kuo Po-chuan (fifth on the right), Pang Tseng-ying (second on the right), and Ku Shian-liang (first on the right).

他們自以為是所謂洋畫家或西畫家，遺憾的是想不到，真正的洋人或西人在任何情形之下，仍然稱呼他們是中國畫家。其實對於西洋畫史，他們又何嘗深入了呢？龐君對於畫史，本國的他倒一度曾經接近過，外國的現在正努力在熱烈接觸中。」「中國畫家或多或少，在筆調上直接間接感受書法的靈秀或影響，自然是一般而非特殊的現象，龐君也不在例外，書畫是姐妹或兄弟藝術，都是各具規模自立門戶的獨立藝術，彼此可以交通，而絕對不應該牽制。除了偶然在樹石方面隱隱約約顯露出一些山水畫所獨創的點法和皴法，在整體上，我們是不容易把龐君的作品密切的和舊家雲煙聯絡在一起的。」「至於題材的親切，色彩的家常，那是日常生活和風俗習慣的反映。西洋方面影響龐君的大部分屬於印象派後期（1876～1900），少部分屬於立體派初期（1900～1908），其中包括塞尚、高更、梵谷、魯奧、畢卡索、勃拉克及馬諦斯。龐君那樣勇於接受外來影響的畫家，如果能夠出國觀摩一番，他是能夠加速趕上世界繪畫新潮流的。」顧獻樑並稱：「他的題材是多方面而且相當平衡發展的，他的風格尚待完全成熟，一時候我們還很難說他偏重某科或科科擅長。龐君一九一六年生，現在還不到四十歲，如果繼續不斷的能夠保持近年以來的創作姿態，多方面嘗試，平衡發展，等到相當一個時候，由廣而趨約，便可以成為專家，由寬而赴博，更可以成為大家。」

具象徵意味的東方超現實山水

中國是一個墨守古諺的國家，宗派心理永遠在大家的心目中是信仰，是典型，是偶像。唯有衝破朝聖般的崇慕宗派主義，才能打開狹窄的模型觀念，而進入真實的人生世界。也唯有向一切美的根源和廣泛的藝術成就學習，智慧才能從機械的定形中，開闢出自然的生命坦途。假若畫家的成就，必須仰仗著向宗師乞討，藝術的命運勢必然癱瘓。如果我們把崇拜古聖、今聖和洋聖的心情，用一份在到處都能發現，隨時都能感應到的真實美上，通過傳統的精神，反映

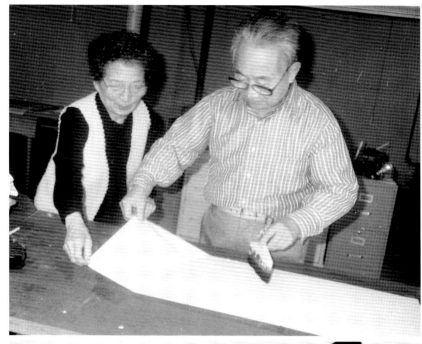

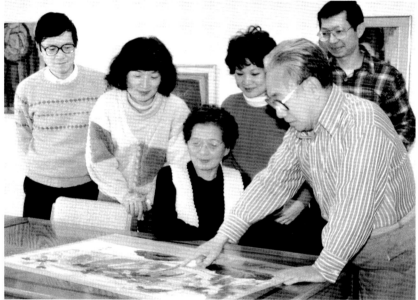

自己生和存的感召，中國的藝術將另有進境。

龐曾瀛在一九六二年集象畫會第二屆畫展的說帖中稱：「傳統絕對不是保守，創作尤其不能抄襲，藝術品是感情、智慧和理想的綜合，繪畫藝術必須新而不抄襲，舊而不保守，失卻傳統則盲目追從，近乎奴，非經創作則東拼西湊，可謂欺。」「我因生存而畫自己生存的真實，所以我尋求及組織生存真實的內在，更希望根據生存真實而見到真美。我的畫究竟是：中國的新畫？還是中國的西畫？或者僅在替西洋人穿上中裝？甚至是硬拉西洋人來冒充中國的新人物呢？同時在傳統、保守、創作、抄襲之間，反省和警惕自己。」

龐曾瀛工作態度極為審慎，作畫前的準備工作時，夫人沈元美在一旁協助。
Pang was meticulously cautious with his work. His wife Shen Yuan-mei often assisted in his preparatory work for painting.

龐曾瀛（前立者）和夫人及子女們談論繪畫時，態度相當認真。
Pang (standing in the front), his wife and children discussed the art of painting vehemently.

繪畫貴在創作自己的風格，無論抽象畫或具象畫，畫中只要有個人的創作表現，而且能不斷的追尋新境界，這種作品很自然的便能引人欣賞。在一九六三年的集象畫展中，龐曾瀛的作品採取了國畫的工具和材料，實質精神上，似乎從超現實主義走上抽象表現主義的西方繪畫般，在心靈上發生了很大的改變。

其實早在一九五七年，龐君既已對現代繪畫表達過自己的看法，首先他表示，雖然我們討論的是洋畫，但是中國人所創造的繪畫，卻不必因為材料的關係，而必須冠以洋字，藝術只有自己的，沒有洋的，藝術可以欣賞洋的，卻不能創造洋的，我們要多研究問題，而減少機械的向人學習，古典、寫實以及其他主義的出現，都有它真實不假的時代背景。古典主義喚醒了垂死的封建沉睡者，浪漫主義指明了古典的錯誤，但是他們仍舊都是封建中的產物，印象派是完全繼承了寫實主義的視覺遺產，但是它比寫實主義對藝術的態度更為完美，因為它發現純視覺的直覺印象。從後期印象主義出現，西方人開始發現自己繪畫藝術的狹窄，他們看到東方繪畫的自由行意的寶貴，自古至今的情與意的真正藝術，後期印象派走回了真正的藝術途徑，而被歐洲人視為現代繪畫的開始。

在談到超現實主義時，龐君認為超現實不是寫實的作品，像立體派、至上派、未來派、抽象派等一樣，我們在了解超現實繪畫之前，必須先明白繪畫上象徵的簡單道理。象徵是一種以符號來代表一個實在的事或物的印象，符號代表事物的實例很多，大家都知道「馬」字就是等

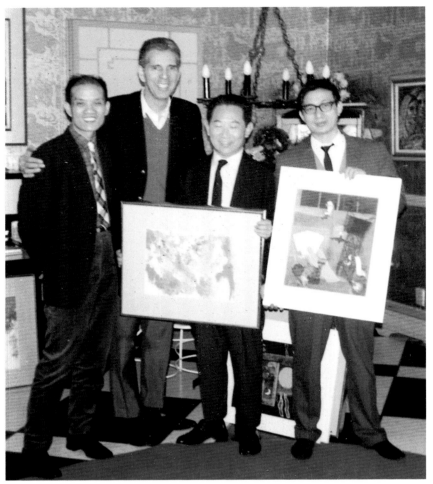

1970年代在紐約，龐曾瀛（右二）與謝里法（右一）兩人手拿畫作，與美籍畫家（右三），以及鄭善禧（右四）合影。

A photo taken in New York in the 1970s (from left to right): Cheng Shan-hsi, an American painter, Pang Tseng-ying, and Hsaih Li-fa, the later two with works in their hands.

於一匹四條腿的馬，但是那是代表一個理智認識下的馬，象徵是代表一個意識印象下的事物。繪畫中有一個象徵主義，這種作品多半是象徵具體的事物，但是超現實主義象徵的是心中的事物。今天的純粹抽象畫派，似乎是人類有意要把情與無意識結合起來，只要我們對美不抱保守的成見，純粹抽象畫就沒有難欣賞的理由，只要我們有一份活力和靈性，就該容易與純粹抽象畫的內在接合。

樹立個人獨特風格並拓展中國繪畫新境界

一九六六年龐曾瀛到了美國之後，他終日與西洋畫為伍，在尋求獨特風格的過程中，他對東方的文化遺產，重新燃起熱誠，抵美後的新作品具有濃厚的東方情調，但卻融會了西方繪畫的精髓。他似乎正為自己描繪出一個世外桃源，東西方疆界山嶺上的神祕王國，他的畫細膩空靈，啟人深思，禮讚自然，而展露出一個永恆的春天。

龐曾瀛是一個非常嚴肅而又敏感的畫家，工作態度極為審慎。他作畫的過程首先是小心翼翼地為自己準備好畫紙，一種吸墨性極強的縐紋宣紙，正像大多數抽象派畫家一樣，動筆之前，他的腦海中並無固定的題材，但某種自然景象，卻經常在下意識裡浮現了出來。

按照東方的繪畫方法，他首先在畫紙上用墨汁揮灑一番，然後開始不斷地增添顏色，直到滿足他的心中情感要求。在這個階段，他從畫中所得到的印象和引起的思想，會在意識中變得更具體。往往當他的思想具象化以後，自然景物便開始呈現，樹木歷歷在目，葉子有了定形。然後再用毛筆鉤勒，再加幾筆，就多出一些人物，小小的，相對地象徵著自然的廣漠，宇宙的無垠和時間的永恆，他也經常在畫中點綴一些昆蟲或鳥獸。

美國《音樂與藝術》雜誌評論家斑比里茲稱：「觀者在參觀龐君的水彩畫，很容易被帶進東方藝術的神祕中。他透過色調的細微差異及和諧的混雜色彩，畫出了具有東方含蓄風格的西方繪畫。」他的畫題都是一些自然景物：海、天、岩石和樹木。作為一個詩人，他喜歡在畫面上添些小生物，甚至停留在尖形葉片上的昆蟲，遠方背景是萬丈峭壁，藉以謳歌空間的莊嚴和廣漠。有時，他用五彩繽紛的顏色，細膩的筆觸，在宣紙上交織出似卡通影片般抽象的畫面。在他豪放的彩色畫的精細筆觸中，可以發現書法的痕跡，深暗的顏色在某些圖畫中，具有刺繡綢緞的高度錯綜性。乍看起來，抽象的形體不著邊際，但很快便呈現明確的形式，並顯示出個人的超現實主義觀。

顯然，龐君開始繪畫時，曾在西方藝術的影響下徘徊逡巡，後來他謳歌東方山水，而發現

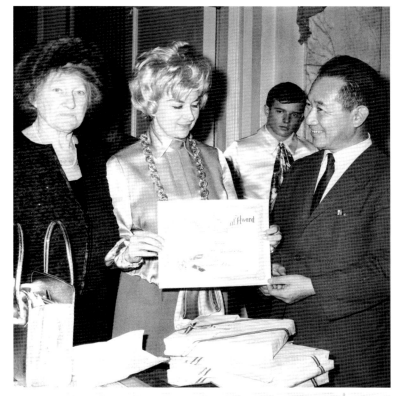

了自己的真正風格，誠如斑比里茲所言：「我確信他的魅力是基於兩個因素，他保留了足夠的東方書法和繪畫技巧，而且下筆嚴謹。但他正趨向現代主義，保留了柔和的裝飾性質，墨汁和吸墨宣紙，產生出錯綜迷人的形象。」「如所周知，中國畫家往往身兼書法家、詩人甚至禪師。他們的畫，蘊含著從書法、自然靈育和尊崇繪畫而生的思想，這許多特質，正是我們激賞的現代藝術家的其中表現之一。」

從龐君的早期作品顯示，他在試圖把相隔數世紀的東西兩種文化技巧融合為一的過程中，可能曾遭受過苦惱。但當他逐漸發現自己的風格，而把兩種技巧恰如他所喜歡的融於一爐後，他的作品中的力量遂不斷增強。得到更大的情感共鳴，並呈現出更強烈的分野。

結合東西方文化的現代新人文主義

龐曾瀛在美國努力奮鬥走出自己的風格，三十多年來不但受到西方一般大眾的接受，成為美國最受歡迎的華裔畫家之一，也引得藝評家的賞識，《藝術雜誌》主編哥頓・布朗（Gordon Brown）

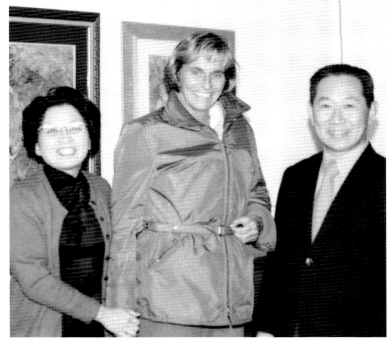

1968年，龐曾瀛榮獲紐約評審展水彩畫獎第一名。
Pang received the first prize in watercolor from a New York exhibition in 1968.

1970年時，紐約市長夫人到龐曾瀛畫室參觀訪問時留影。
The New York mayor's wife visited Pang's studio in 1970.

即認為龐氏的畫已超越了文化國界，其獨特成功之處是「將西方藝術的影響臣服於東方的情調之下，創造出一個全新而卻又純東方格調的藝術境界」。龐氏的水彩畫，融合了中國傳統藝術中對大自然的詩意詮釋和二十世紀西方抽象表現主義的自由。龐氏自己獨特的藝術風格，其實也開拓了中國藝術的新境界。

龐氏繪畫純以技術而論，已突破了中國傳統國畫中純粹依賴畫筆的侷限。對此，他有極精闢的論述，他將中國的國畫傳統的主流，概括歸結為「王維主義」。王維對中國藝術傳統的貢獻，照龐氏的評論，就是創立了詩情畫意的山水畫模式的美學基礎。王維的傑出之處在於，作畫運筆時引進了行草書法，在構圖上講求詩意情懷，在筆法上則有氣韻之說。龐氏認為王維在當時的歷史情境中，確實是為中國繪畫開天闢地的一代巨匠。然而，由一代巨匠而為萬世師表，王維的繪畫風格筆法技巧，千多年來為後世畫家所承襲，而無法突破。

在中國的王維主義繪畫傳統和西方的抽象主義之間探索徘徊之後，不甘於承襲古人和洋人

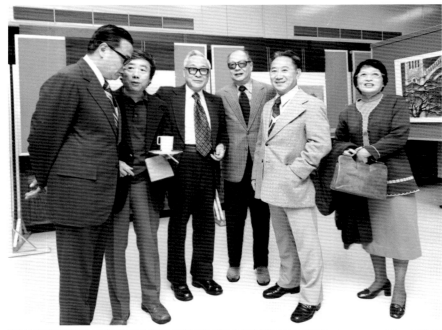

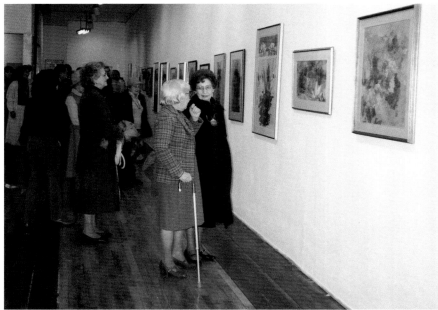

1976年在紐約州牙買加市「聖若望大學中正美術廳」個展時，龐曾瀛夫婦（右一、右二）與來賓合影。來賓包括：王季遷（右三）、薛光前（右四）、廖未林（右五）、龔弘（右六）。
On the solo exhibition held in Chung Chan Gallery of St. John's University, Jamaica, New York, 1976 (from left to right): Kung Hung, Liao Wei-lin, Hsueh Kuang-chien, C. C. Wang, and the Pang couple.

1985年龐曾瀛在美國費城個展，美國藝評家梅朵復到場觀畫（右二）。
The American critic Eve Medoff (second on the right) went to one of Pang's solo exhibitions in Philadelphia in 1985.

的龐曾瀛，終於尋找試驗出自己的獨特風格，也為中國藝術拓展出一嶄新的境界。純從技法而論，摸索出屬於他自己的特殊表達媒介或工具。例如：用木刻方法引進墨彩之中在木板上刻線刻面，拓印在畫紙上，或者用特殊的紙皺法，把畫紙先抓摺成各種形狀，在各種水彩色的打底中再加上傳統的筆法，造成新的視覺感受。他有時也用揮發油加顏色加水，讓顏色的聚散融合成各種抽象形狀及用紙印在上面，造成一種隨意而卻有意料不到的生動效果。他認為中國的繪畫藝術要從王維主義的境界典範中突破、提升、創新，就一定要在毛筆以外，嘗試其他的工具、材料和方法。

對龐曾瀛而言，旅行遷移可能造成個人身份具顛覆性的逆轉，而離開已知的自我和回到未知的自我，異鄉人熱衷於追尋一種屬於他們自己內心的第三類文化。華裔現代藝術創作者能在異邦有所成就的，均充分表現了個人風格，並在有意無意中，顯現出一絲曖昧與邊際的東方情愫。而龐氏覺得自己期待的是中國的新山水畫，即現在大家所稱的新的中國畫，不僅是山水而已，也可以把人物與其他的任何題材，如花鳥概括進去。華人藝術家在現階段所擁有的文化自覺，不只豐富與發展了自身的繪畫歷史，也是為整個繪畫注入了新觀念。如今不論是旅居歐美或海峽兩岸的當代華人藝術家，他們的成長背景及作品樣貌雖然各異，但在內涵及精神上，均相當接近新人文主義風格，他們多年來的創作實踐精益求精，所累積的成果，已成為華人當代文化的可貴資源，而龐曾瀛更是其中彌足珍貴的代表人物。

The Evolvement of Pang Tseng-ying's Art Thought:
from Chinese Modern Painting to Modern Chinese Painting

Pedro Tseng

Chinese Modern Painting or Modern Chinese Painting

The Western big powers once colonized almost all of the countries in the Far East region, which thus received significant colonial influence. Consequently, the art development of this area in the first half of the 20th century was going through a series of tests and struggles in its Westernization and modernization process. However, Modernism which places emphasis on self-expression had its limitation in East-Asian societies where Confucian philosophy still dominated as the mainstream way of thinking of man-rule society.

In the early stage of modern art development in China, leading painters such as Liu Hai-su, Gao Jian-fu, Lin Feng-mian and Xu Bei-hong, who had traveled to Japan or France for further study, had mostly already spent a significant period of time on Chinese painting prior to their contact with Western painting. Therefore, on returning from abroad after completing their study of Western painting, they began striving to incorporate into Chinese painting the theories and techniques of Western painting, thus creating a new version of Chinese painting, also known as Western-nourished Chinese Painting. In contrast, contemporary Taiwanese painters, being faced with the hard choice between the old art and new art, had chosen to shake off the shackles of obsolete tradition and culture, and delved into finding new paths or techniques. Some even devoted their whole life to studying the raw materials, medium and techniques used in Western paintings.

During the Japanese rule, Kinichiro Ishikawa was well respected by Taiwanese painters, who esteemed the authority of Imperial Art Exhibition and Taiwan Art Exhibition and persevered in pursuing the painting style of Impressionism and Fauves schools. During this period, only a few painters studying abroad chose to stay after completing their art study; they included San Yu and Pang Yu-liang who resided in Paris till old age, Yun Gee who died of illness in New York, and He De-lai who resided in Japan. They all formed the first group of art learners staying overseas on a long journey aimed to develop modern Chinese painting. They made great sacrifice in writing and telling sad stories about the struggle of the first generation overseas Chinese painters. The more accomplished painters such as Zao Wou-ki, Wu Guan-zhong, Walasse Ting, and Chu Teh-chun, were ones who headed for Europe or the United States on observation or exhibition tours after the end of World War II and afterward chose to stay on.

Pang Tseng-ying had directly participated in Taiwan's modern art movement of the 1950s and 60s, before he immigrated to the United States in 1966. Pang is thus a familiar figure to the

majority of Chinese artists living and working in the United States. Pang's life can be briefly sketched like this: Receiving his formative traditional Chinese art education in mainland China, he polished his creative approach in Japan, honed his modern sensitivity in Taiwan, and created a distinctive painting style in the United States, winning widespread acclaim in Europe and North America. Successful examples of the marriage of Eastern and Western art, Pang's works opened up new realms of possibility for Western abstract painting.

At Pang's first overseas solo exhibition in New York in 1954, Art Critic Ku Shian-liang once commented, "Mr. Pang learned more from the Western art history than he did from the Chinese one. That's a common trait shared by Chinese oil painters and watercolor painters. Most of them are either entirely unaware or not totally and constantly negligent of the art history of their own country; they oftentimes are almost completely westernized. They always claim to be yang, to be Western painters. Unfortunately and regretfully, genuine Westerners would call them Chinese painters at any rate. Actually, these Chinese-born Western painters had very little or no knowledge about Western art history. Mr. Pang once spent time studying Chinese art history in China. Now, residing abroad, he is doubling his effort to learn more about it." The brush stroke or drawing style of an average Chinese painter is more or less, directly or indirectly, affected by the bright and beautiful calligraphy - this is a general and not a specific phenomenon. And Mr. Pang is no exception. Calligraphy and painting are like a brotherly or sisterly art with a style of their own. Both can communicate with each other while absolutely not detaining each other. However, besides an occasional faint display of his inventive technique of dotting and "texture stroke" in his landscape painting, as a whole, it s not easy for us to connect Mr. Pang's works closely with the traditional techniques.

"As for the warm-feeling subjects and family colors he adopts, that serves to reflect everyday life and customs and habits, much of the impact Western art has made on Mr. Pang comes from the late Impressionism (1876-1900) with little influence deriving from the early Cubism (1900-1908), including the works of Paul Cézanne, Paul Gauguin, Vincent van Gogh, Georges Rouault, Pablo Picasso, Georges Braque, and Henri Matisse. A painter like Mr. Pang so apt or ready to absorb foreign impact will rapidly catch up with the new trends of global art if he is able to go abroad to see the world. " Ku added, " Mr. Pang's subjects are multiple and rather balanced in developing. In spite that his style is yet to attain complete maturity, we still cannot tell what category of art he specializes in or whether he's good at every art category. If Mr. Pang, aged below 40 as he was born in 1916, carries on his usual pace of creating, trying out as many paths as he can to ensure balanced development, for a period of time, he will surely return to simplicity from breadth based on his rich experience and extensive knowledge, ending up as an expert. Further, he will be able to turn from breadth to complexity, ending up as a

great master."

Surreal Oriental Landscape with Symbolic Meaning

Generally speaking, Chinese people are conservative and prefer to stick to the ancient proverbs. They seem forever to be embracing a sectarianism mentality. Such a deep-rooted mentality has become a kind of belief, a model and an idol in them. It is only through breaking down such pilgrim-like worship of sectarianism can people dispel or relinquish their belief in narrowly modeled concept and thus open up a real-life world. And it is only by learning from a great variety of accomplished artists based on all the true source of beauty can the wisdom be extracted from the mechanical framework to open up an easy path to nature. If painters must rely on the favor of their sectarian art master, their art life will certainly be suffered or crippled. If they can allow their mind of worshiping the past, the present and foreign masters to transcend, they can see and feel the true beauty everywhere and all the time, reflecting the call of life and existence by way of the spirit of our tradition, Chinese art will enter a new level.

In his statement prepared for the 2nd Chi Hsiang Group Exhibition in 1962, Pang noted, "Tradition absolutely does not equal to conservativeness. Creation cannot be yielded from plagiarism. An artistic work is a combination of emotion, wisdom and ideal. Painting art must be new and not copying; it can be old but not conservative. When deprived of tradition, it becomes a work of blind obeying, like the way a slave behaves. Undergoing no creative process but scraping together all the borrowed ideas can be said to be cheating." "I paint to live and I truly paint to depict my life as it is so as to search the real inner existence. This way, I hope to see the true beauty based on the true fact of living. Then, what is my painting ultimately is? A Chinese new painting? A Chinese Western painting? An Chinese outfit on Western painting? Or a Western painting masquerading as a new figure of China? Reflecting and alerting myself while creating and imitating within tradition, I sincerely pray for guidance. "

The value of a painting consists in the individual style created by the painter. No matter what category it belongs, a work can naturally attract the attention of people as long as it has an original expression which keeps on opening up and widening a new horizon. In the 1963 Chi Hsiang Group Exhibition, Pang's works demonstrated his use of paraphernalia and materials for Chinese painting. This substantially reveals Pang's transcending from Surrealism to Abstract Expressionism as seen in Western painting,and thus spiritually, signals a huge change in his art path.

In fact, in 1957, Pang had expressed his views on modern paining. First, he opined that, though the topic in discussion is the Western painting, the paintings created by Chinese artists ought not to be given the title of 'yang' (which means foreign-style or imported) or 'Western' simply because of the materials or tools they applied in producing it. What they produced are works of Chinese art, not Western ones. We can appreciate Western painting; however, we can never create a Western one. We must do more study on art issues and do less blind copying. Classicism, Realism and other -isms emerge out of their specific contexts; for example, Classicism awakens the dying Feudists, while Romanticism points out the mistake of Classicism; still, both are products of Feudalism. Impressionism inherits the heritage of visual art from Realism and develops a better attitude toward art than Realism, because the former discovers a pure visual impression generated by natural instinct. With the emergence of Post-Impressionism, the West began to perceive the narrowness of their painting art and, at the same time, to find the value of the free walking and meaning exhibited in oriental painting as a form of true art, which, from ancient times up to the present, conveys moods and emotions as well as ideas and thoughts. Post-impressionism reverts to the real path for true art, which is regarded by the Europeans as the beginning of modern painting.

Speaking of Surrealism, Pang did not agree that Surrealist works belong to Realism. Like Cubism, Futurism, Suprematism and Abstractionism, before we could understand Surrealist works, we must first be aware of the basic principle of symbols. A symbol is a sign which is employed to represent our impression of a physical occurrence or thing. There are many examples of symbolization. For example, the Chinese character ˙馬˙ (pronounced as 'ma') stands for a real horse with four legs. But, the appearance of that character represents what is sensibly perceived to be a horse, while a symbol stands for the impression of something different from that perception. In painting, Symbolist works mostly refer to something concrete, but for Surrealists, the symbols stand for something in their minds. Today, those pure abstract painters seem to intend to connect human emotions with the unconscious. But, as long as we can rid ourselves of conservative prejudice against beauty, we can be ready to appreciate pure abstract painting. As long as we are vigorous and intelligent enough, we should be easily able to emotionally connect with pure abstract painting.

Building His Own Unique Style and Expanding New Horizon for Chinese Painting

After his emigration to the United States in 1966, Pang had enjoyed learning and producing Western painting all day long. In search of his own style, he rekindled enthusiasm for the heritage of Oriental culture. During his U.S. residence, all of his new works would exhibit much of the Oriental spirit while merging the quintessence of Western painting. He appeared to be drawing a picture of Land of Peach Blossoms, a mythical kingdom located on the top of

mountain that divides the east and west worlds. His paintings of this period are fine and smooth; they describe celestial scenery that inspires praise of Nature, constantly greeting an eternal spring.

Pang, always serious and sensitive, was very cautious in dealing with his work. He usually began work with extreme care when preparing painting paper — a kind of highly ink-absorbing crepe paper. Just like most of the other abstract painters, before taking up his painting brush, he did not have in mind any fixed topics. Nevertheless, certain natural sight, scene or image would always appear subconsciously before his eyes.

Following the techniques and methods for Oriental painting, he would first sprinkle ink freely on the paper with ease. Then he would incrementally add colors, until he achieved the desired effect. At this stage, the impression he gained from the painted image would excite his thought which would consciously become relatively concrete. Often, as his thinking became more concrete, natural scenery would begin to emerge — trees appearing before his eyes, with fully-shaped leaves. Lastly, he would use his brush to draw the lines and add strokes to produce tiny figures in contrast to the hugeness and vastness of Nature as well as the boundless universe and eternal time. He would often embellish the picture with insects, birds, or animals.

As Ben Britz, an American commentator of *Music and Art*, put it, "When viewing Pang Tseng-ying's watercolor paintings, the audience are apt to be taken into the mystery of Oriental art. By using the nuanced color tones and mixed coloring, Pang has created a Western painting with the reserve often felt in a typical Oriental painting." Most of Pang's topics consist of natural scenery: sea, sky, rocks and trees. As a poet, he loves to add to the picture tiny creatures in minute detail, such as an insect which makes its stop on the tip of a pointed leave, contrasting with the background of distant lofty cliffs. This serves for him to extol the solemnity and vastness of the cosmos. Sometimes, he applies on the rice paper all of the colors of the rainbow with delicate brushwork so as to interweave different hues into a cartoon-like abstract image. In the nuanced brushwork of his bold use of color, you can trace his great calligraphy skill, which enables dark colors to display high complexity as can be seen in the embroidery work of silk and satin. At first glance, abstract image seems to be irrelevant to the whole picture, but shortly later it shows a clear and definite figure, which embodies the concept of Surrealism in the mind of the artist.

Clearly, when he started to paint, Pang could be first lingering and patrolling along the path of the Western art. Afterward, in his praises of Oriental landscape, he eventually discovered his

own style, just as Ben Britz stated, "I'm certain that his charm comes from two factors: he preserves a wealth of Oriental calligraphy and painting techniques and skills, and he is very scrupulous and exact in using brushes. Meanwhile, as he is moving towards modernism, he sustains the soft, gentle nature of decoration, and uses prepared ink and ink-absorbing rice paper to produce a charmingly complex image that attracts many." "As is widely known, most of the Chinese painters are themselves accomplished calligraphers, poets and even Zen masters. Their paintings usually contain the combination of thoughts deriving from calligraphy, Nature and respect for painting. These qualities are among the key expressions of modern artists that inspire and excite us."

From Pang's earlier-time works, we can see that he had been trying hard to combine Eastern and Western cultures and techniques having been separated from each other for centuries. In this tedious merging process, he might have encountered distresses and frustrations. Nonetheless, as he was gradually forging his own style and melting the two techniques into a new thing as he so desires, the driving force of his works accumulated and accelerated to build up. The works thus acquired a greater resonance and response from people, and manifested a distinctive power.

Modern Neo-Humanism Combining Eastern and Western Cultures

During his residence in the United States for more than 30 years, Pang had been striving to establish a solid individual style. The unique style won him broad acceptance not only by the American public, making him one of the most popular overseas Chinese painters, but also by the Western art critics as well. The distinguished U.S. *Art Magazine* editor-in-chief Gordon Brown thought that Pang's paintings had transcended the cultural boundary between East and West, and had successfully "subjected the Western influences under the Eastern mood, and created a totally new and purely Eastern artistic realm." Pang's watercolors blended the poetic interpretation of Nature featured in traditional Chinese art, along with the freedom expressed by the Western Abstract Expressionism. The unique art style forged by Pang had actually expanded the horizon for Chinese art.

In terms of technique, Pang's works had gone beyond the limitation of traditional Chinese painting whose composition relies solely on writing brush. He is highly insightful in generalizing the mainstream Chinese art as Wang Wei-ism. According to Pang, the distinguished contribution of Wang Wei to the traditional Chinese art consists in his initiation of a landscape modeled with distinctive feature of picturesque scenery or idyllic scene as its aesthesis basis. Wang Wei's distinguishing attribute lies in his introduction of running script of calligraphy

into painting. Paying special attention to the poetic sentiment in the composition of a picture, and to the aura as an embodiment of the essence of painting, Wang Wei, as Pang noted, was indeed a great master in Chinese history. His skills and techniques, while highly inspiring, have been insurmountable for successive generations for centuries.

Having lingered between the painting tradition of Wang Wei-ism and the Western Abstractionism, Pang, who was reluctant to merely imitate the ancient and foreign masters, ended up seeking his own unique style, and thus expanded the horizon for Chinese art. Purely in respect of painting techniques, he tried to find his own special media or tool of expression. For example, he would employ the evenly etched lines of wood carving techniques on his colored ink paintings; he would also roll the paper into a ball or fold it into various shapes before spreading it back out again to apply colors to produce a brand-new visual experience. Sometimes he would mix naphtha with paint and water and make the colors merge into various abstract forms, resulting in a casual and exceptionally vivid effect. He insisted that we must revolt, elevate and innovate by breaking out of the paradigm of Wang-Wei-ism and, in order to accomplish this, we must try out different tools, materials and methods that go beyond the limits of traditional Chinese painting which purely relies on brush strokes.

To Pang, traveling and moving from one place to another might overturn one s sense of identity, making it develop in a reverse direction. Through a departure from the known self and return to an unknown self, the cultural outsider might devote himself or herself to search for the third category of culture to which their internal world belongs. The accomplished overseas Chinese artists are those who display an individual style and consciously and unconsciously demonstrate Oriental sentiments which are somewhat vague and marginal. Nevertheless, Pang felt that he had been expecting a new kind of landscape painting that is genuinely Chinese. In the new landscape painting, popularly known as new Chinese painting, landscape was not the only content — any other elements such as human figures, flowers and birds could also be included. The cultural awareness of contemporary Chinese artists had not only enriched and nourished their painting career, but also introduced a new conception to the overall painting world. Despite their diverse backgrounds, training and appearance of paintings, the essence and spirits of the works of today's Chinese painters, whether they are in the U.S., Europe, mainland China or Taiwan, are as a whole rather close to the style of the neo-humanism. Over the years, they have accumulated fruits through constant improving and perfecting efforts in mastering their painting skills. These fruits have become a valuable wealth of cultural assets for the Chinese people among whom Pang no doubt is the most worthy representative figure. (translation/Morris Huang)

I

龐曾瀛 油畫作品圖版
Oil Paintings

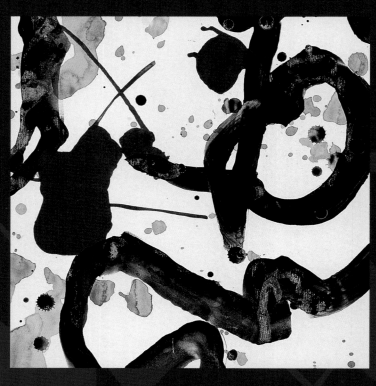

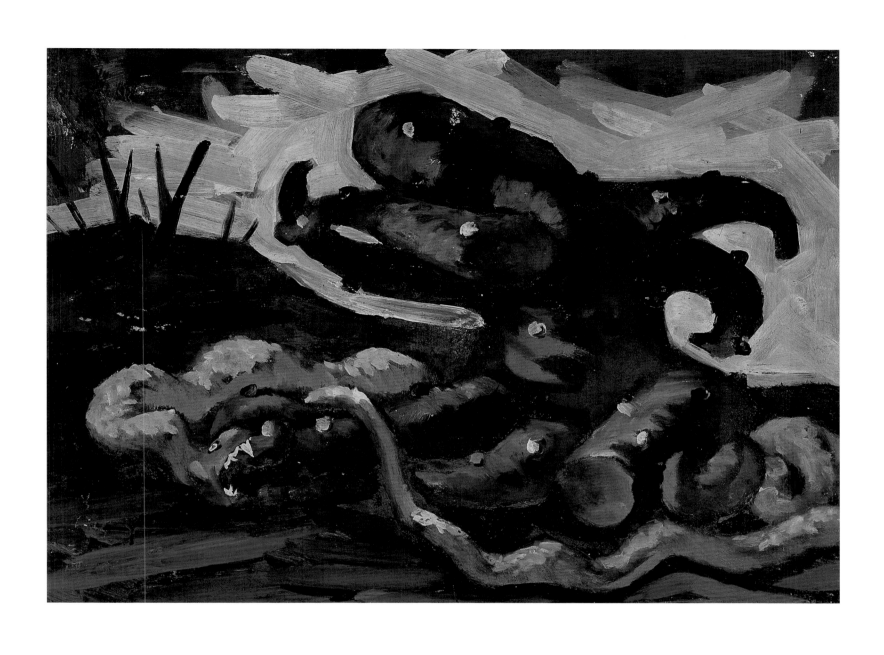

快樂的烏賊　油彩・紙・裱於畫布　38.5×54cm　1934
A Happy Cuttle　Oil on Paper, Mounted on Canvas

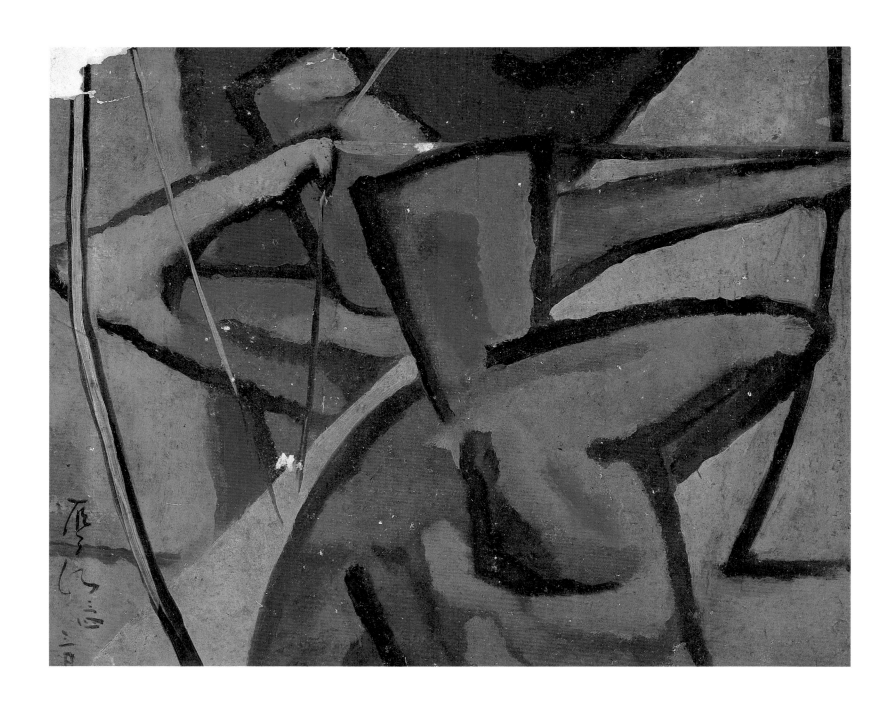

射箭　油彩・紙本　42×53cm　1934
Arrow Shooting　Oil on Paper

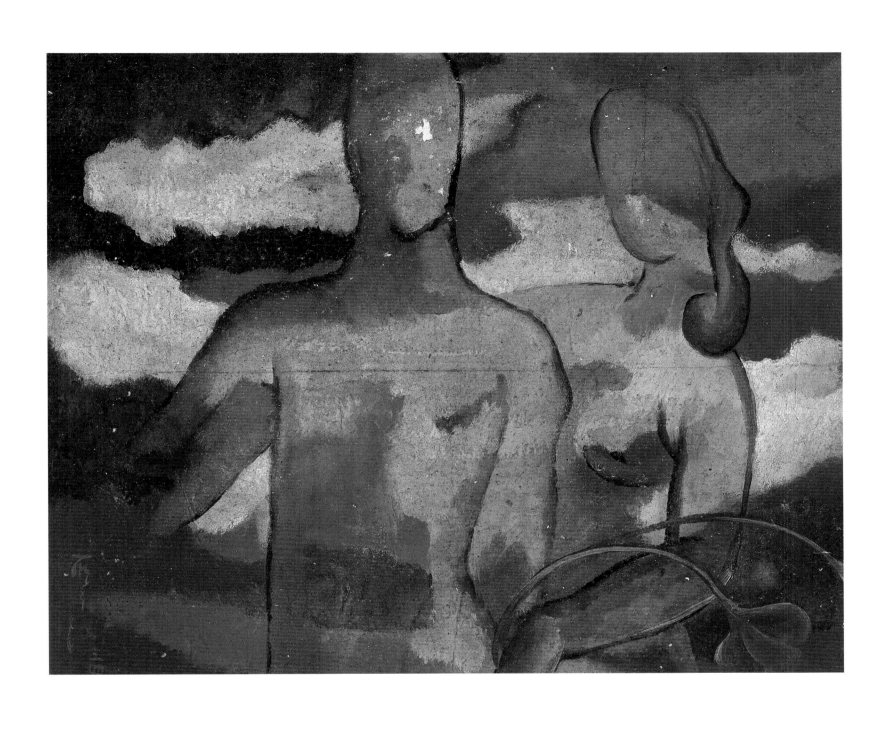

侶　油彩・紙本　39.7×51.5cm　1934
The Couple Oil on Paper

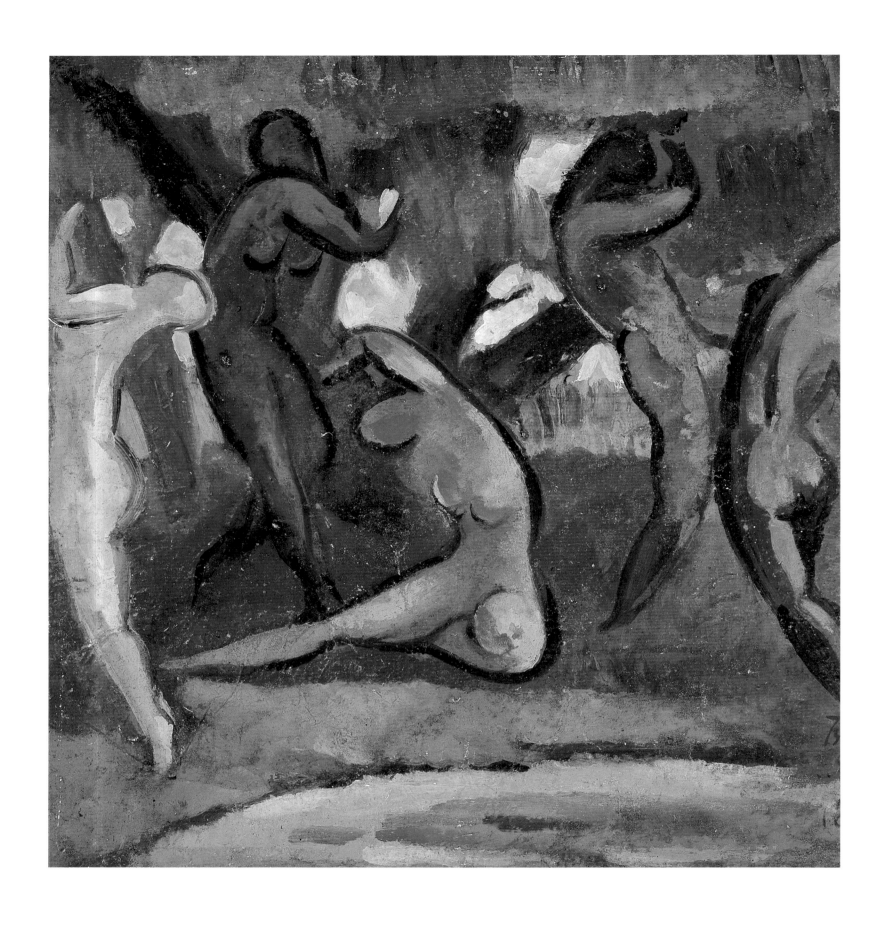

昏之舞　油彩・紙本　40×39cm　1941
Dance of Twilight Oil on Paper

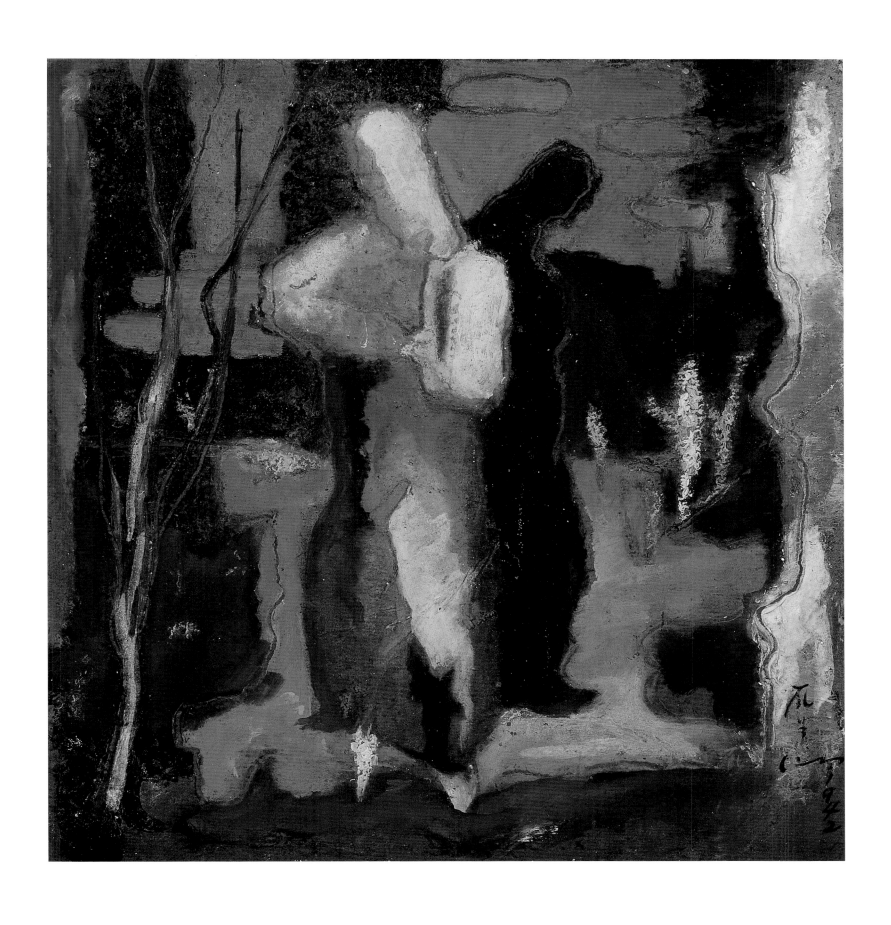

靜默中的不融洽　油彩・紙本　41×40cm　1942
The Recluse　Oil on Paper

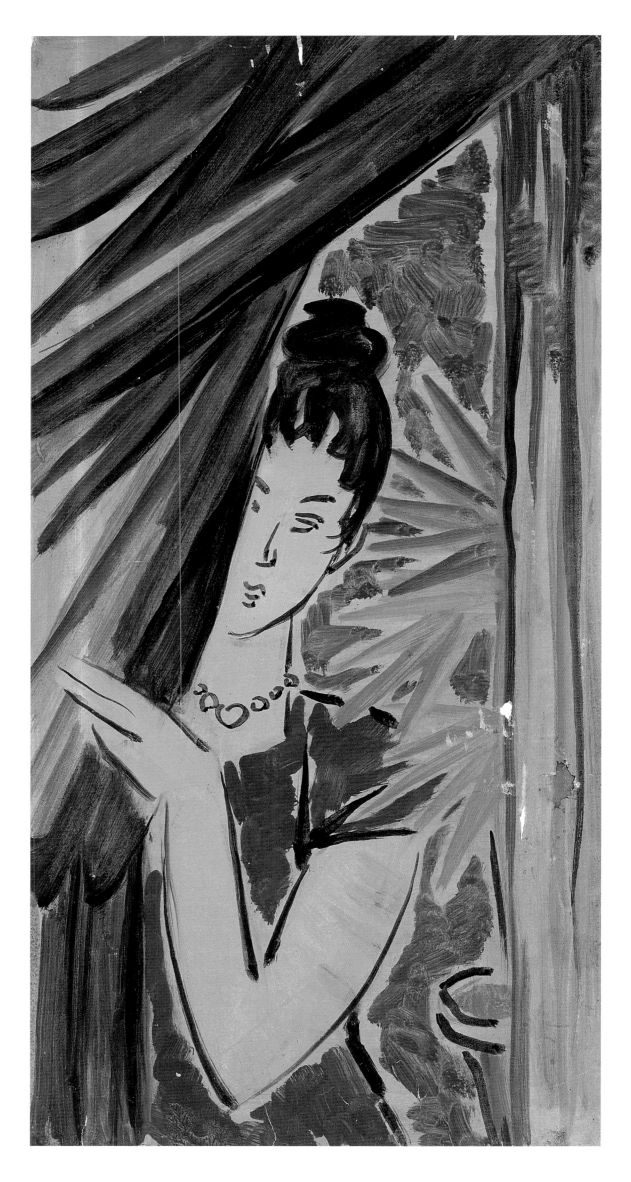

少女
油彩・紙・裱於畫布
54.7×28.8cm　1950

Maiden
Oil on Paper,
Mounted on Canvas

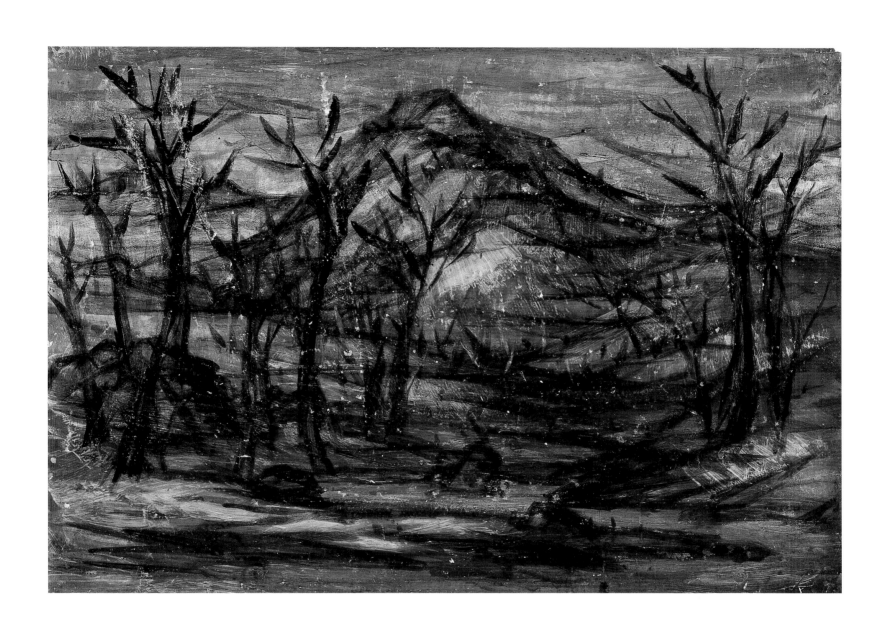

黃昏的樹林　油彩・紙本　40×55.3cm　1950s
Forest Sunset Oil on Paper

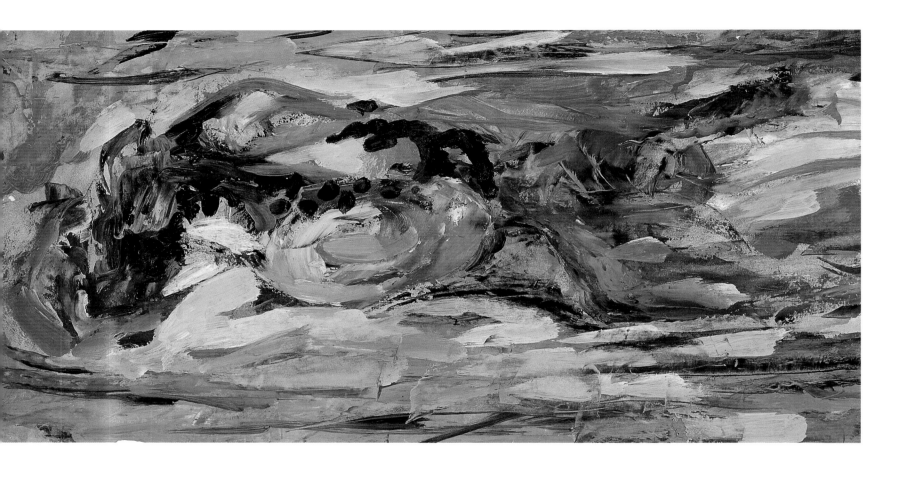

橙和綠的構成　油彩・紙・裱於畫布　27.3×57cm　1950s
Composition of Orange and Green　Oil on Paper, Mounted on Canvas

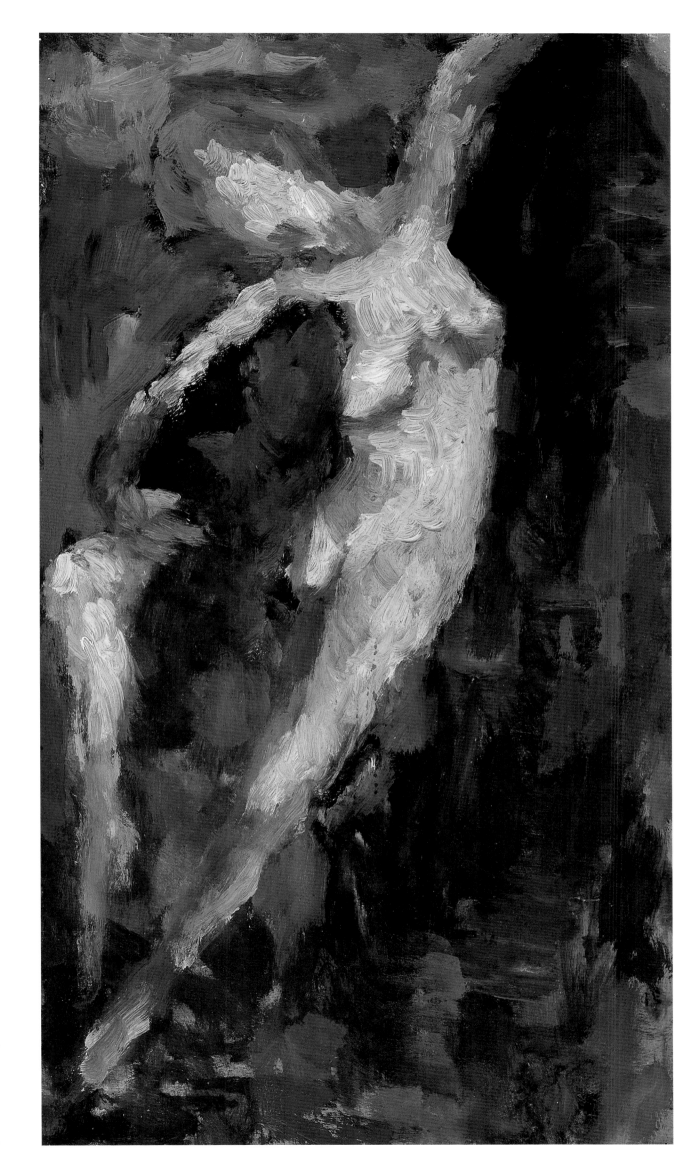

裸舞
油彩・紙・裱於畫布
53×29.5cm　1950s

Naked Dance
Oil on Paper,
Mounted on Canvas

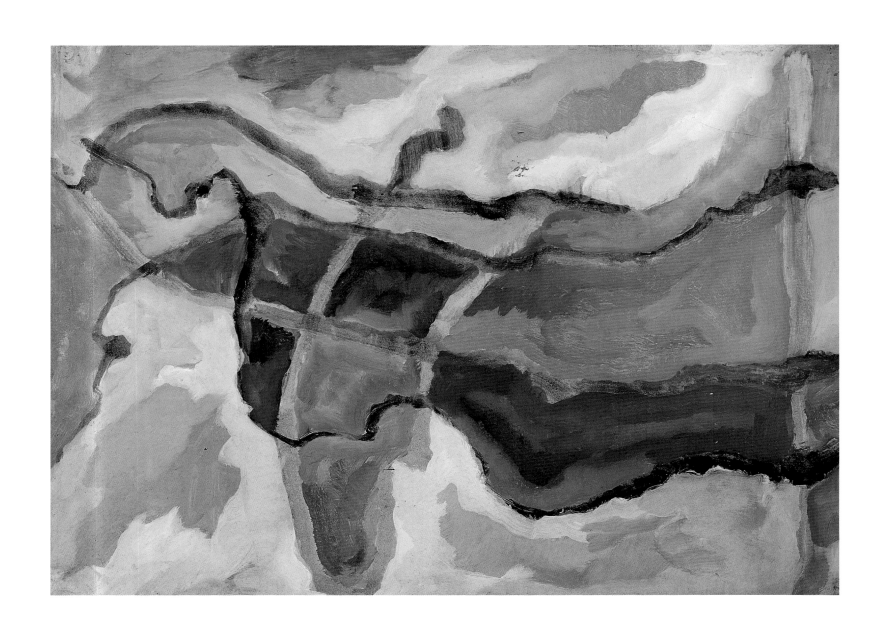

粉紅、綠與藍的構成　油彩・紙本　54.6×39cm　1950s
Composition of Pink, Green, and Blue Oil on Paper

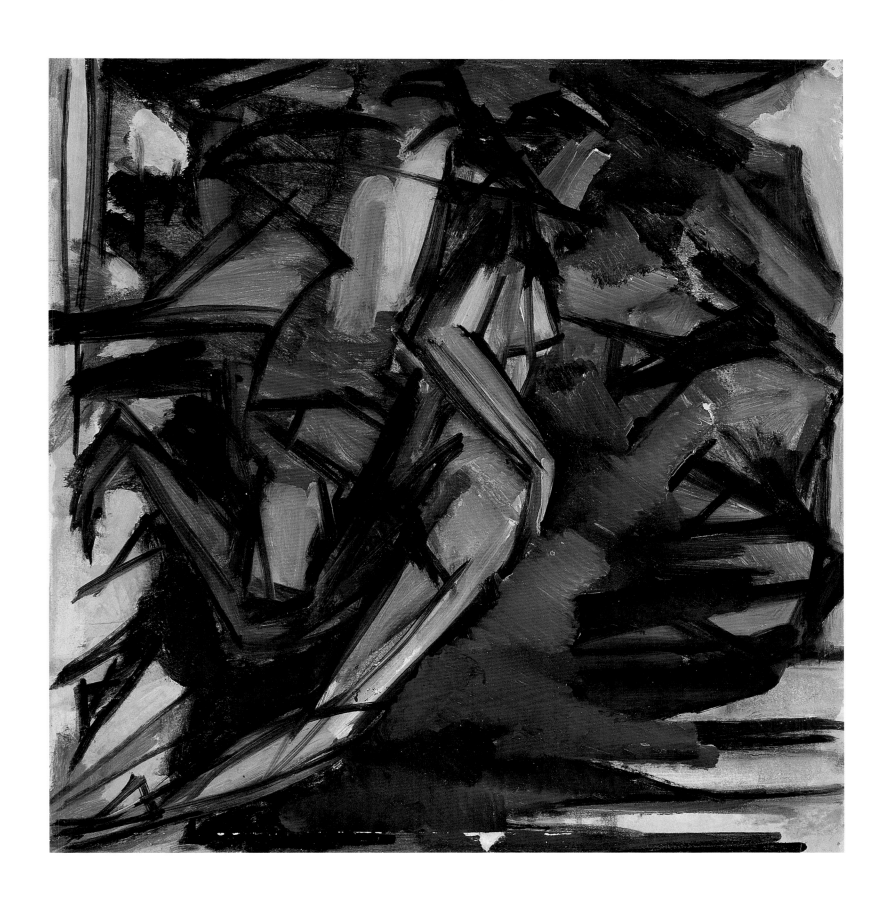

臥　油彩・紙本　39×39cm　1950s
Lying　Oil on Paper

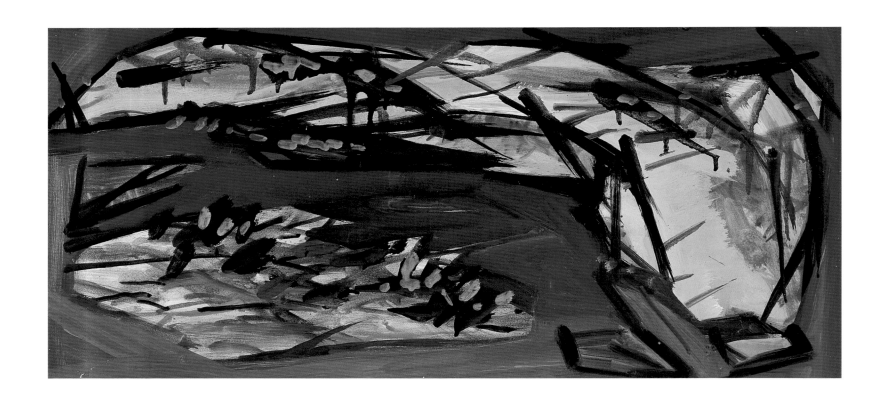

藍色風景　油彩・紙本　24.7×54cm　1950s
Blue Landscape　Oil on Paper

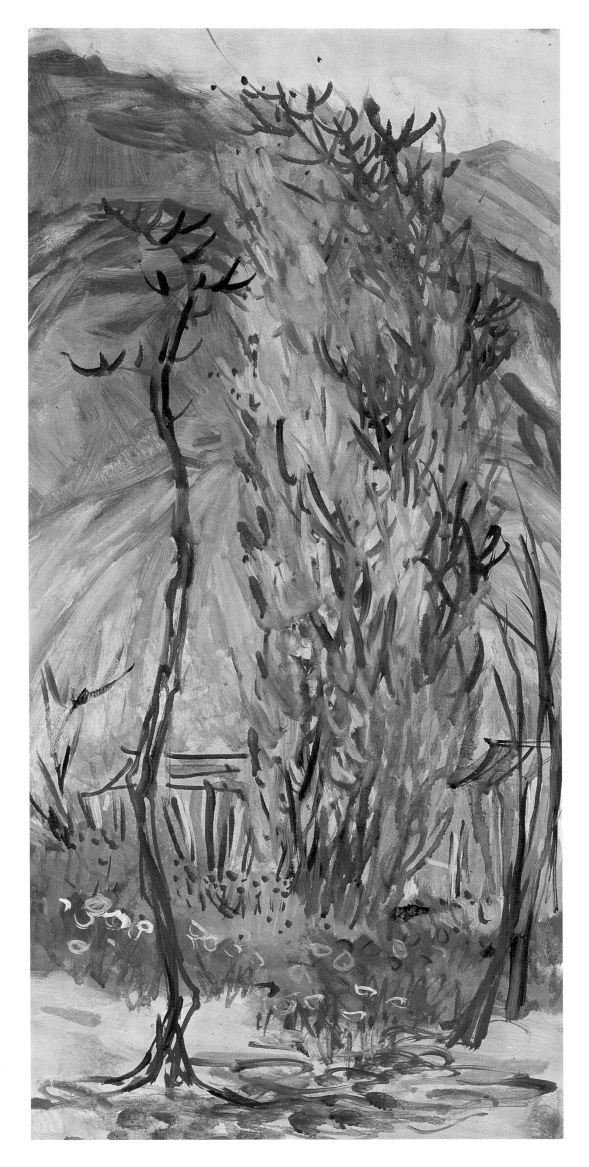

秋山下
油彩・紙・裱於畫布
55.8×27cm　1950～1960s

Landscape
Oil on Paper,
Mounted on Canvas

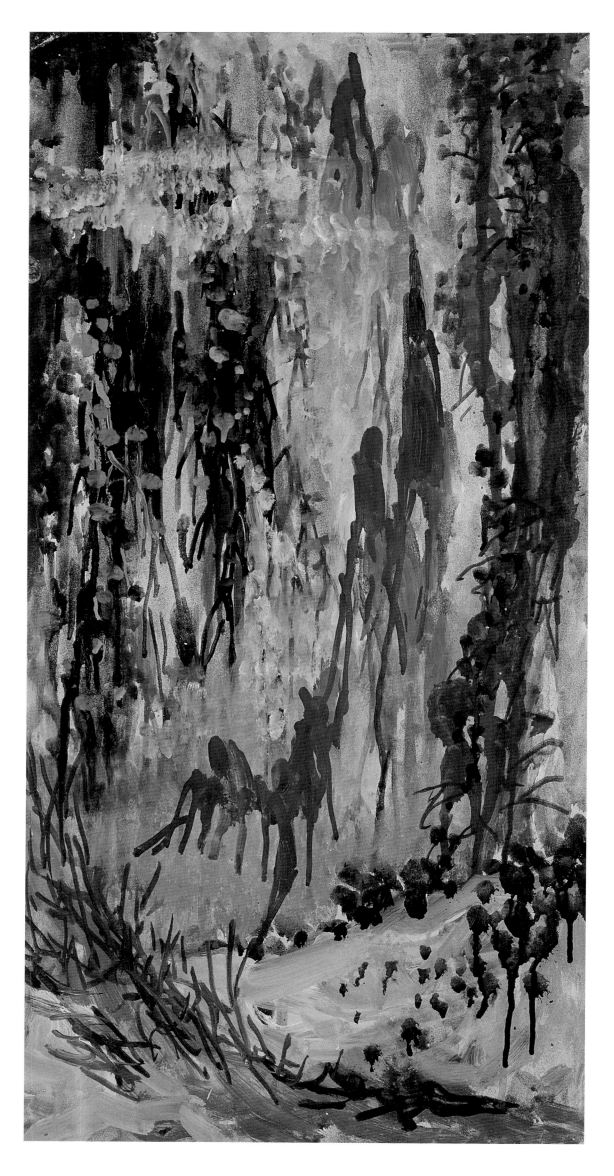

巖
油彩・紙・裱於畫布
56×28cm 1950～1960s

Cliffs
Oil on Paper,
Mounted on Canvas

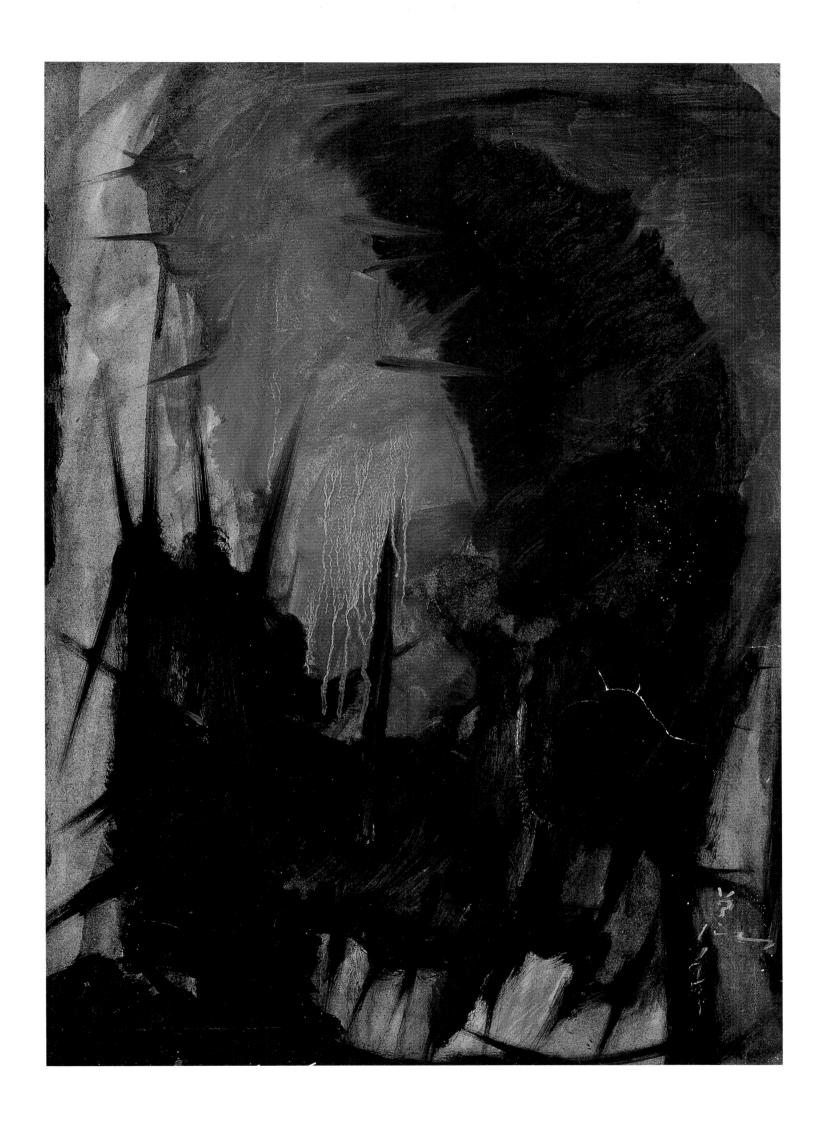

暮　油彩・紙本　54.3×39.5cm　1951
Dusk　Oil on Paper

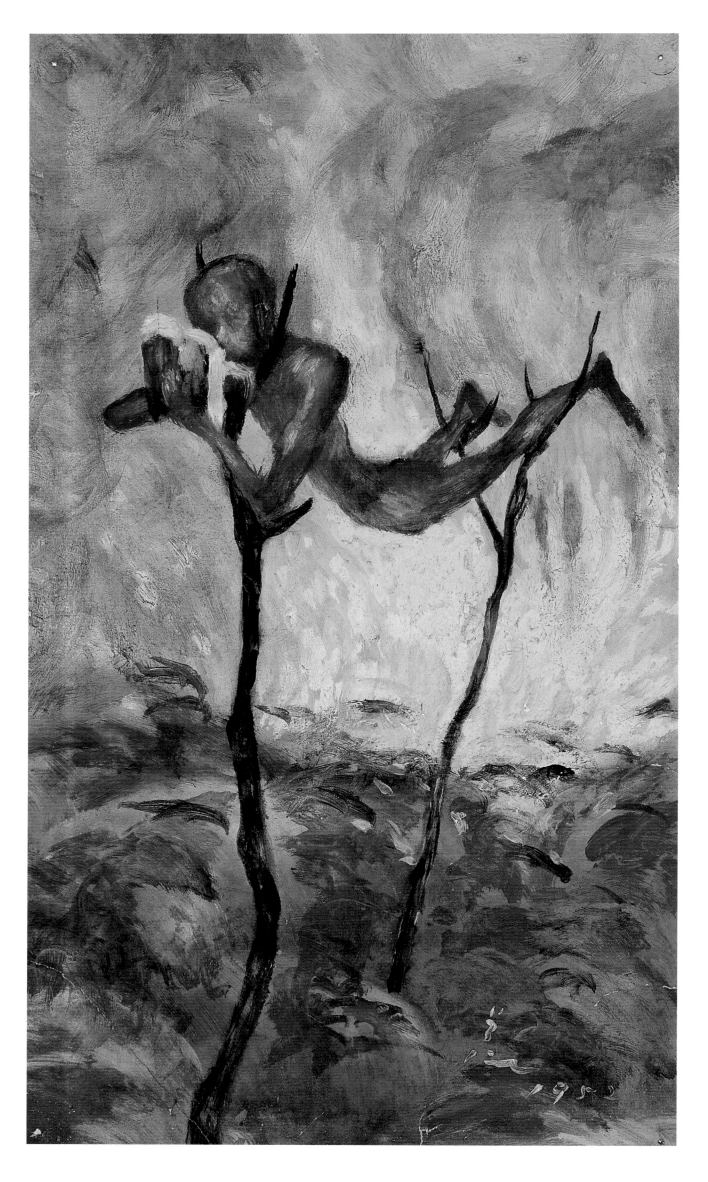

閱讀者
油彩‧紙‧裱於畫布
29×16.6cm　1952

The Reader
Oil on Paper,
Mounted on Canvas

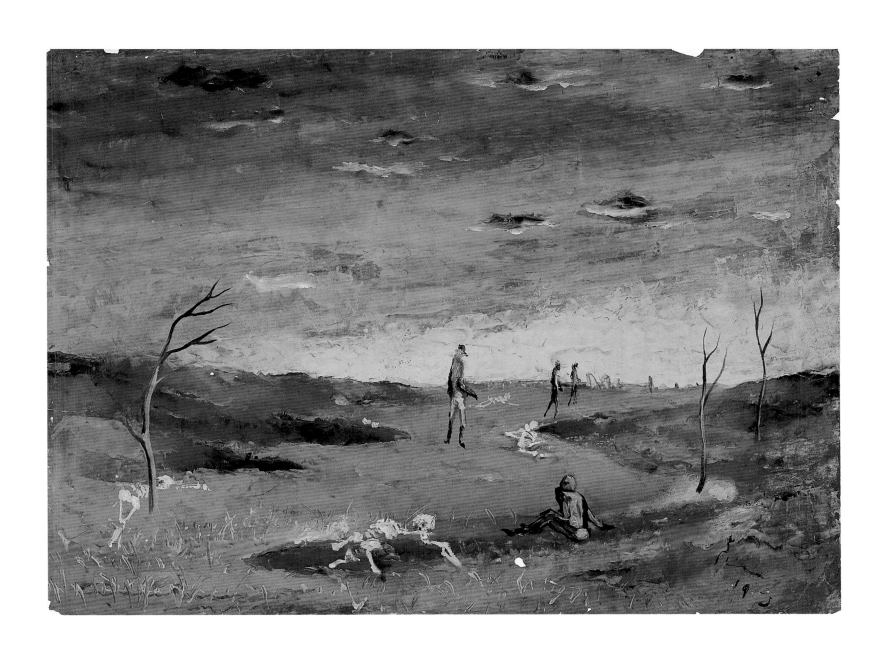

綠野　油彩・紙・裱於畫布　40×54.2cm　1953
Landscape Oil on Paper, Mounted on Canvas

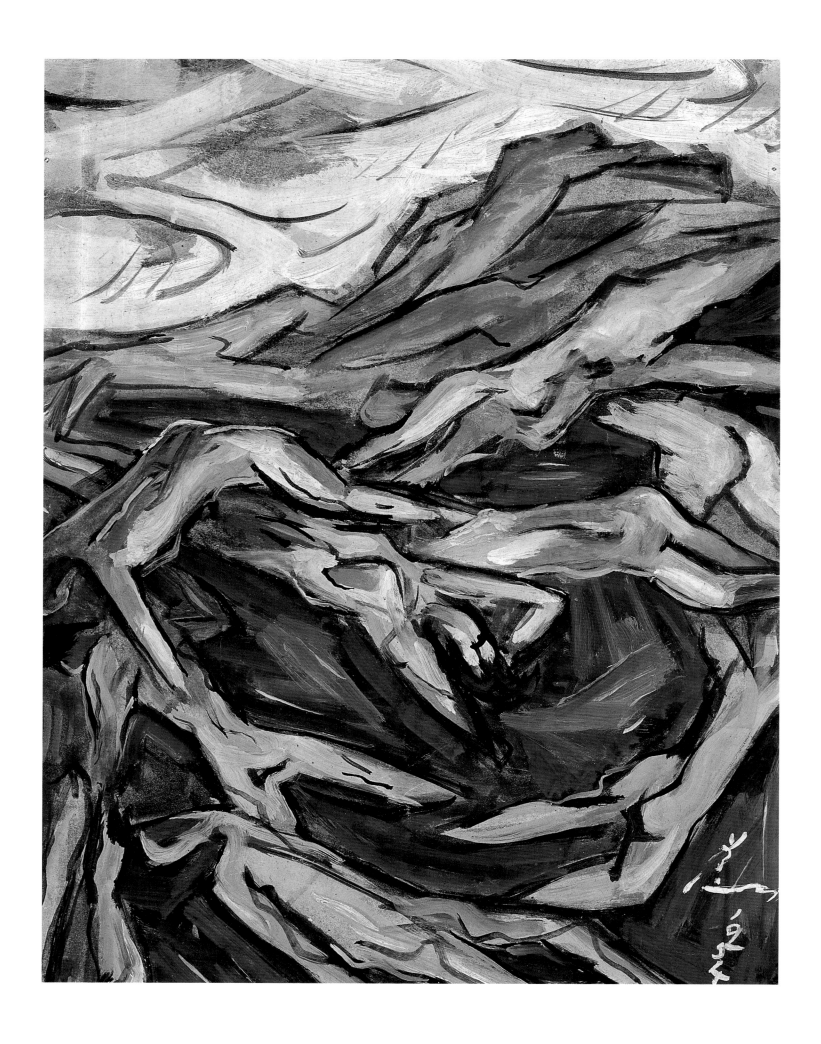

群舞　油彩・紙本　39.5×27.8cm　1954
Dancers　Oil on Paper

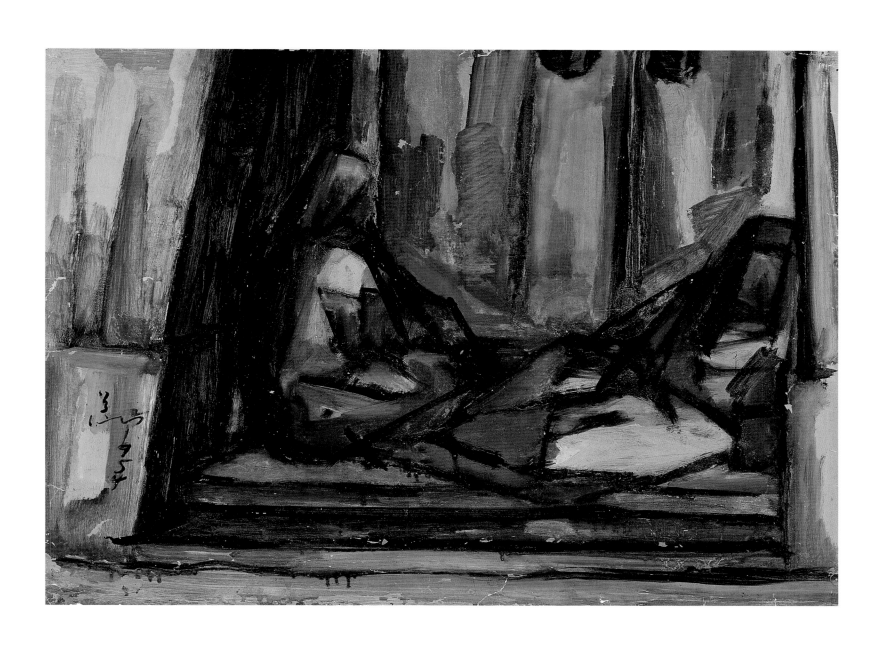

憩　油彩・紙・裱於畫布　39.9×55cm　1954
Rest Oil on Paper, Mounted on Canvas

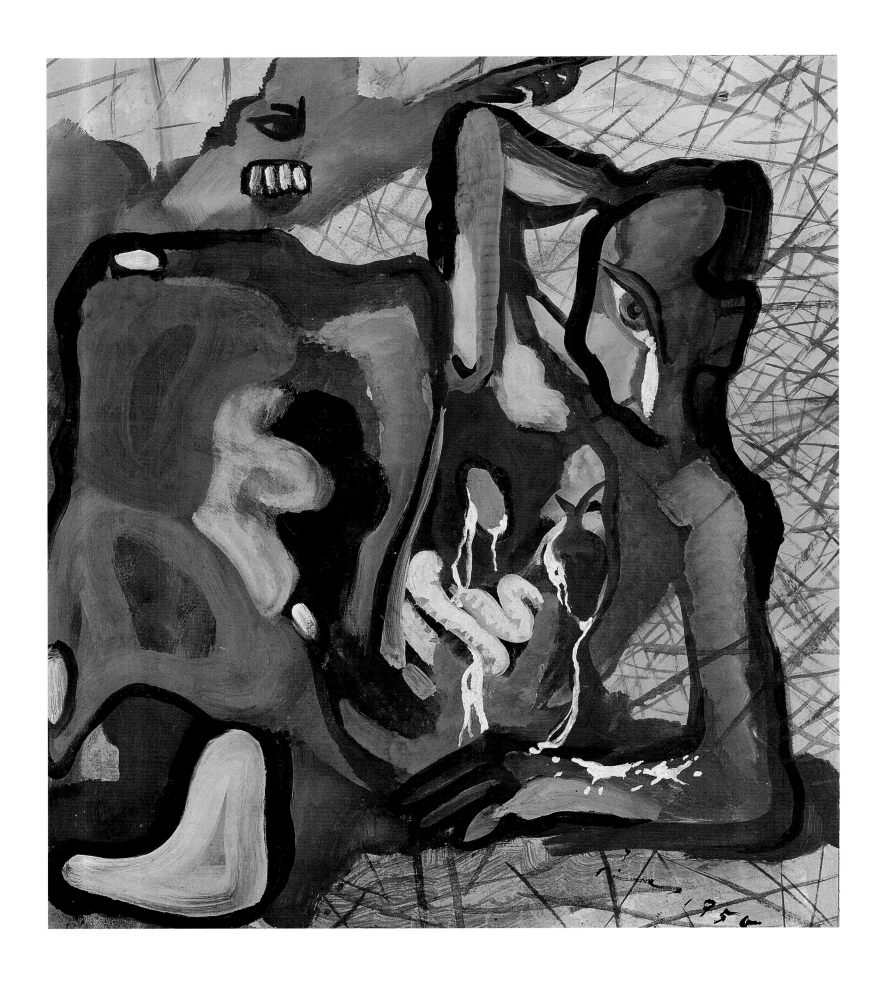

泣　油彩・紙・裱於畫布　38×33.5cm　1955
Weeping　Oil on Paper, Mounted on Canvas

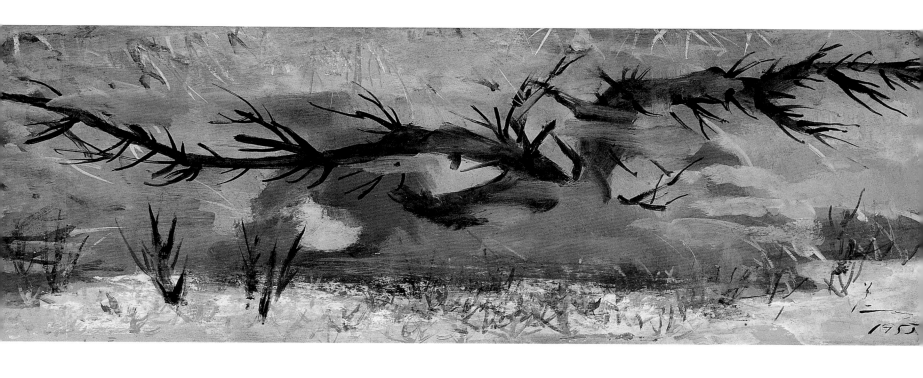

開展　油彩・紙本　18.6×54cm　1955
Stretch Oil on Paper

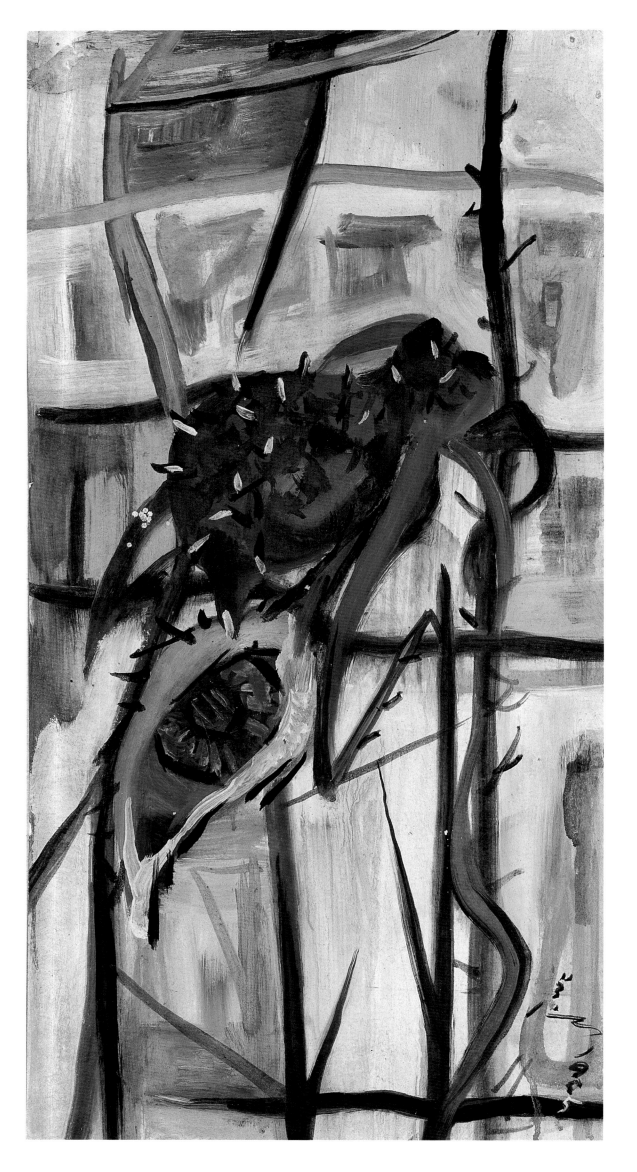

橫豎的構成
油彩・紙・裱於畫布
53.5×27.5cm 1955

Composition of Horiozntal and
Vertical Lines
Oil on Paper, Mounted on Canvas

瀑
油彩・紙本
39×15cm　1956

Cascade
Oil on Paper

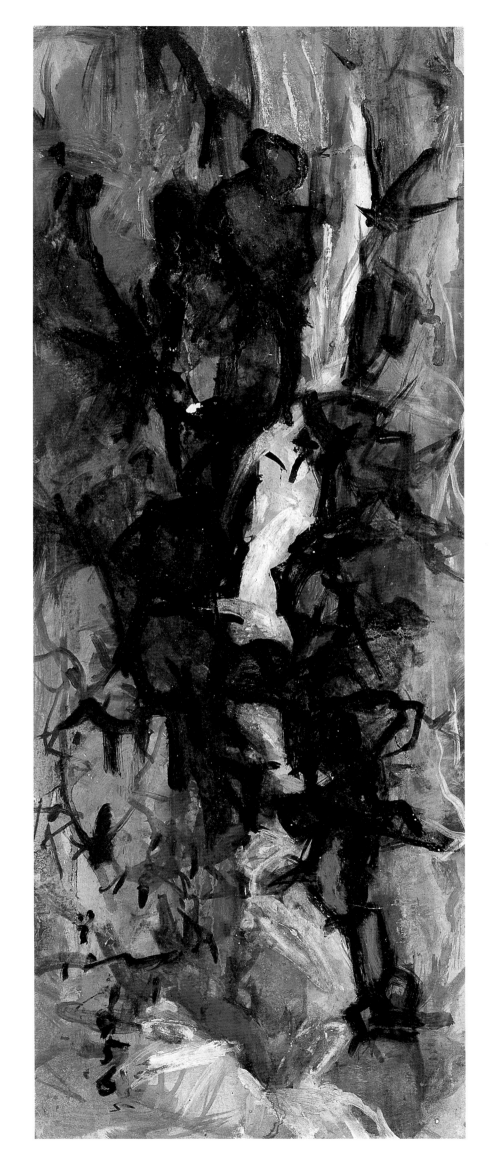

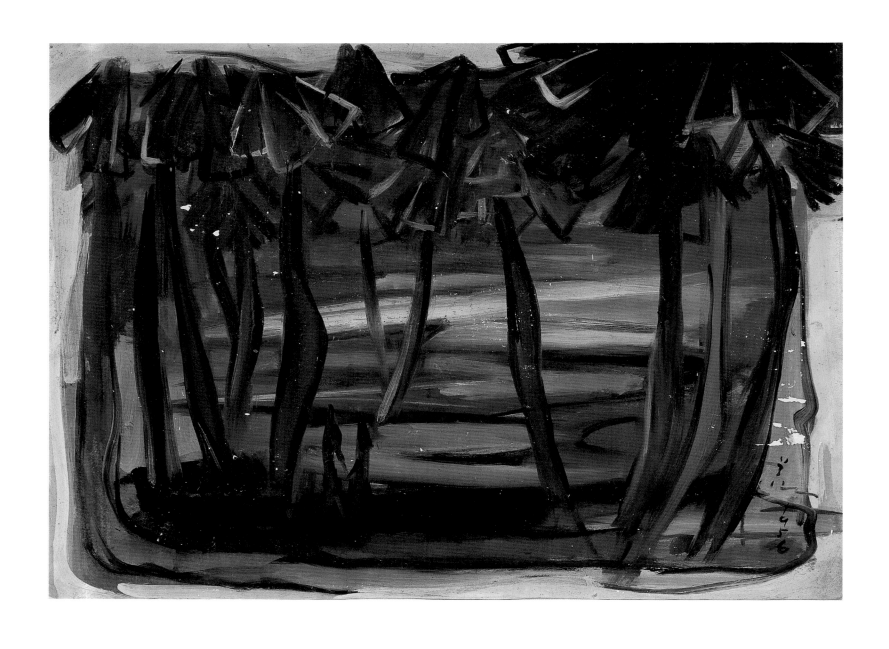

海邊一夢　油彩・紙・裱於畫布　38.8×54cm　1956
Seaside Dream　Oil on Paper, Mounted on Canvas

蘆葦
油彩・紙本
54×21.8cm 1956

Reeds
Oil on Paper

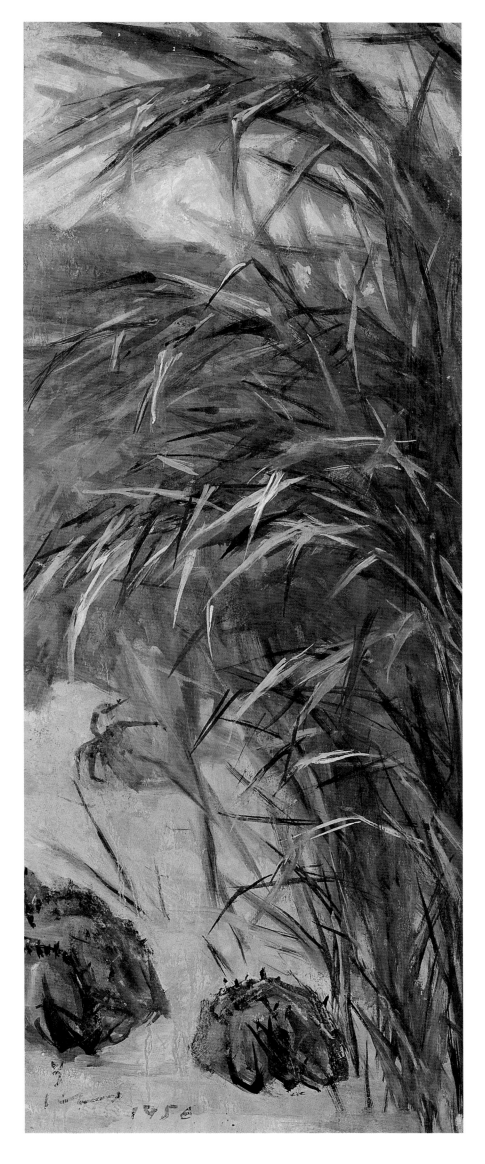

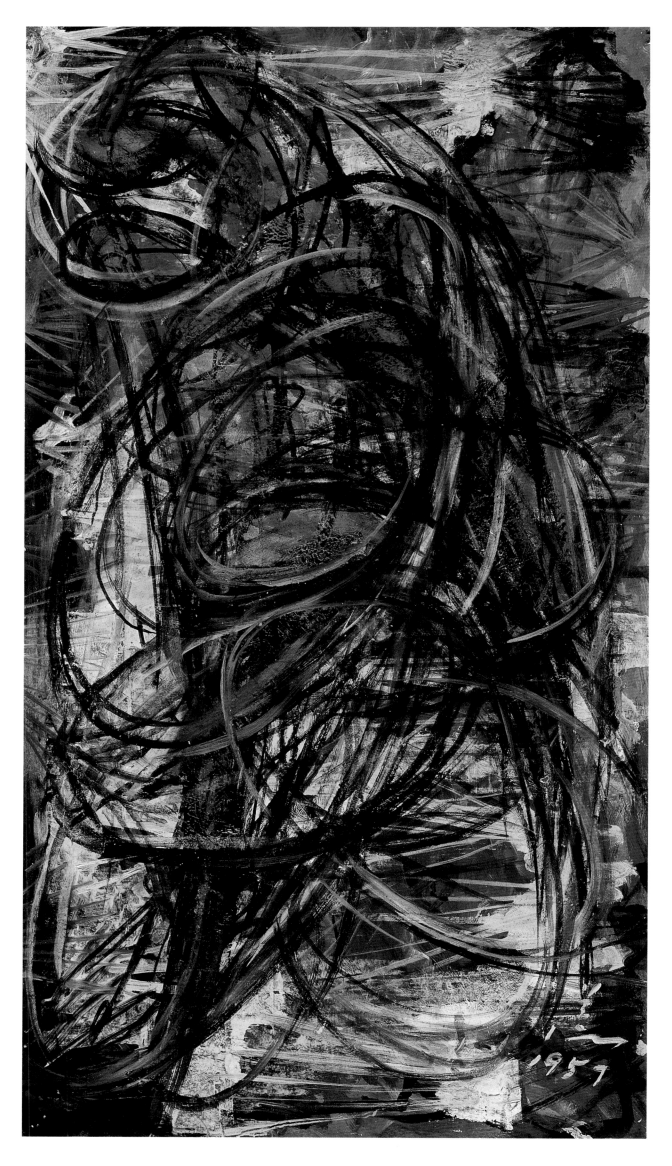

狂舞
油彩・畫布
31.3×28.5cm　1957

Delirious Dance
Oil on Canvas

光芒萬丈　油彩・紙本　39.7×39.7cm　1957
Rays of Light　Oil on Paper

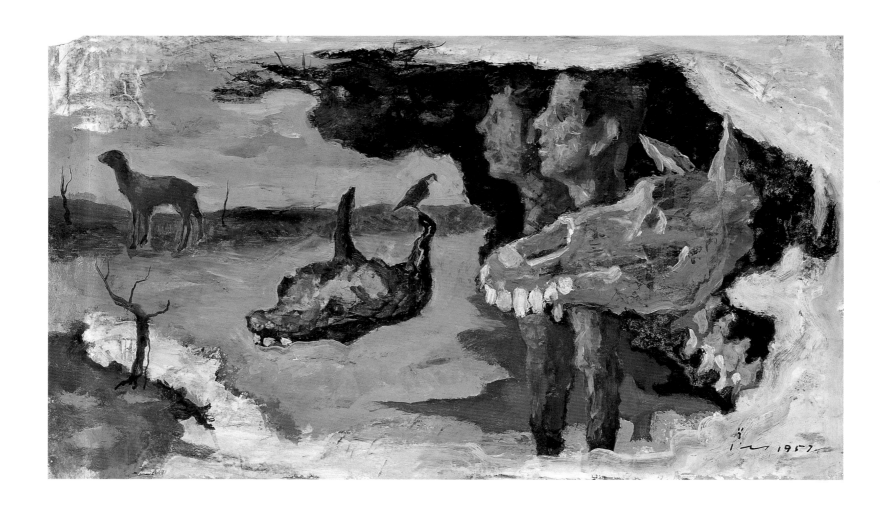

天長地久　油彩・紙・裱於畫布　32×55cm　1957
Eternal and Immortal Oil on Paper, Mounted on Canvas

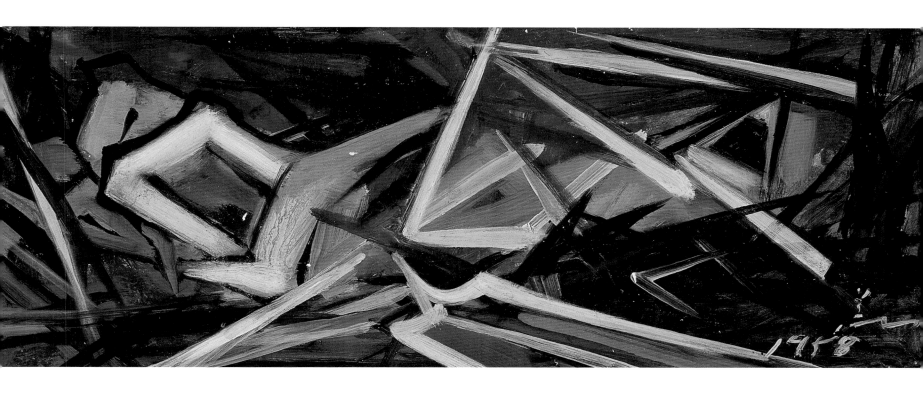

憤怒的鬍子　油彩‧紙本　19.5×54.5cm　1958
Angry Bristles Oil in Paper

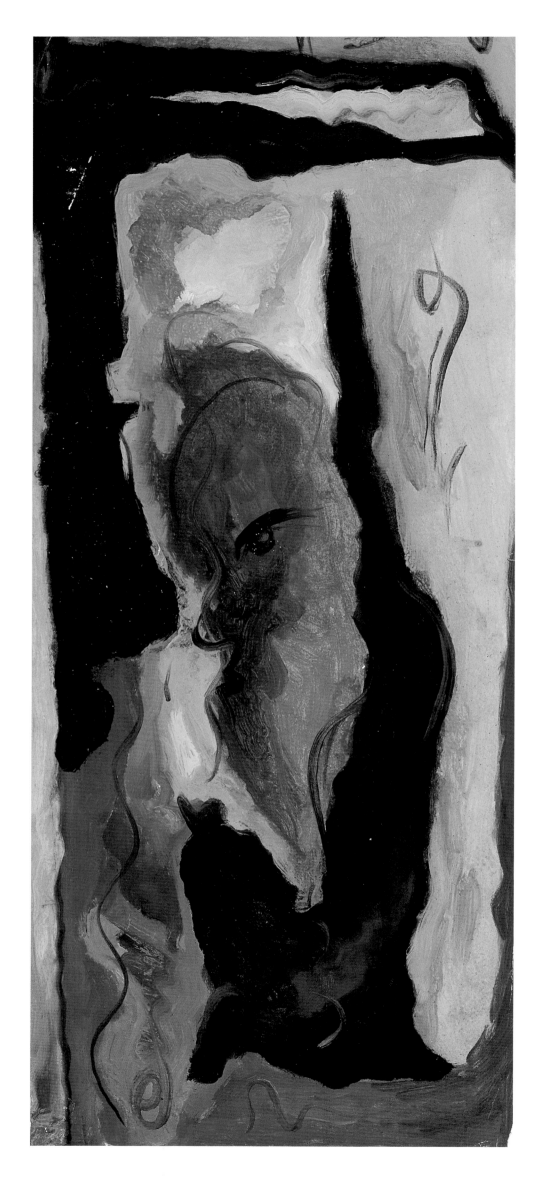

流轉
油彩・紙本
46×20cm　1958

Flux of Life
Oil on Paper

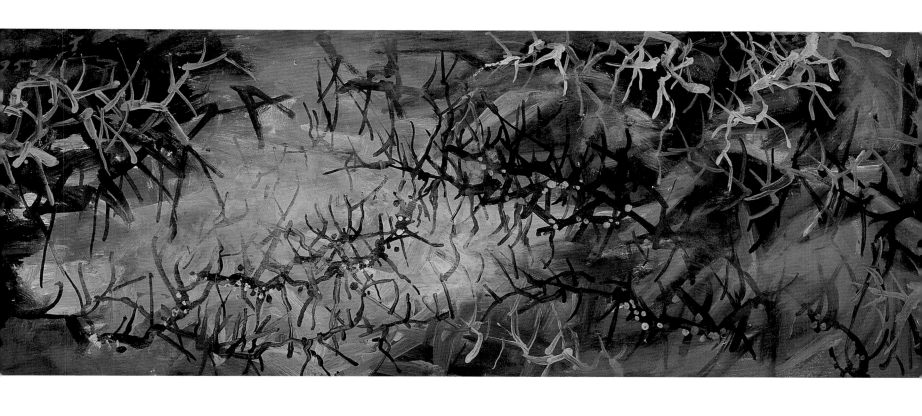

幻影（煩擾中的希望）　油彩・紙本　19.6×53.5cm　1958
Illusion (Hope in Times of Vexation)　Oil on Paper

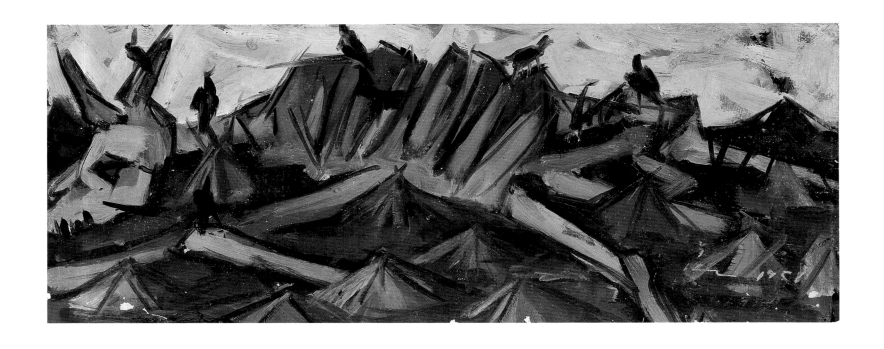

告別　油彩‧紙‧裱於畫布　21.2×54cm　1958
Farewell　Oil on Paper, Mounted on Canvas

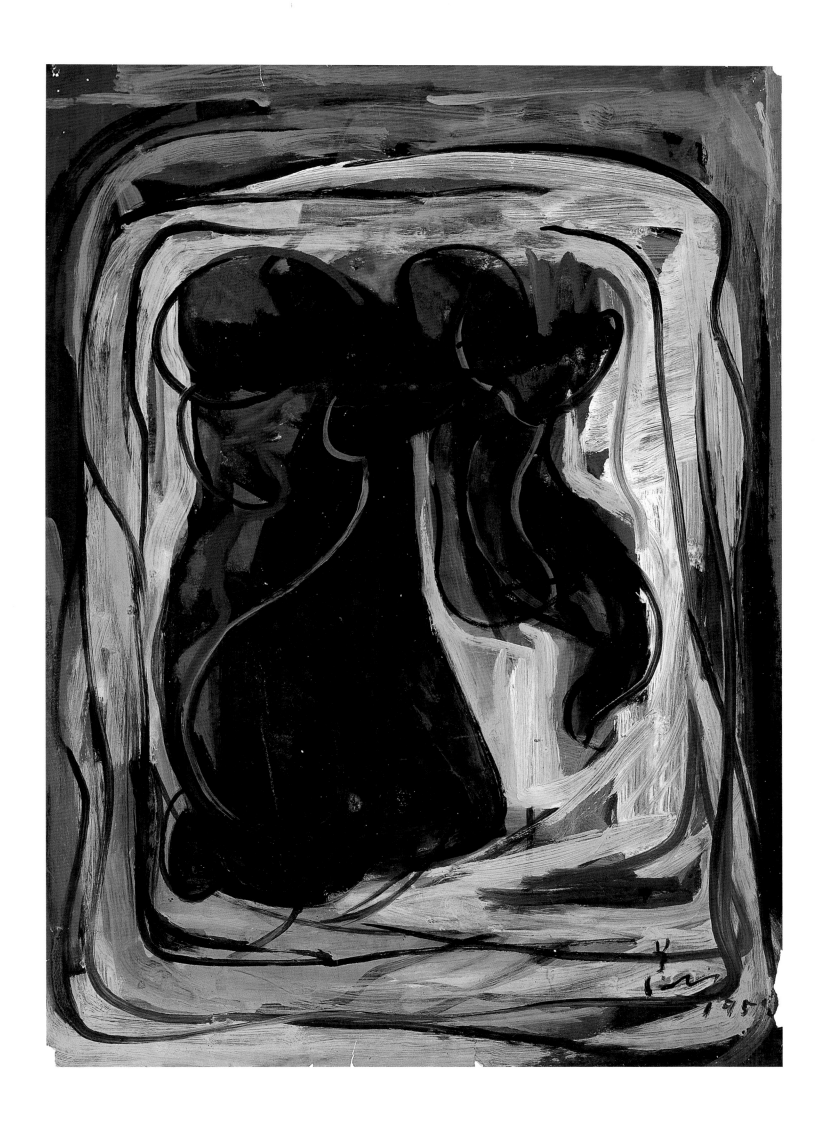

黒色構成　油彩・紙本　53.3×39cm　1958
Black Composition　Oil on Paper

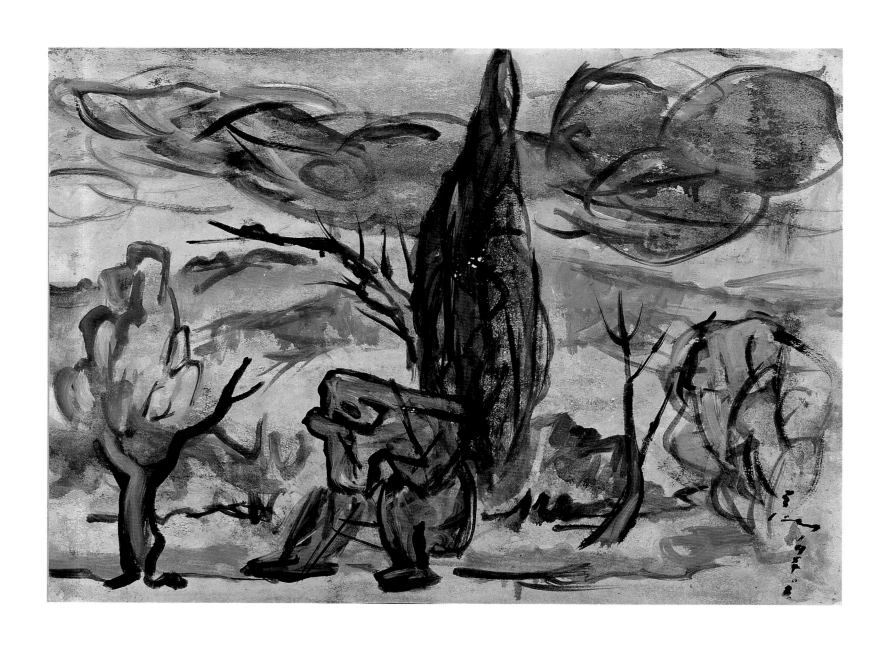

疲途　油彩・紙・裱於畫布　39×54cm　1959
A Weary Way Oil on Paper, Mounted on Canvas

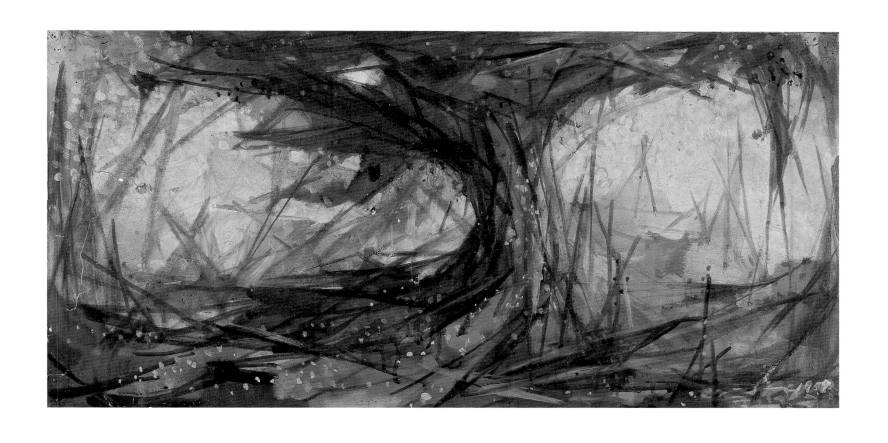

紅色風景　油彩・紙・裱於木板　27×55.2cm　1959
Red Landscape　Oil on Paper, Mounted on Wood

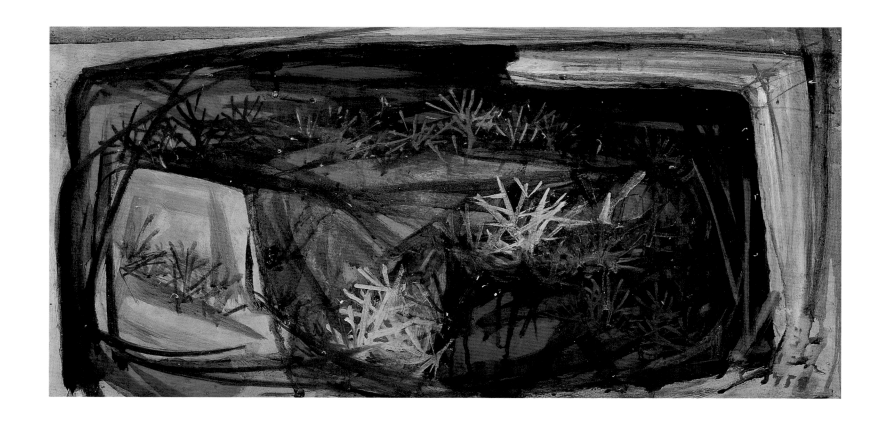

深藍色風暴　油彩・紙本　26×54.3cm　1959
Deep Blue Storm Oil on Paper

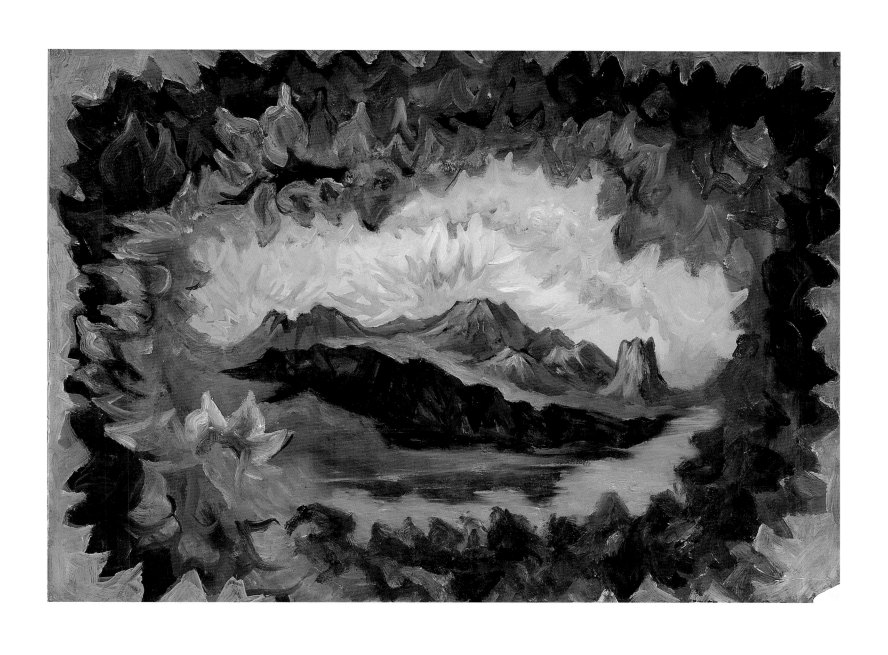

晨曦　油彩・紙・裱於畫布　39.2×54.7cm　1960s
Sunrise　Oil on Paper, Mounted on Canvas

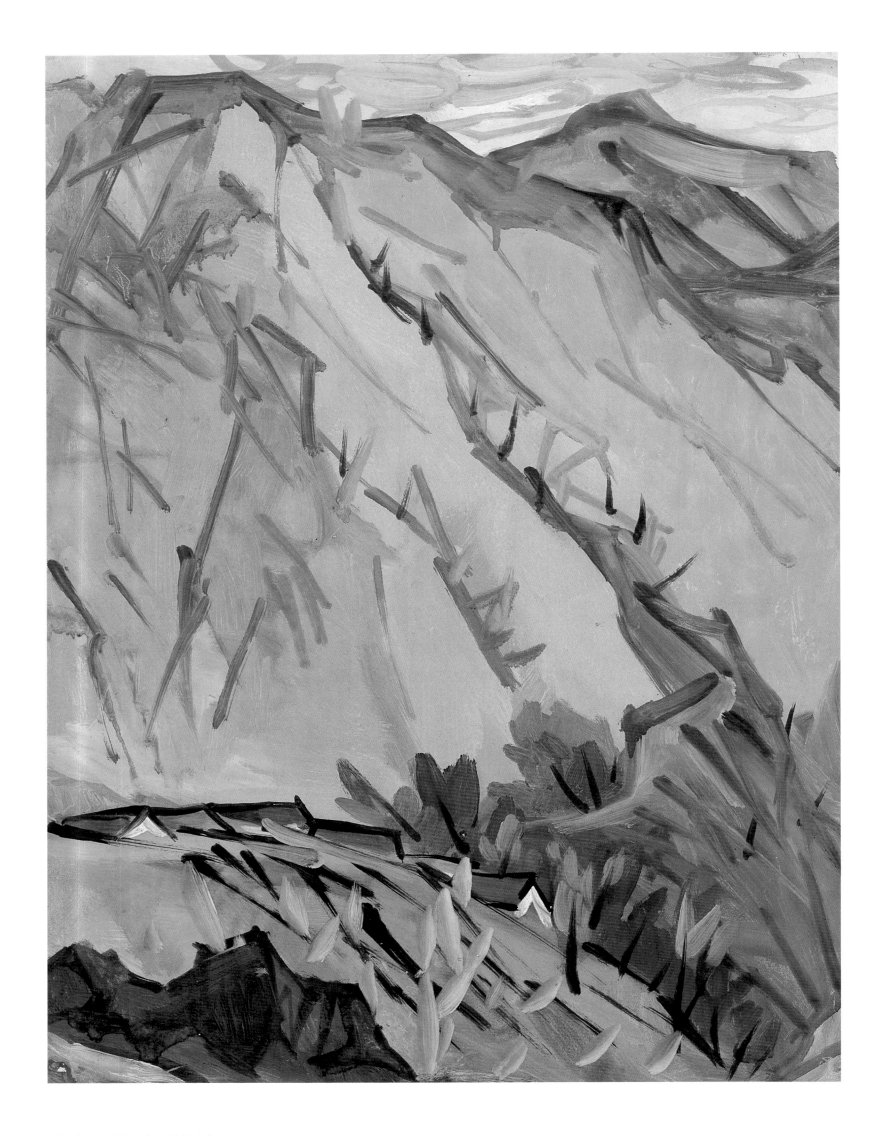

山間小屋　油彩・紙・裱於畫布　53×40cm　1960s
Cabin on the Hill　Oil on Paper, Mounted on Canvas

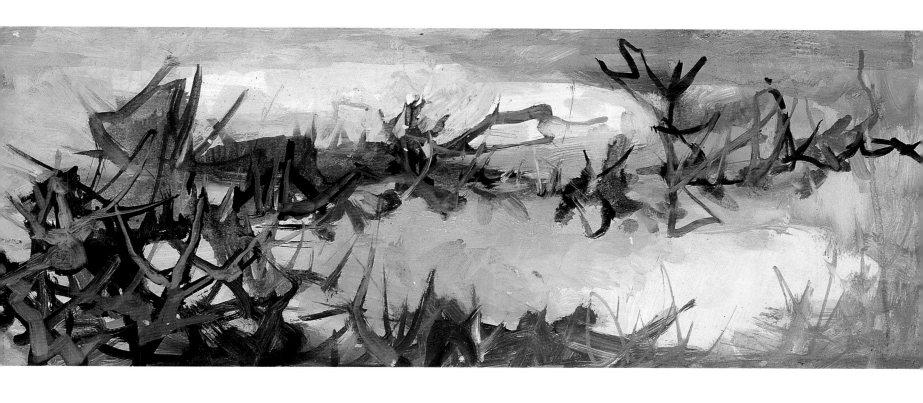

松　油彩・紙本　19.7×54.8cm　1960s
Pine Needles　Oil on Paper

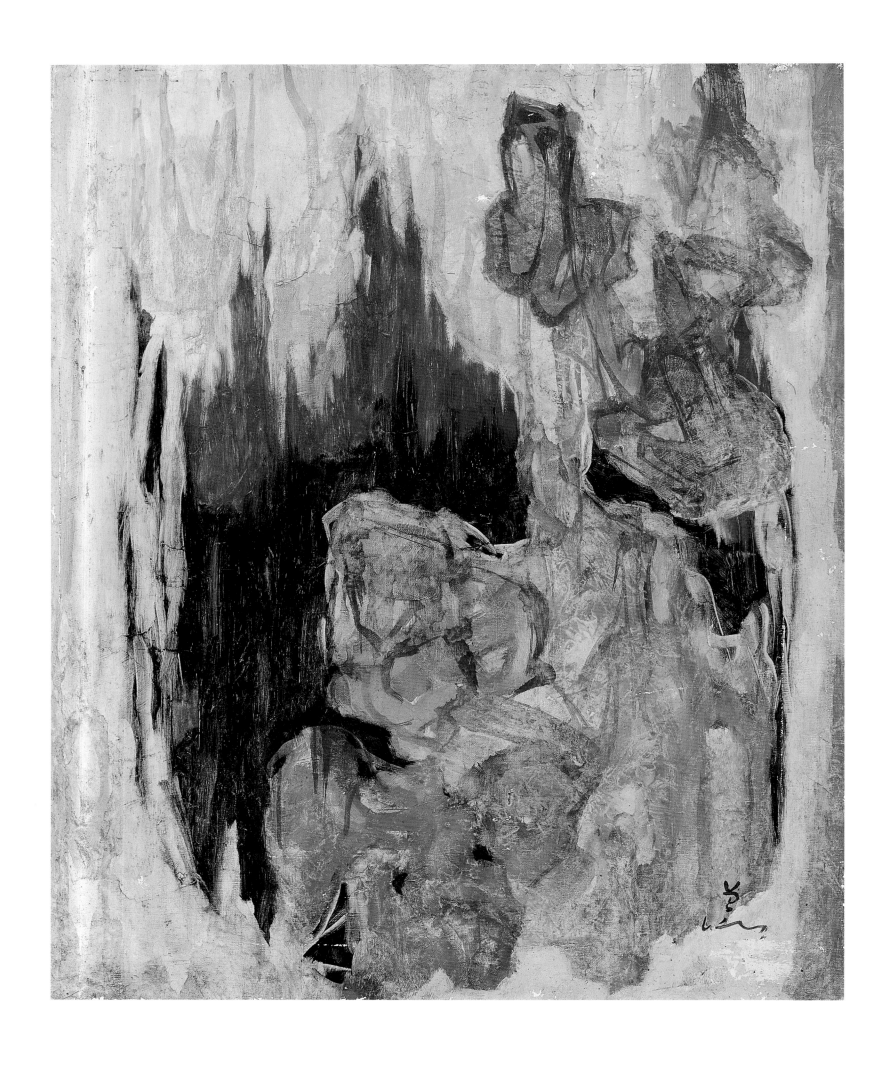

紅與黑　油彩・畫布　72.5×60.5cm　1960s
Red and Black Oil on Canvas

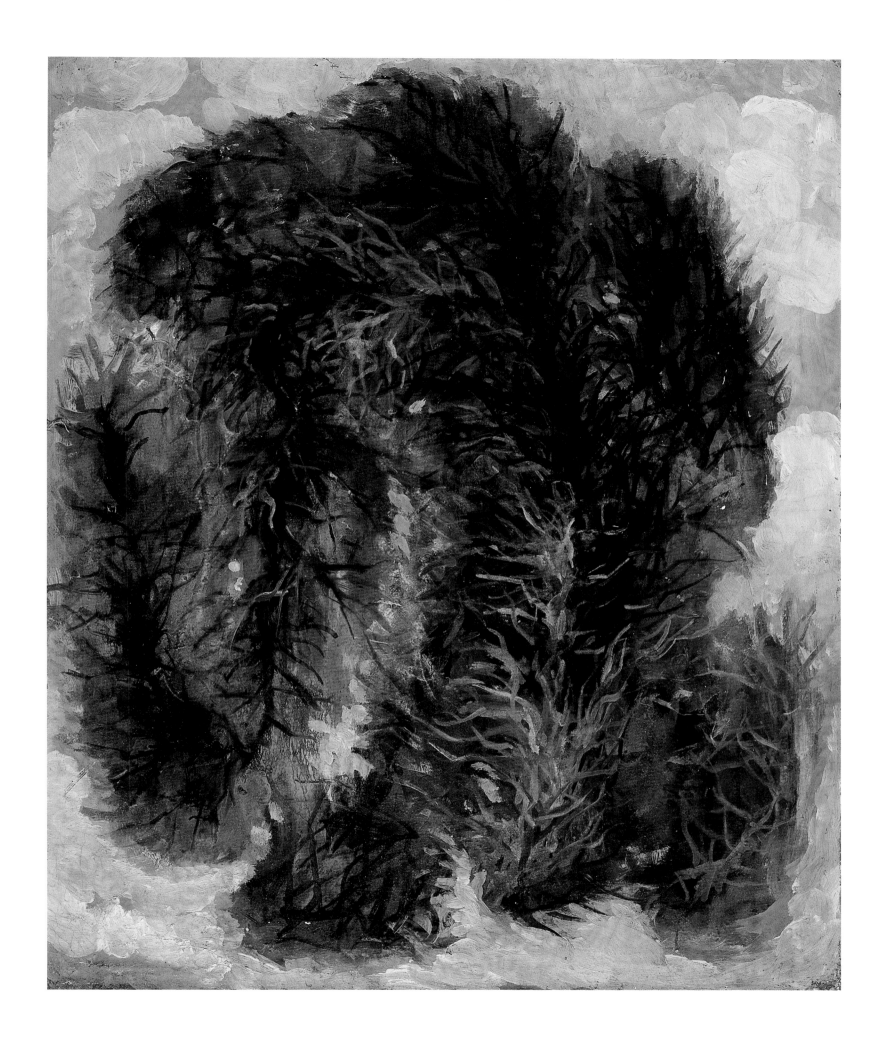

叢　油彩・畫布　72.7×60.4cm　1960s
Cluster Oil on Canvas

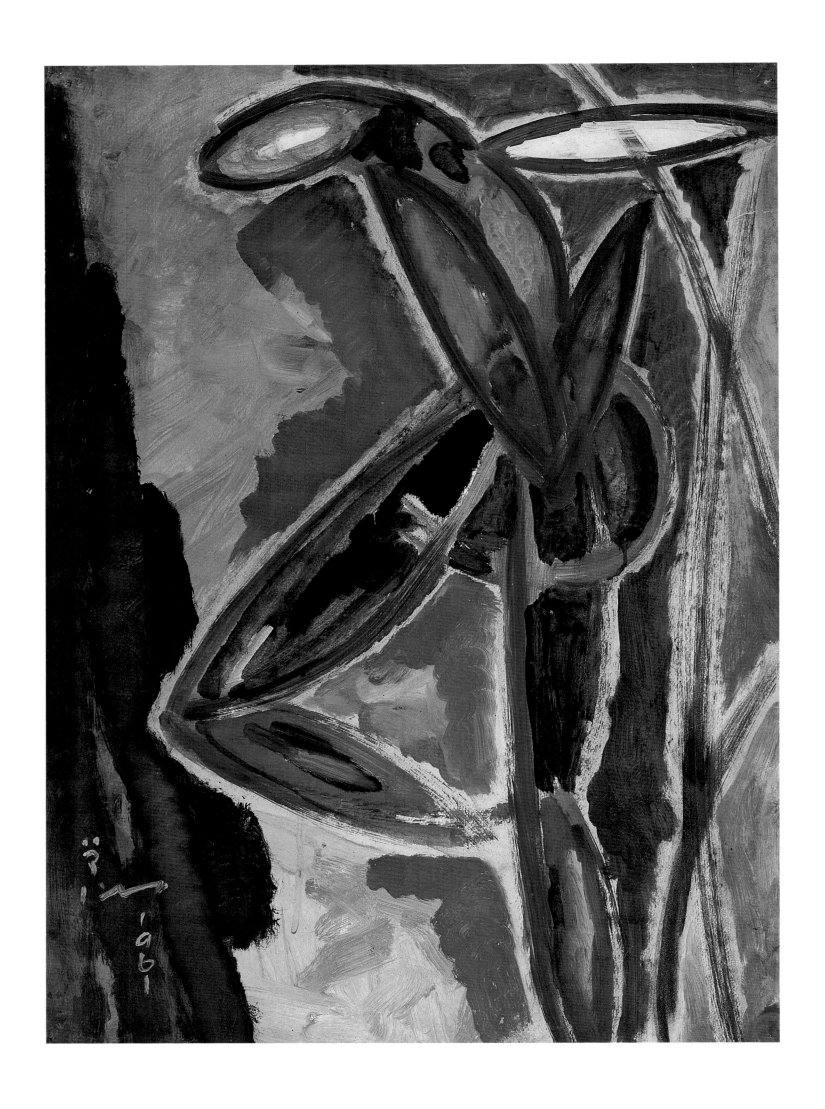

藍色人物　油彩・紙本　53.3×39.3cm　1961
Blue Figure Oil on Paper

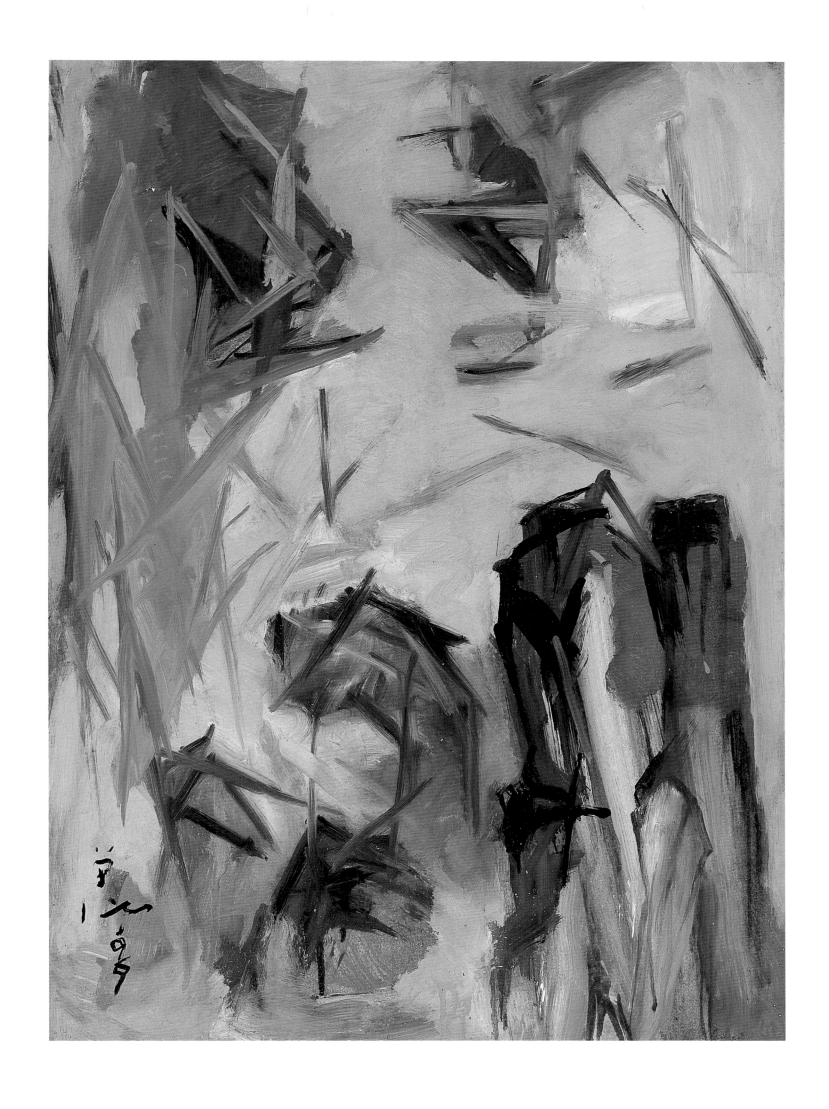

藍調　油彩・紙本　52×39.6cm　1961
Blues　Oil on Paper

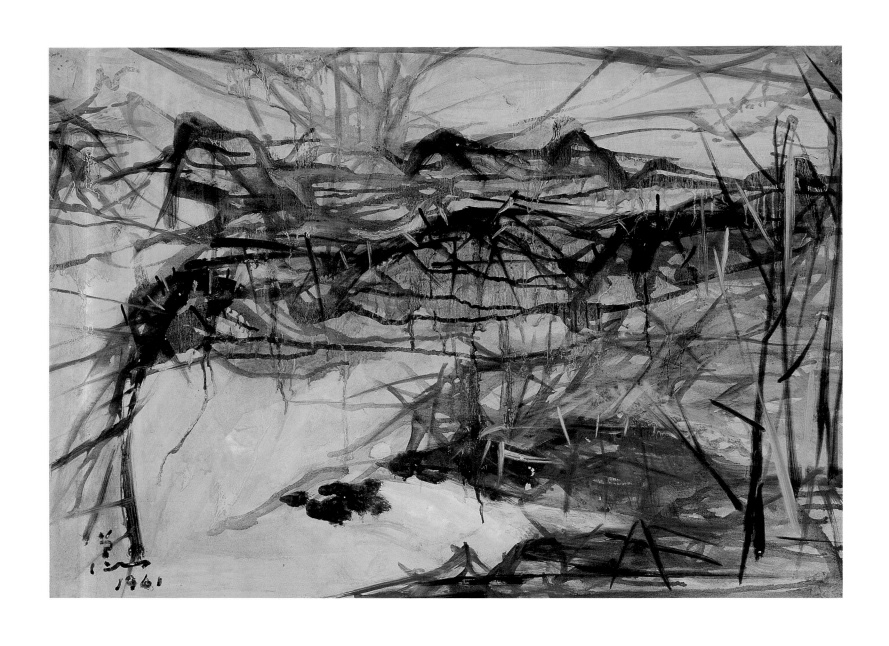

線的律動　油彩・紙本　38.8×54cm　1961
Rhythm of Lines Oil on Paper

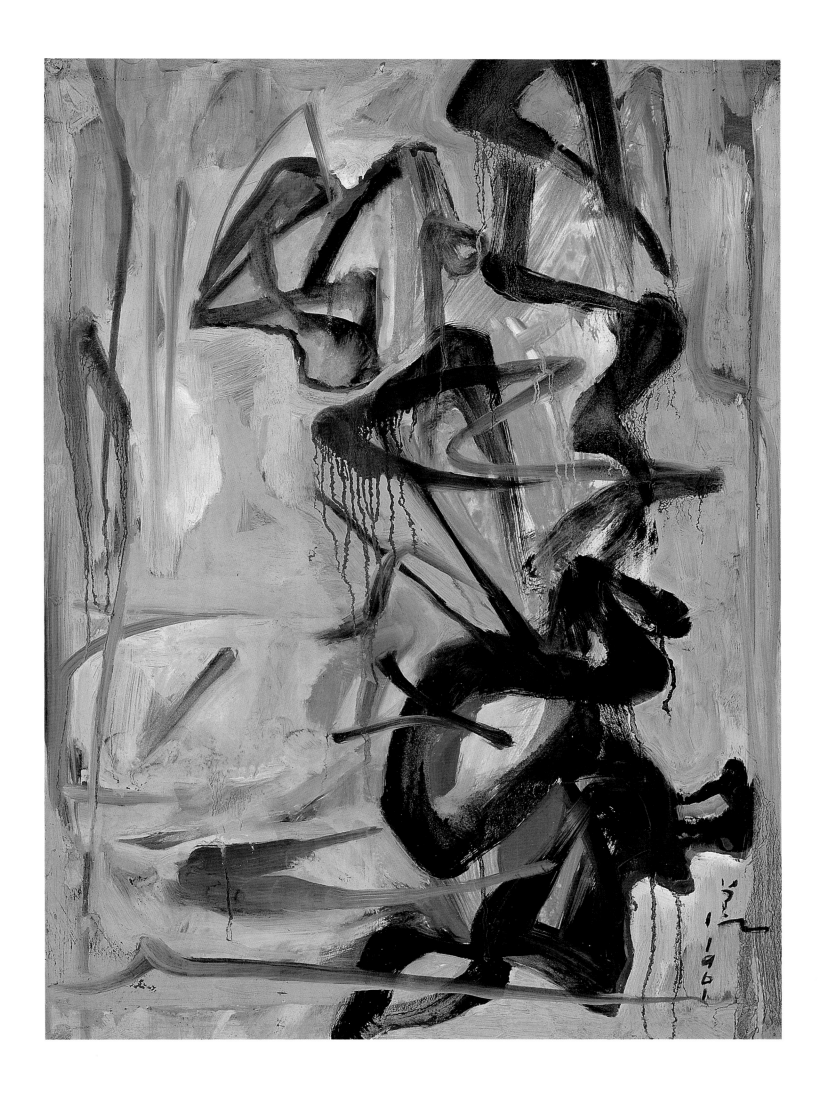

羞　油彩・紙本　53×39.6cm　1961
Shyness　Oil on Paper

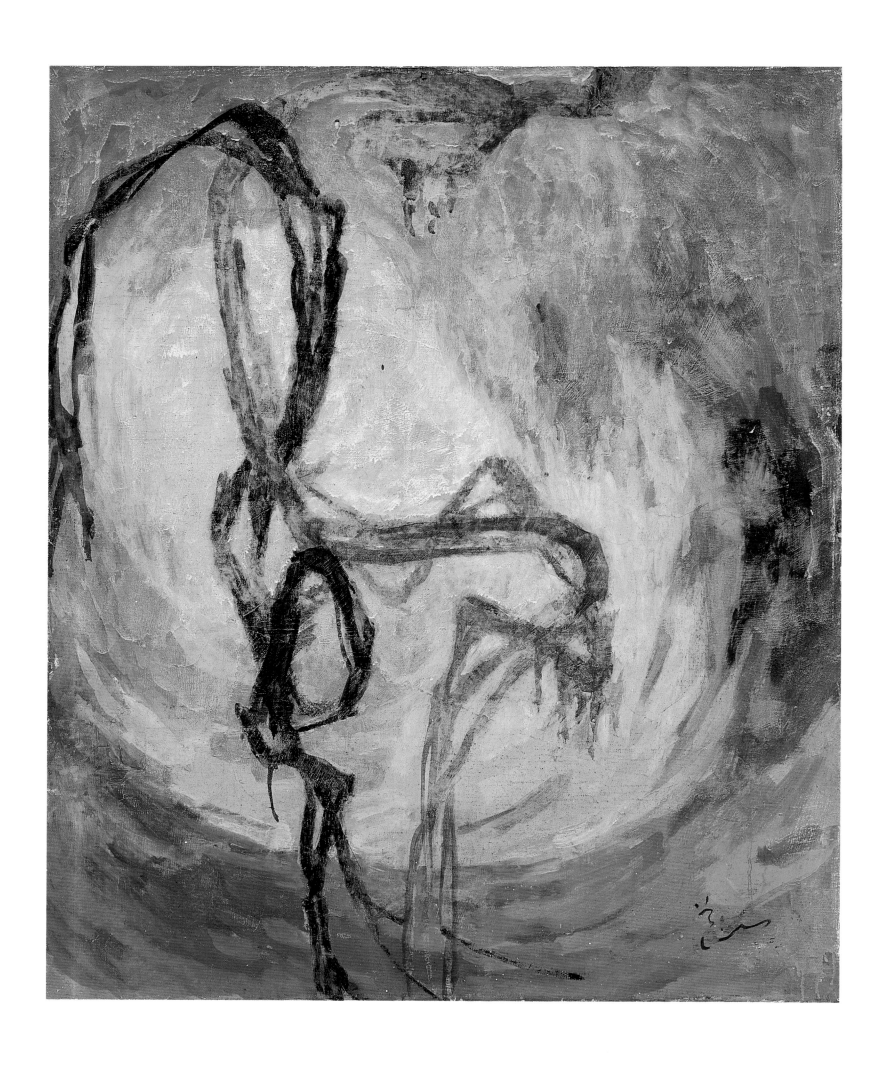

迴旋　油彩・畫布　72.5×60cm　1961
Rondo　Oil on Canvas

74

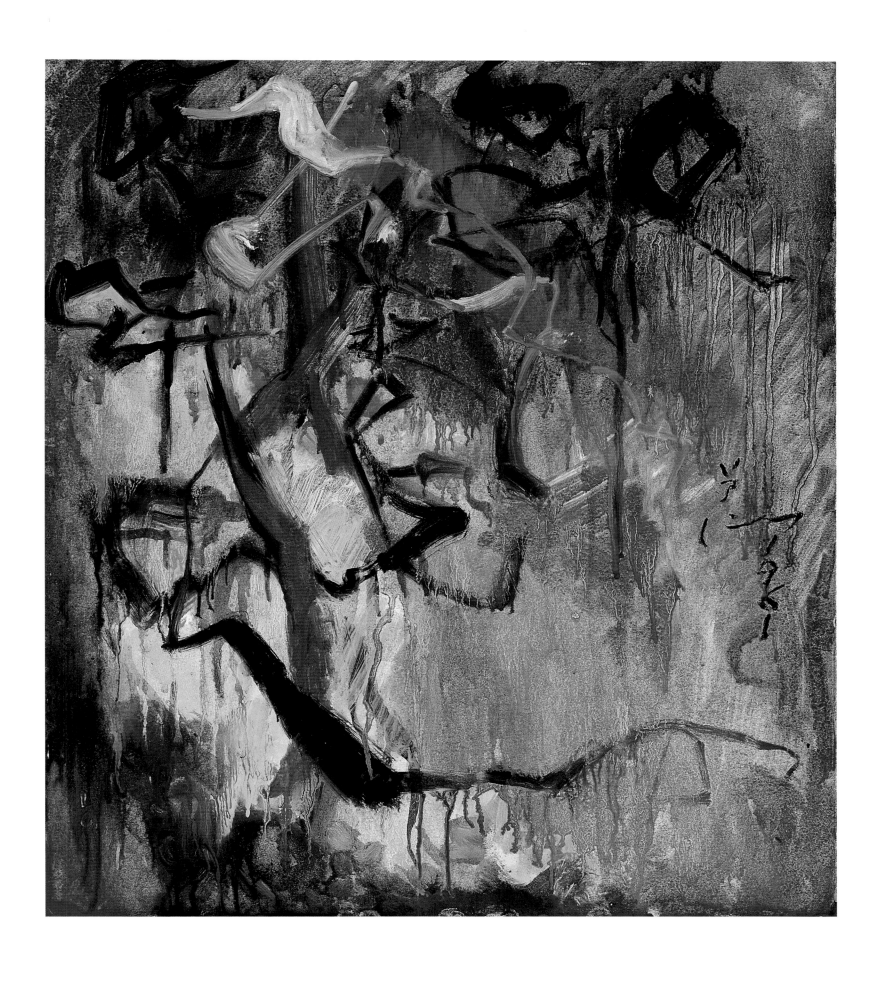

韻　油彩・紙本　39.7×36cm　1961
Rhythms Oil on Paper

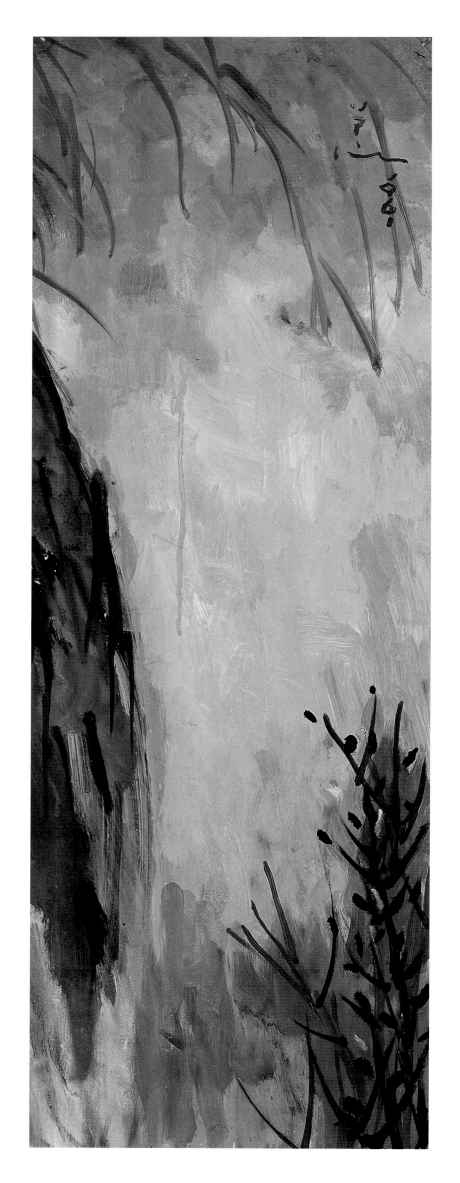

秋景
油彩・紙本
53.7×19.5cm　1961

Autumn Scene
Oil on Paper

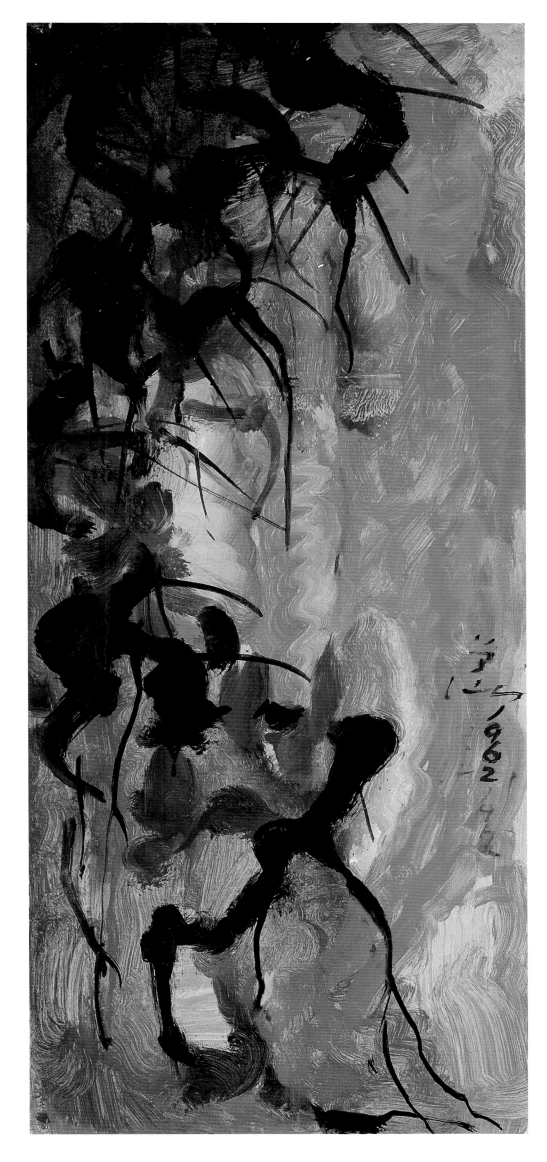

墨色枝椏
油・紙本
54×24cm　1962

Black Twigs
Oil on Paper

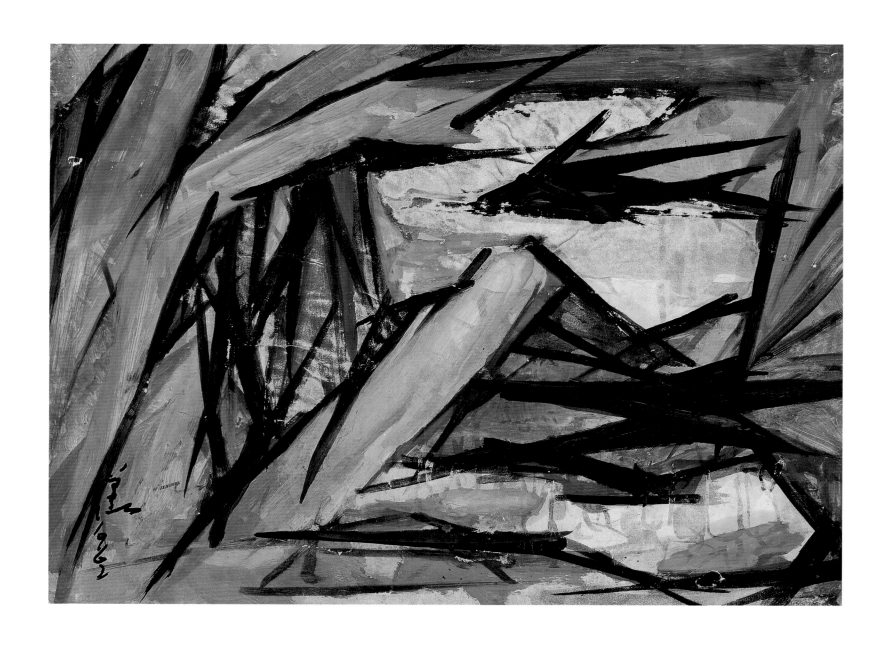

抽象風景　油彩・紙・裱於畫布　40×55cm　1962
Abstract Landscape Oil on Paper, Mounted on Canvas

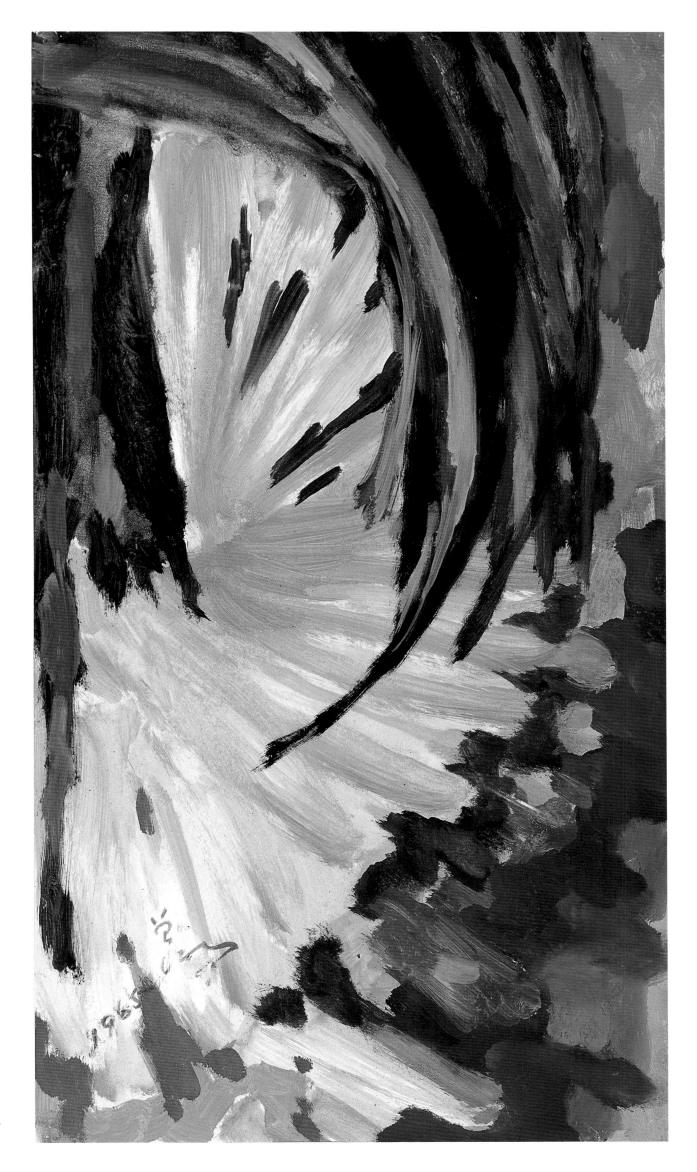

張
油彩・紙・裱於畫布
52.5×30cm 1965

Flit Open Oil on Paper,
Mounted on Canvas

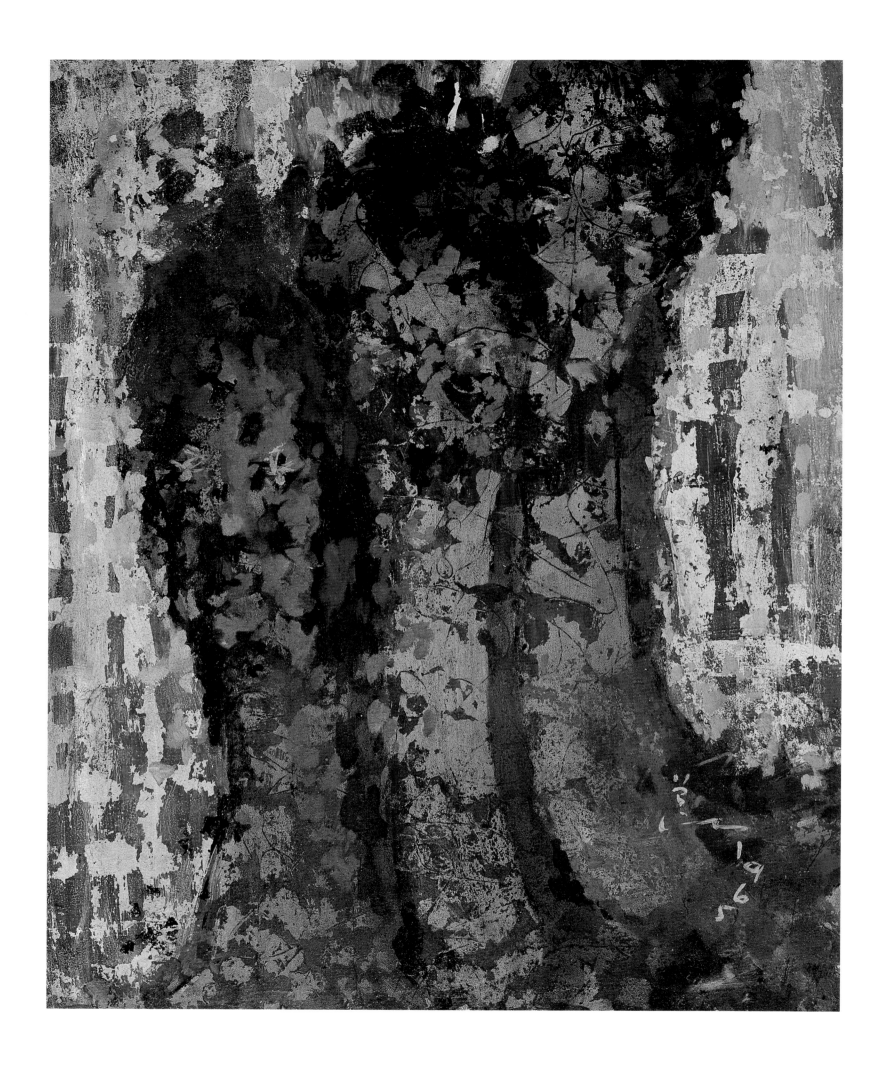

三美圖　油彩・紙本　59×49.5cm　1965
The Three Graces　Oil on Paper

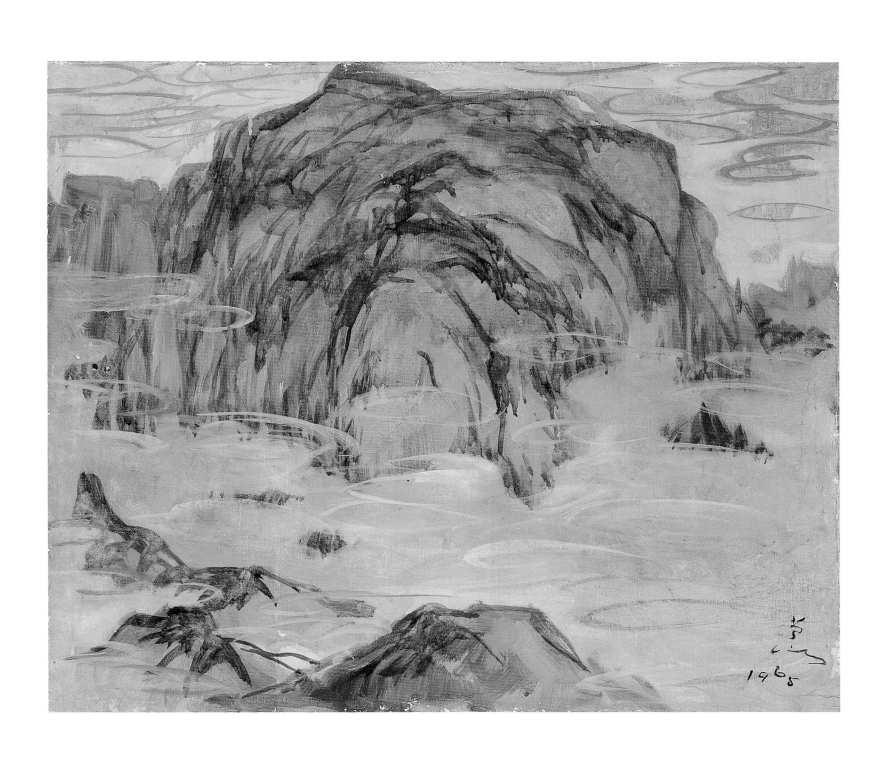

翠山浮雲　油彩・畫布　60.5×72.2cm　1965
Cloudscape Oil on Canvas

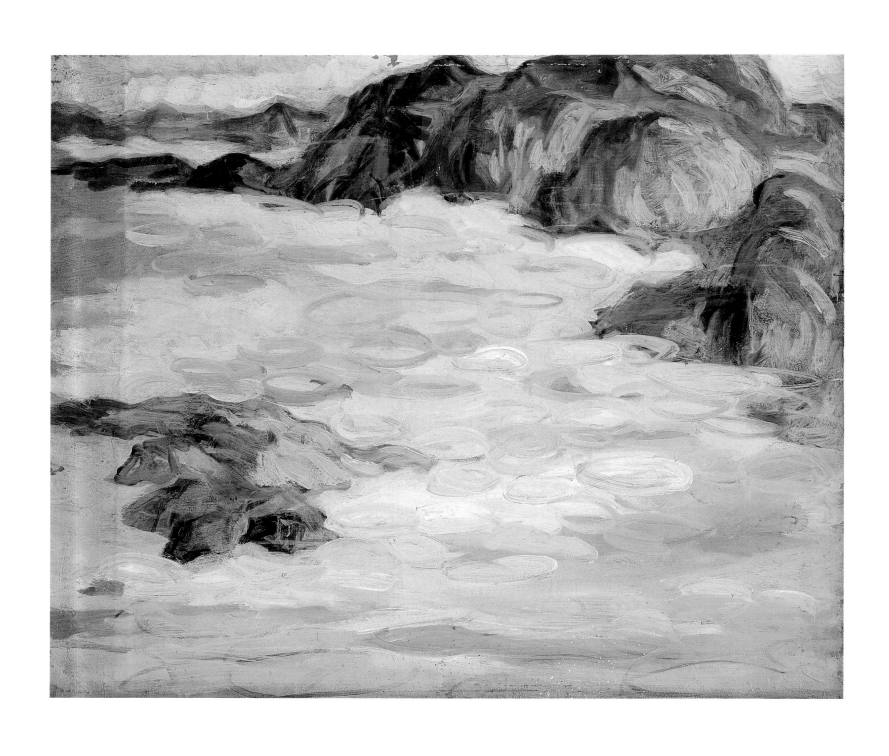

雲海（一）　油彩・畫布　60.2×72.2cm　1965
Sea of Clouds I　Oil on Canvas

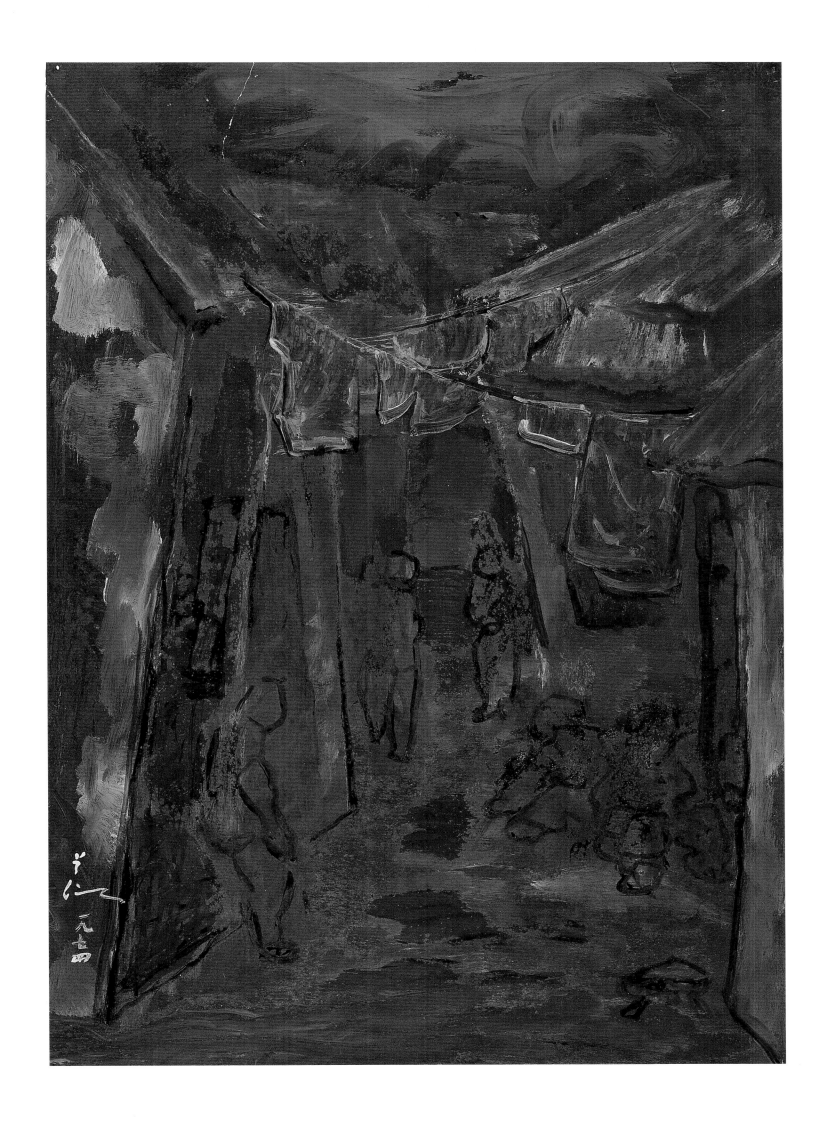

農村　油彩・紙・裱於畫布　42×31cm　1974
Village Oil on Paper, Mounted on Canvas

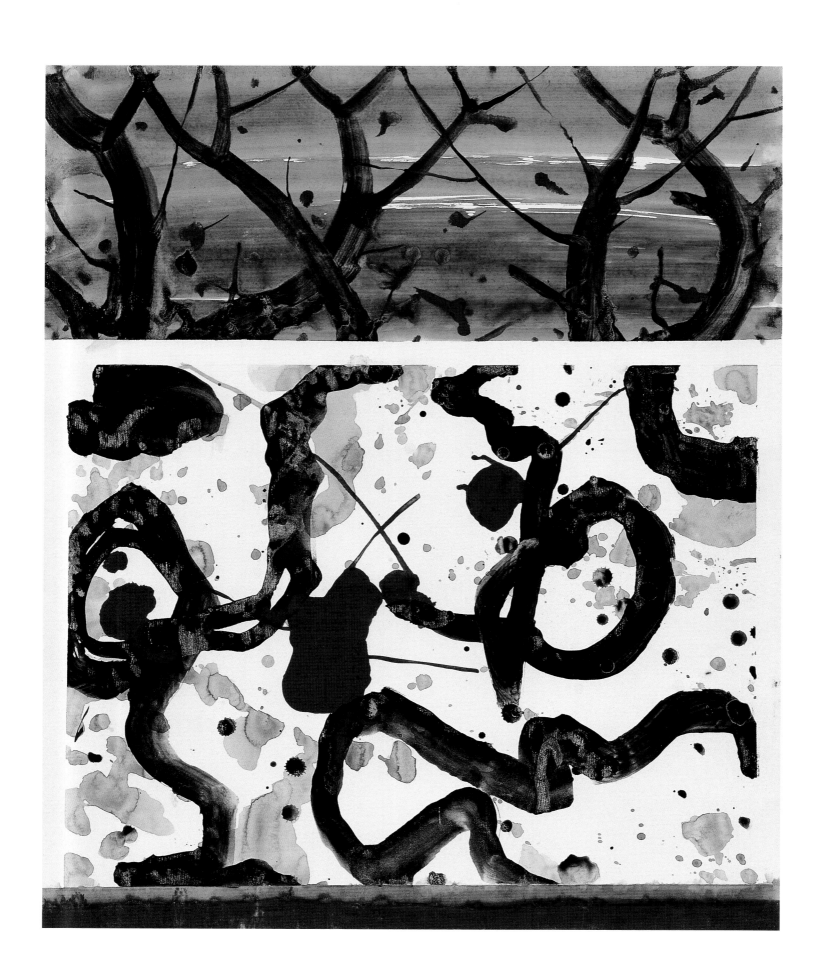

綠樹林　油彩・紙本　70.9×59cm
Woods　Oil on Paper

II

龐曾瀛 紙上作品圖版
Watercolor and Ink Paintings

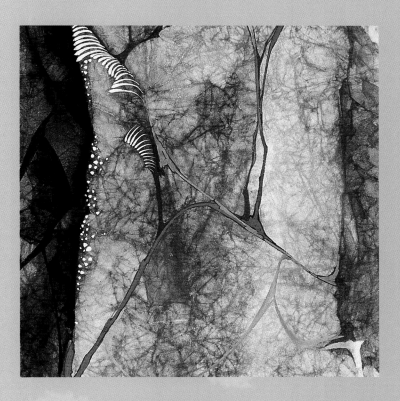

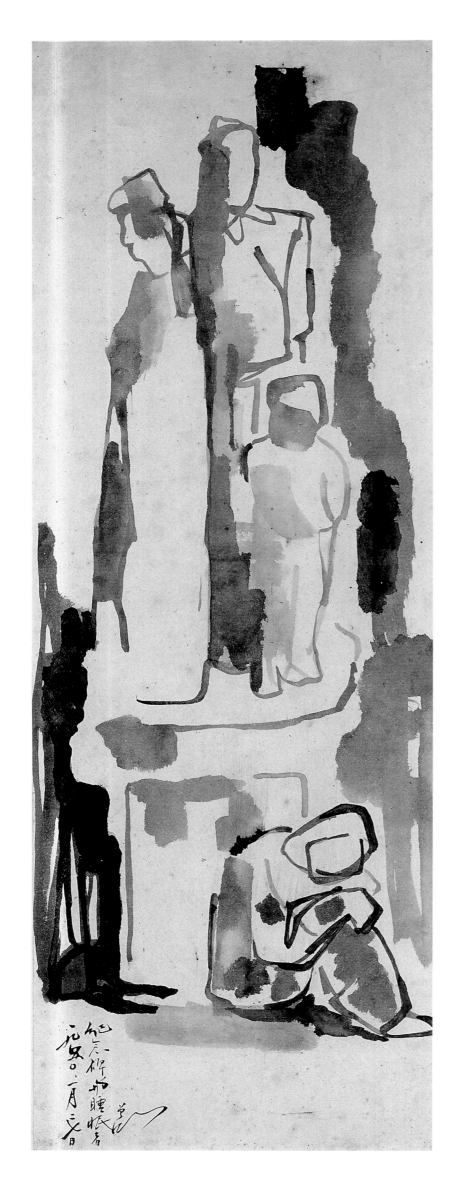

紀念碑與睡眠者
水墨・紙
53.9×30cm　1950

Sleeper and the Memorial Sculpture
Ink on Paper

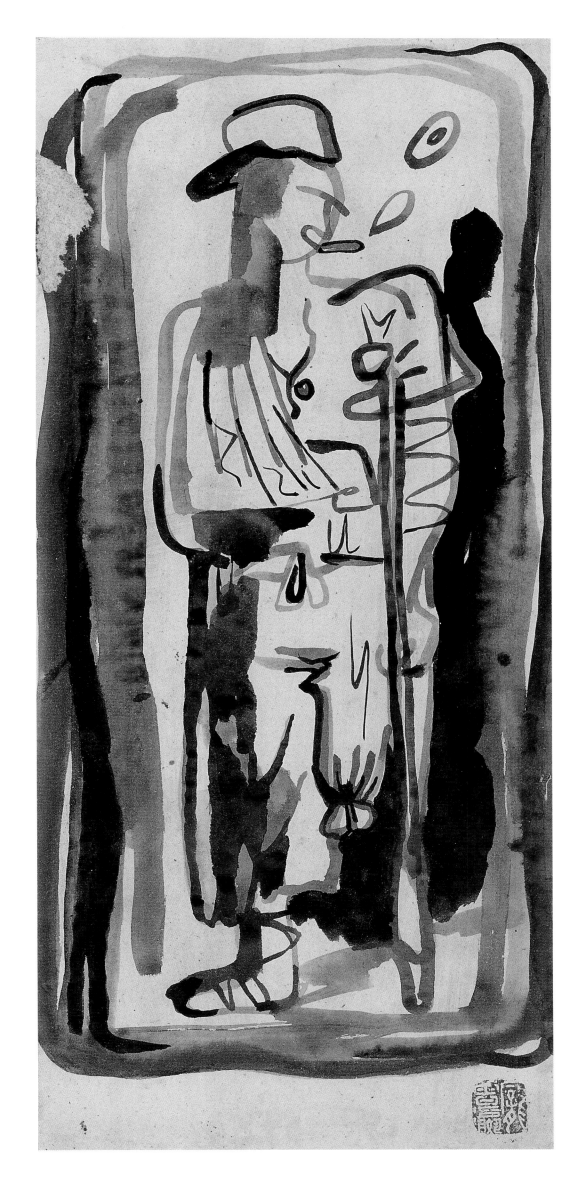

殘者
水墨・紙
39×18cm　1950s

The Handicapped
Ink on Paper

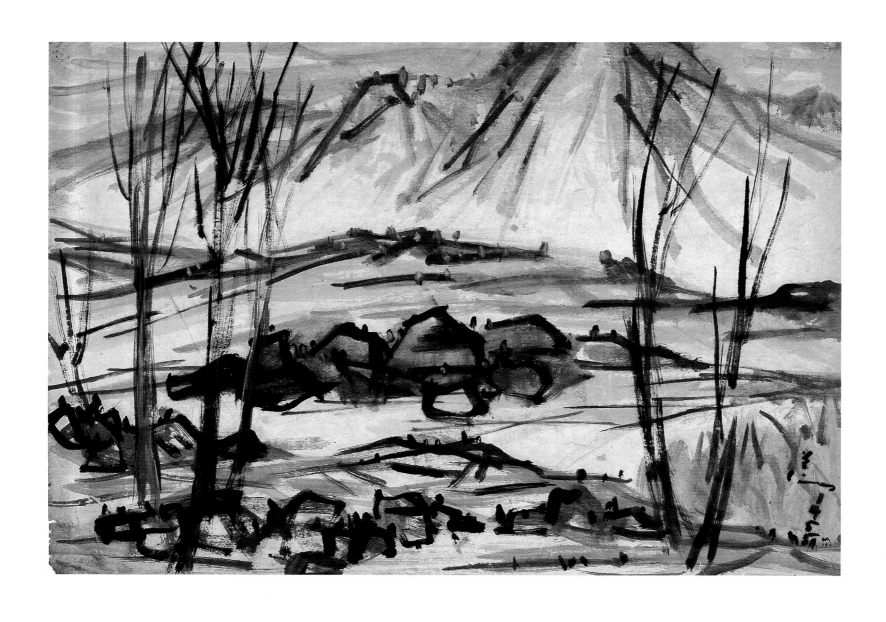

山景　水彩・紙本　40×57.6cm　1955
Mountain Landscape　Watercolor on Paper

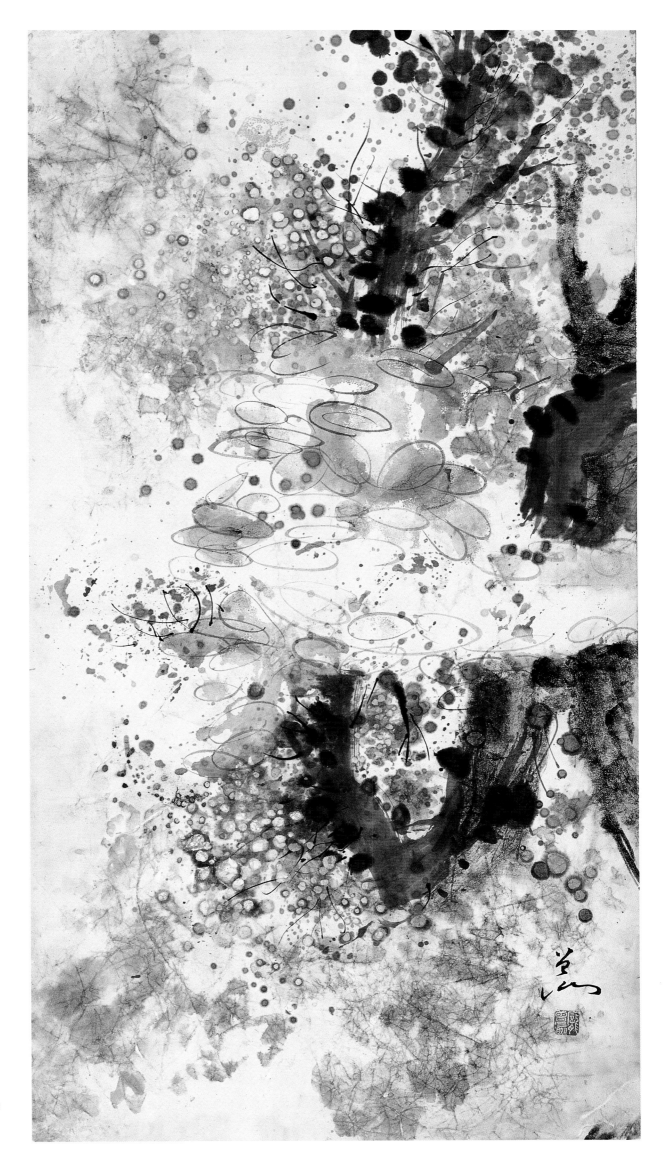

樹影搖曳生風
水彩‧紙本
86.6×46.6cm
1960～1970s

Wind in the Trees
Watercolor on
Paper

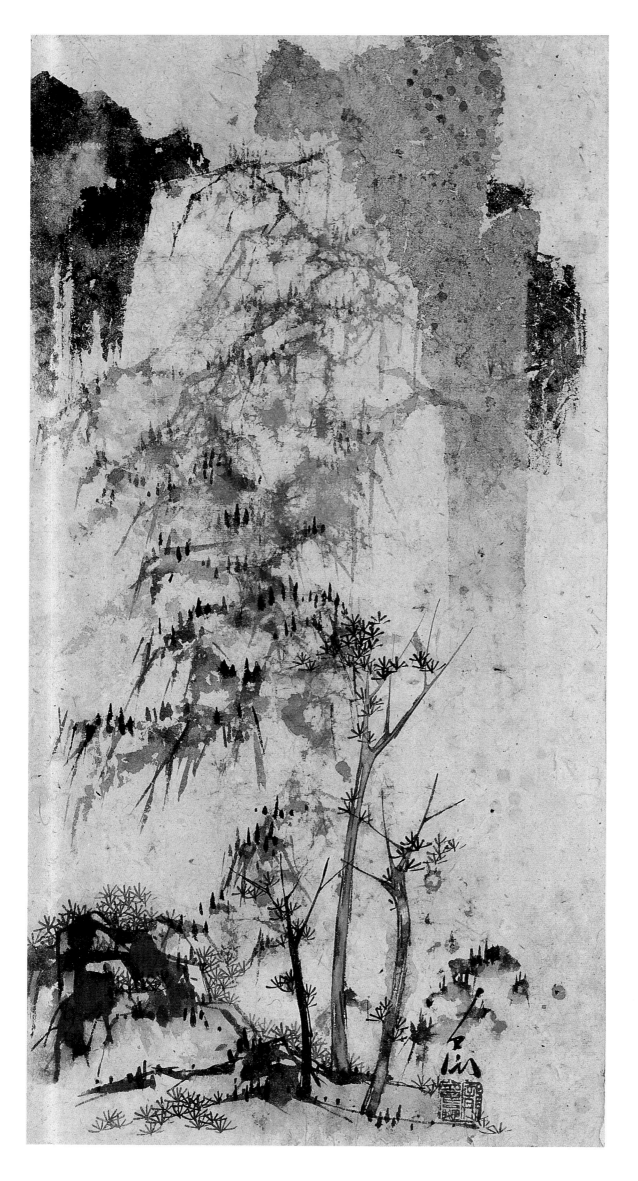

松山圖
水彩・紙本
60.4×31cm　1960s

Pines on Mountain Side
Watercolor on Paper

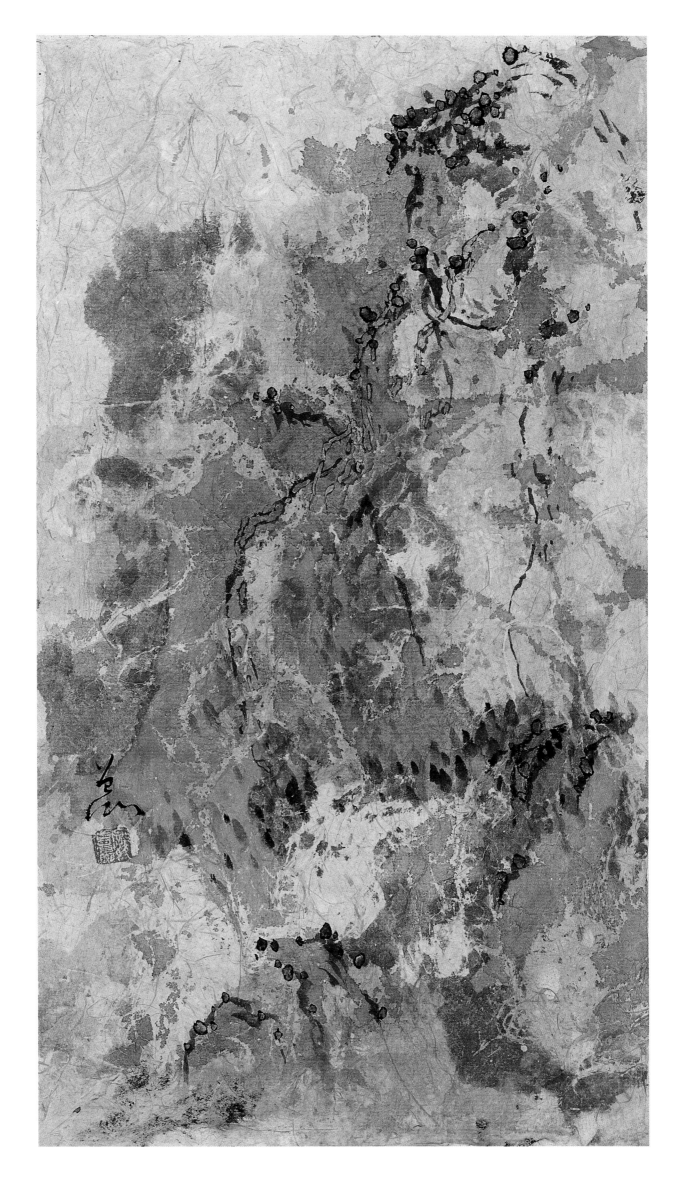

山水
水彩・紙本
63.5×35cm　1960s

A Landscape
Watercolor on Paper

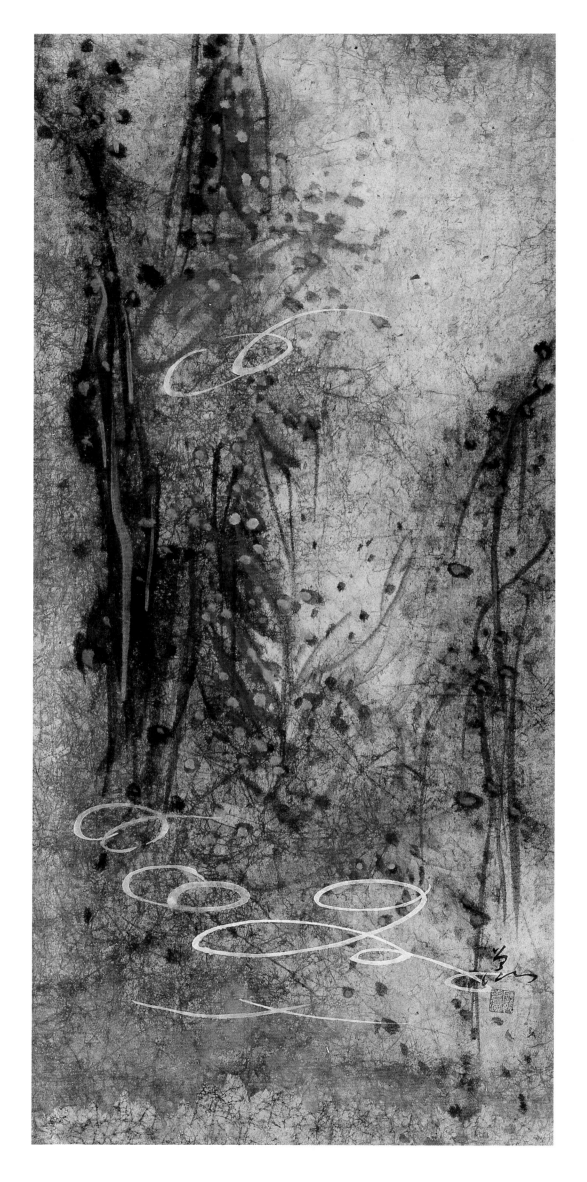

飄
水彩・紙本
91.3×43cm　1960s

Breeze
Watercolor on Paper

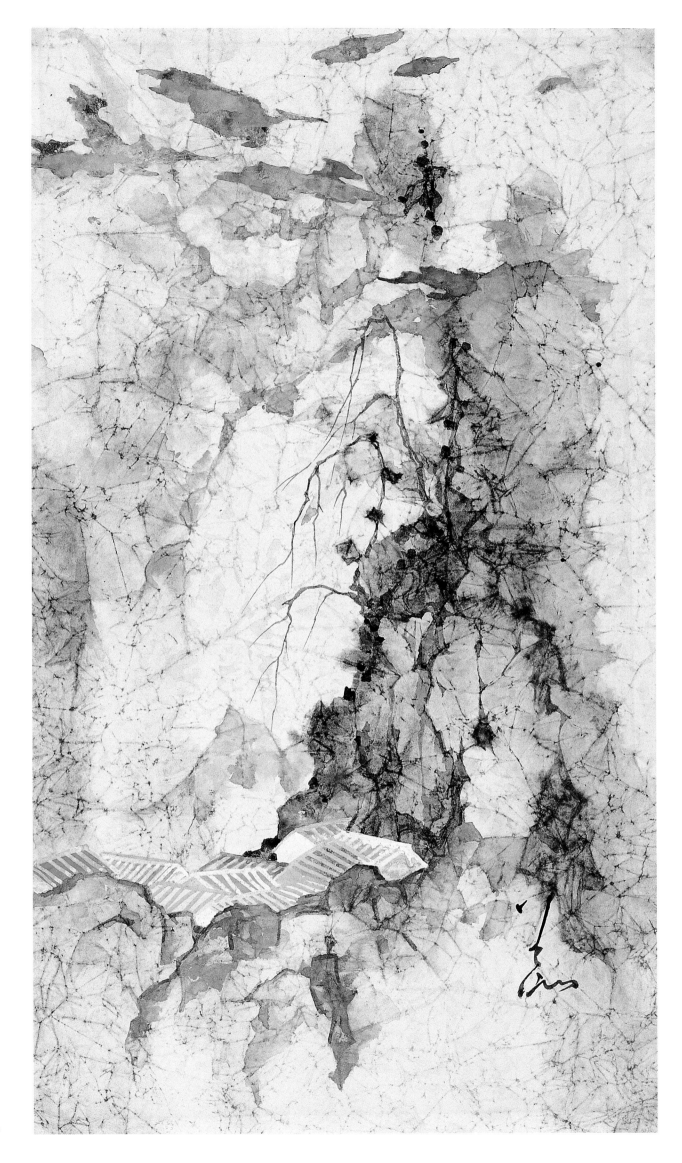

閒居
水彩・紙本
61.6×34.5cm　1960s

Idle Days
Watercolor on Paper

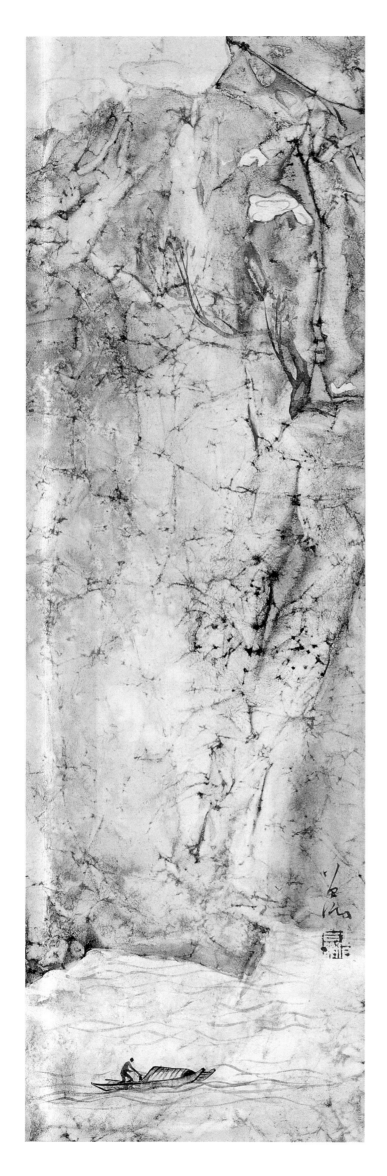

渡
水彩・紙本
55×17cm　1960s

Landscape with a Boat
Watercolor on Paper

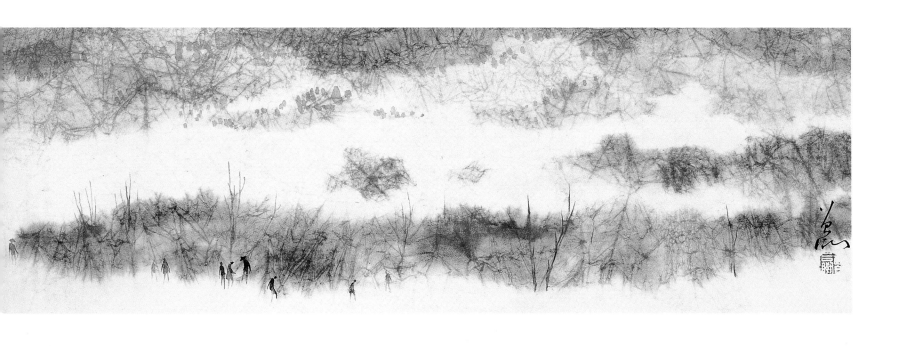

薄霧嶺上　水彩・紙本　20.5×60.8cm　1960s
Misty Ridge Watercolor on Paper

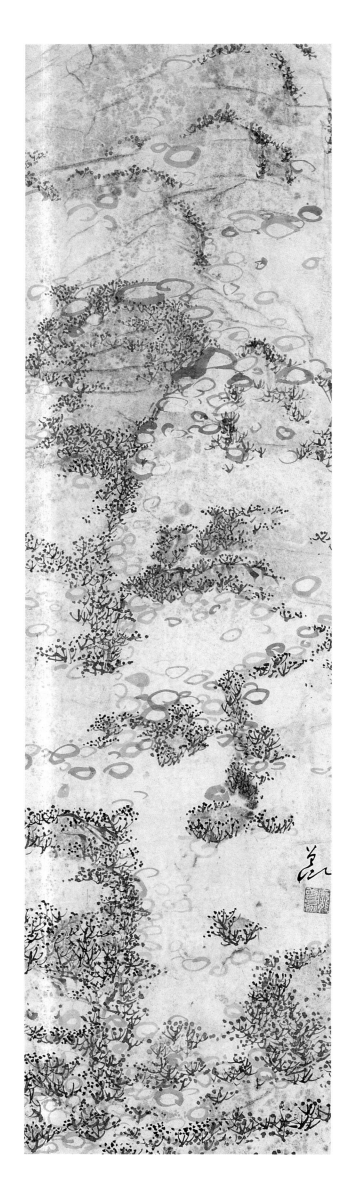

白雲松嶺圖
水彩・紙本
88.3×26cm

Hill with White Clouds
Watercolor on Paper

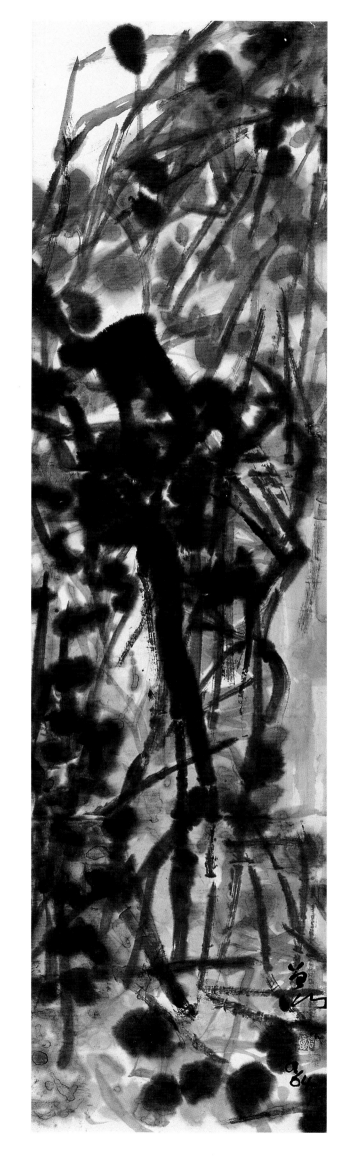

潤
水彩・紙本
136×35.6cm　1964

Moist
Watercolor on Paper

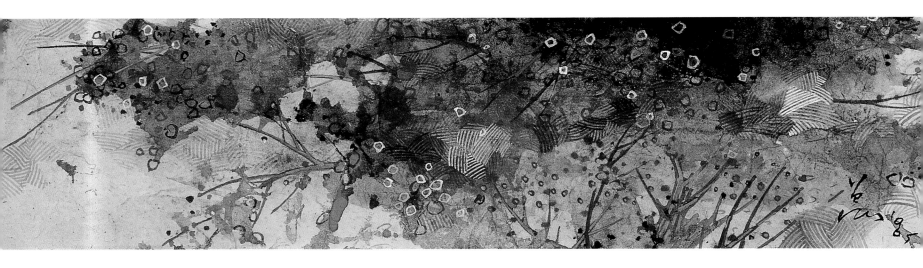

青枝紅葉圖　水彩・紙本　14.8×60cm　1965
Red Leaves on Blue Boughs　Watercolor on Paper

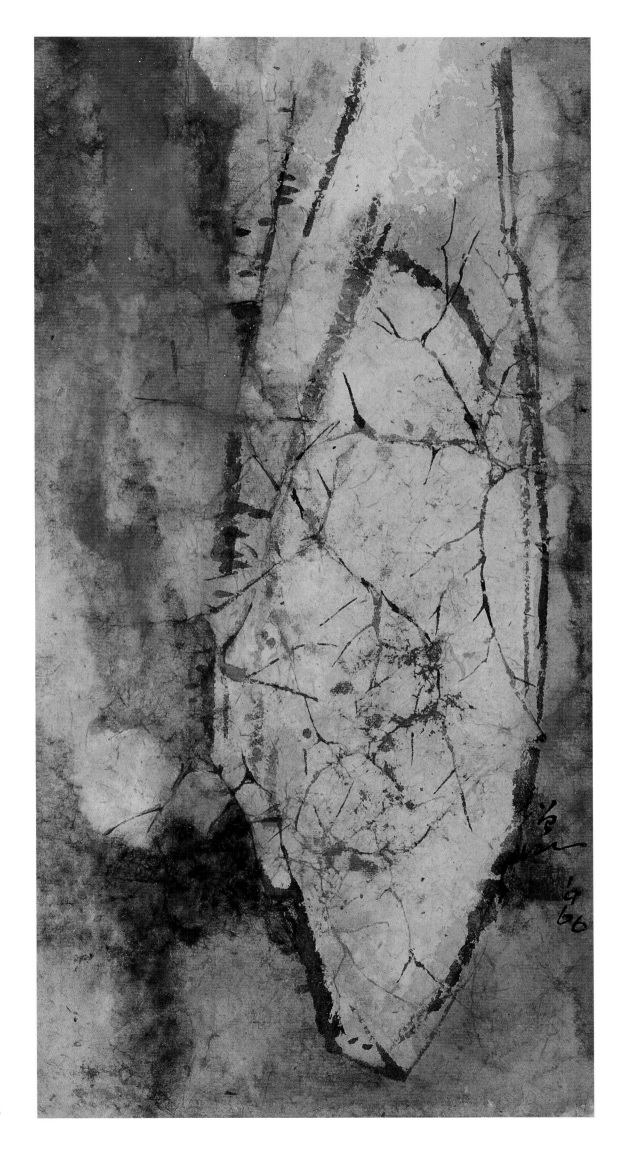

枝色
水彩・紙本
60×30.5cm 1966

Beauty of Twigs
Watercolor on Paper

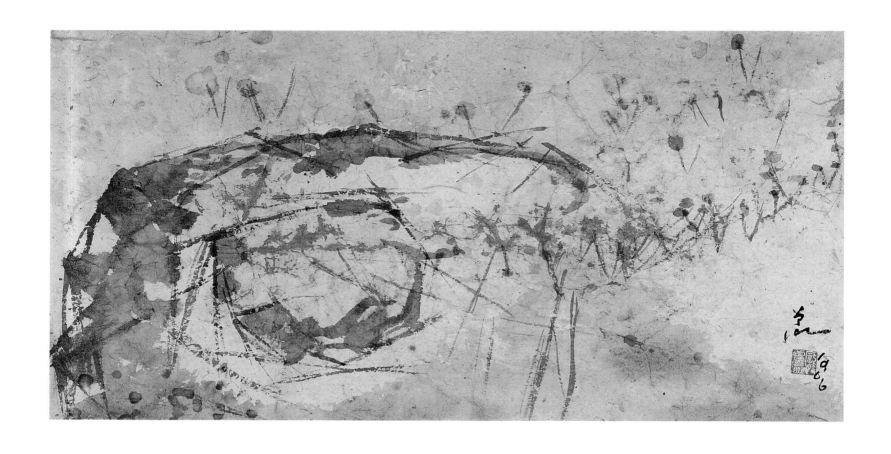

秋景圖　水彩・紙本　30.5×60.4cm　1966
Autumn Landscape Watercolor on Paper

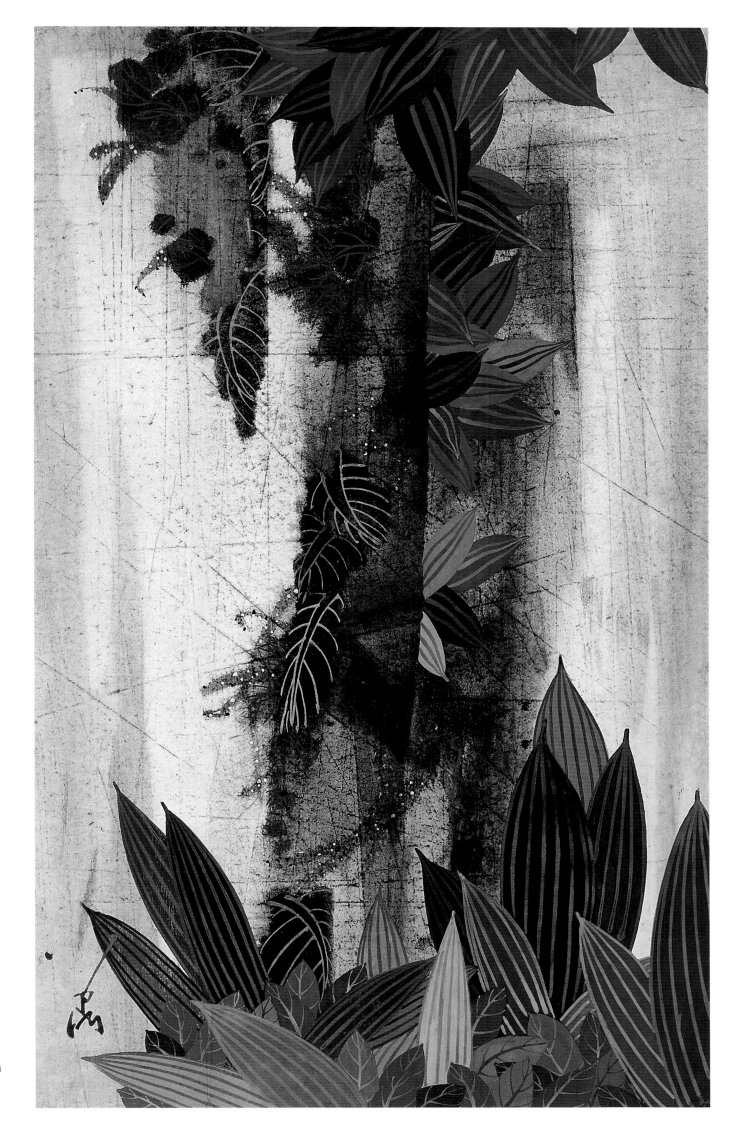

紅調的節奏
水彩・紙本
63.4×39.2cm
1966

Autumn Sonata
Watercolor on
Paper

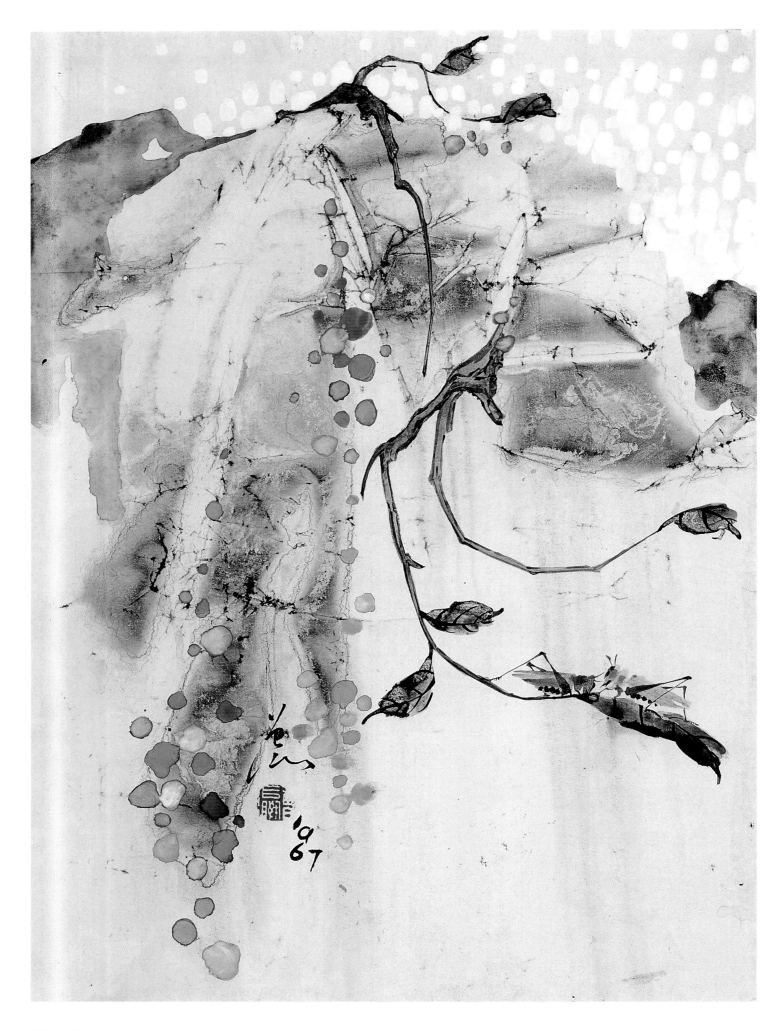

對語　水彩‧紙本　41.7×31cm　1967
Above: Conversation　Watercolor on Paper

逸　水彩‧紙本　60.5×41cm　1970s〈右頁圖〉
Right: A Thing of Beauty　Watercolor on Paper

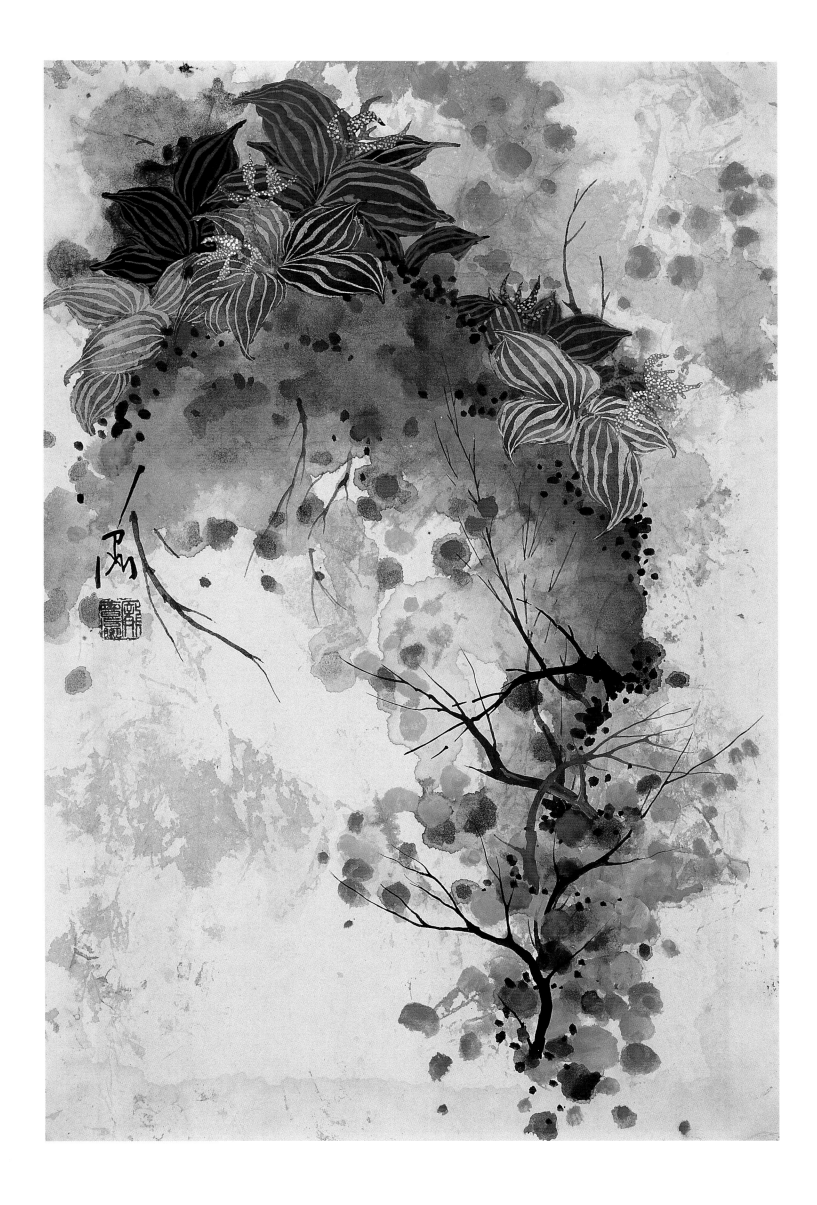

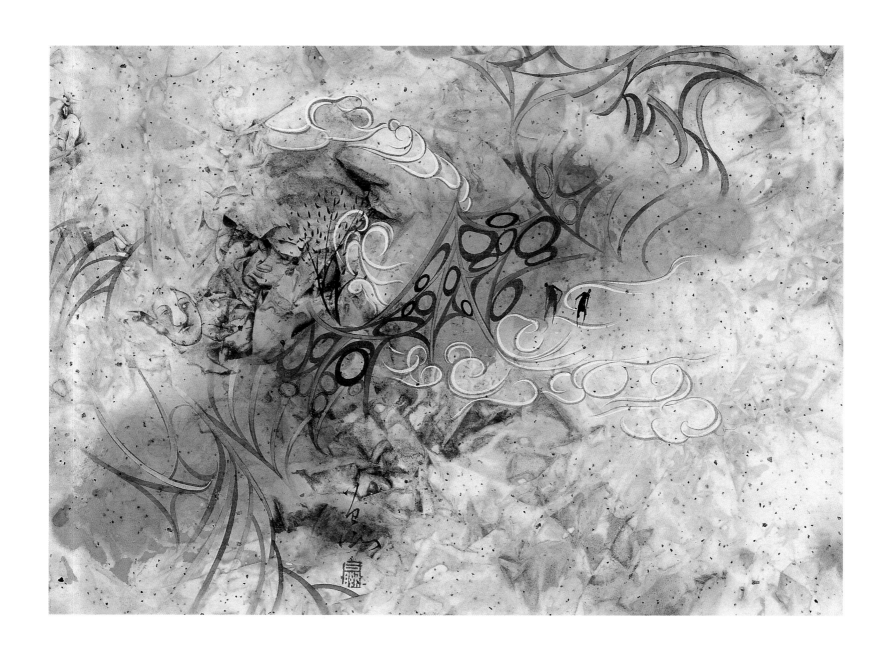

雲之憶　水彩・紙本　30.5×41cm　1971
Memory of Clouds　Watercolor on Paper

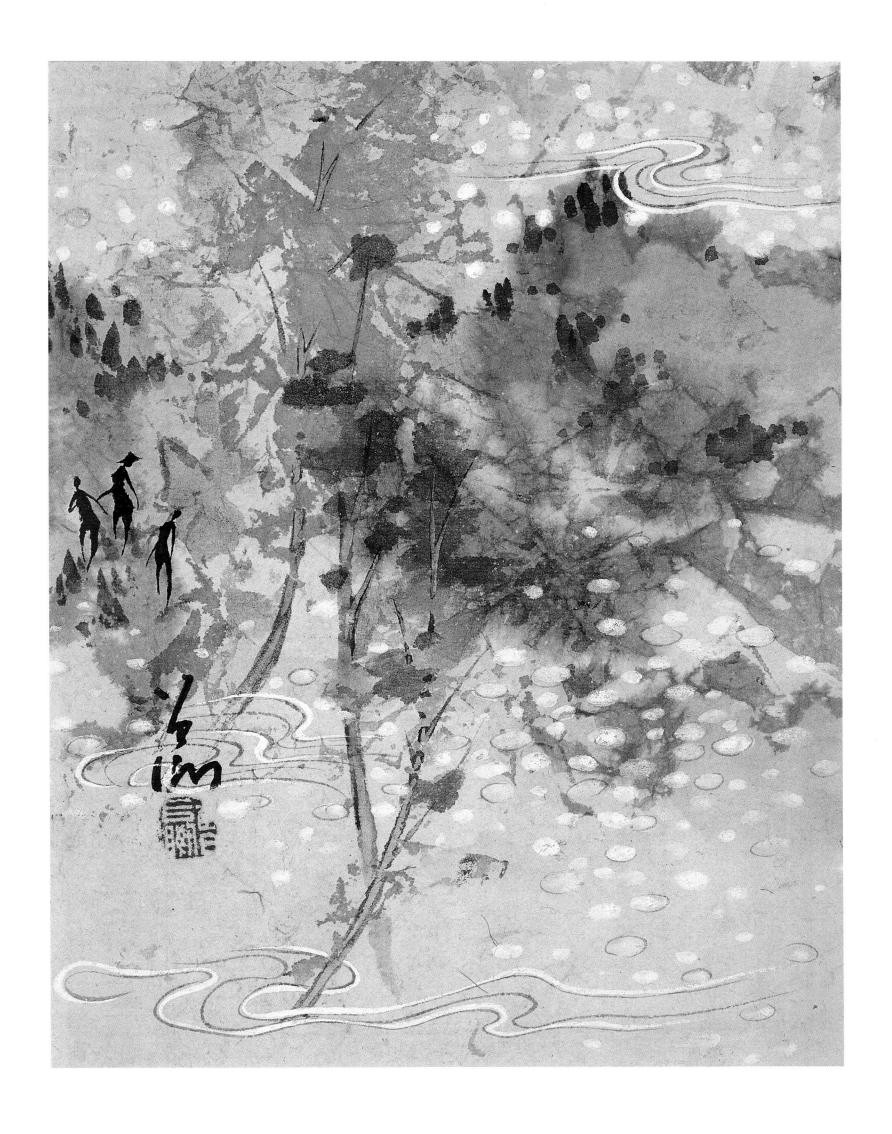

開遊　水彩・紙本　25.7×20cm　1978
Stroll　Watercolor on Paper

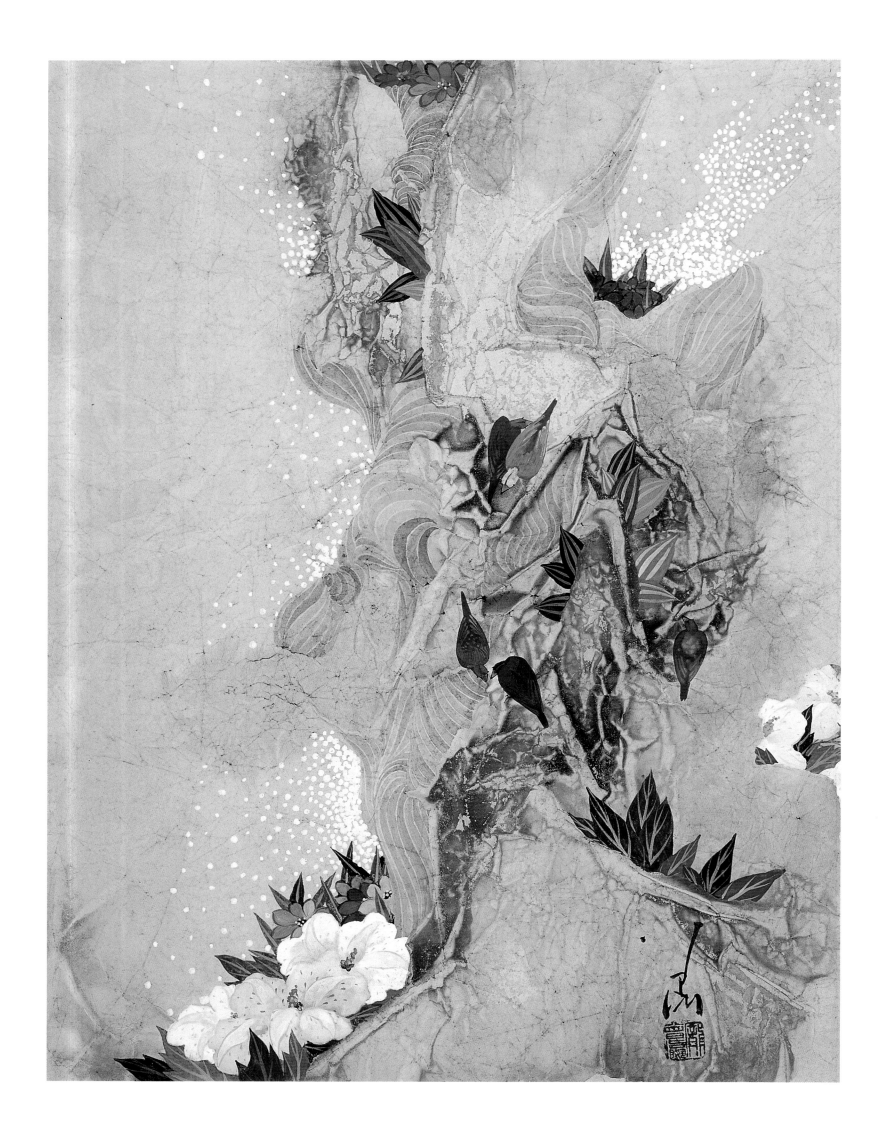

黃色主調　水彩・紙本　60.5×46.4cm　1979
Yellow Tone　Watercolor on Paper

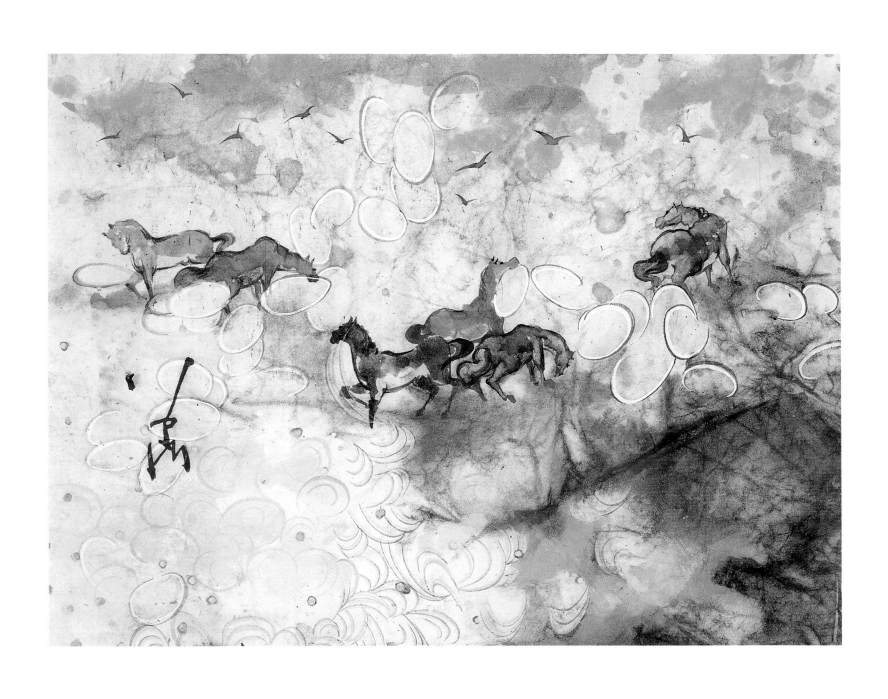

馬　水彩・紙本　24×31cm
Horses Watercolor on Paper

花期　水彩・紙本　32×24cm
Flower Season Watercolor on Paper

108

紅葉　水彩・紙本　23.3×26cm
Red Leaves　Watercolor on Paper

風　水彩・紙本　20×25cm
The Wind Watercolor on Paper

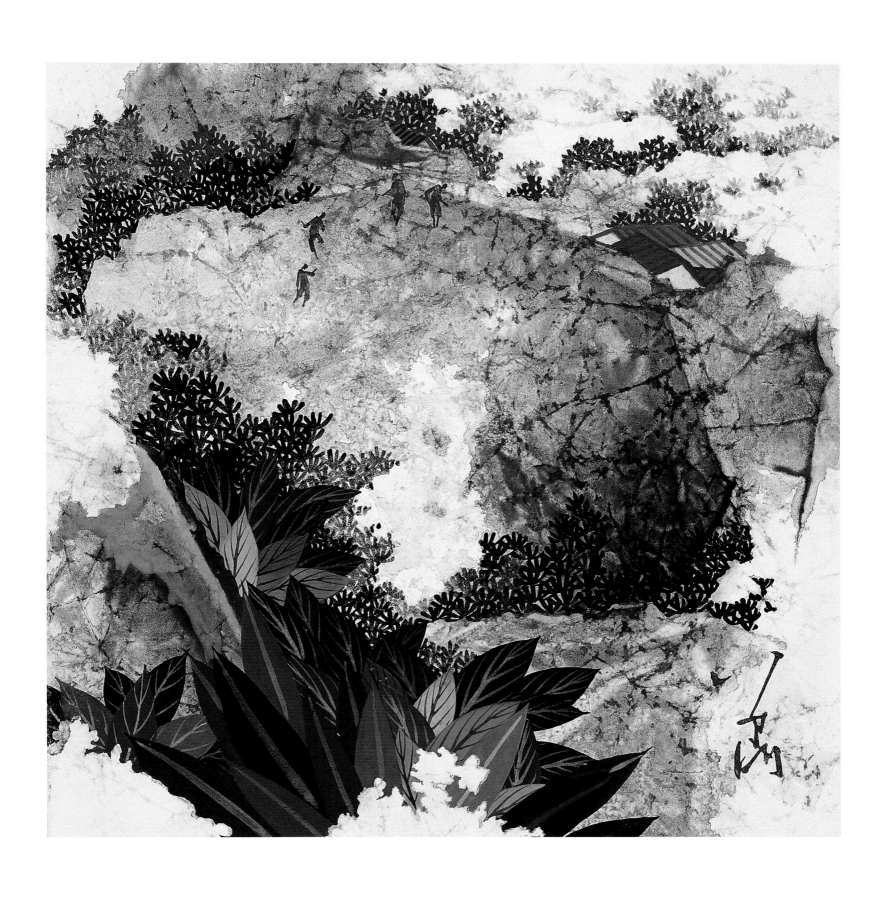

山間結鄰　水彩・紙本　29.7×29.7cm
Hillside Neighbors Watercolor on Paper

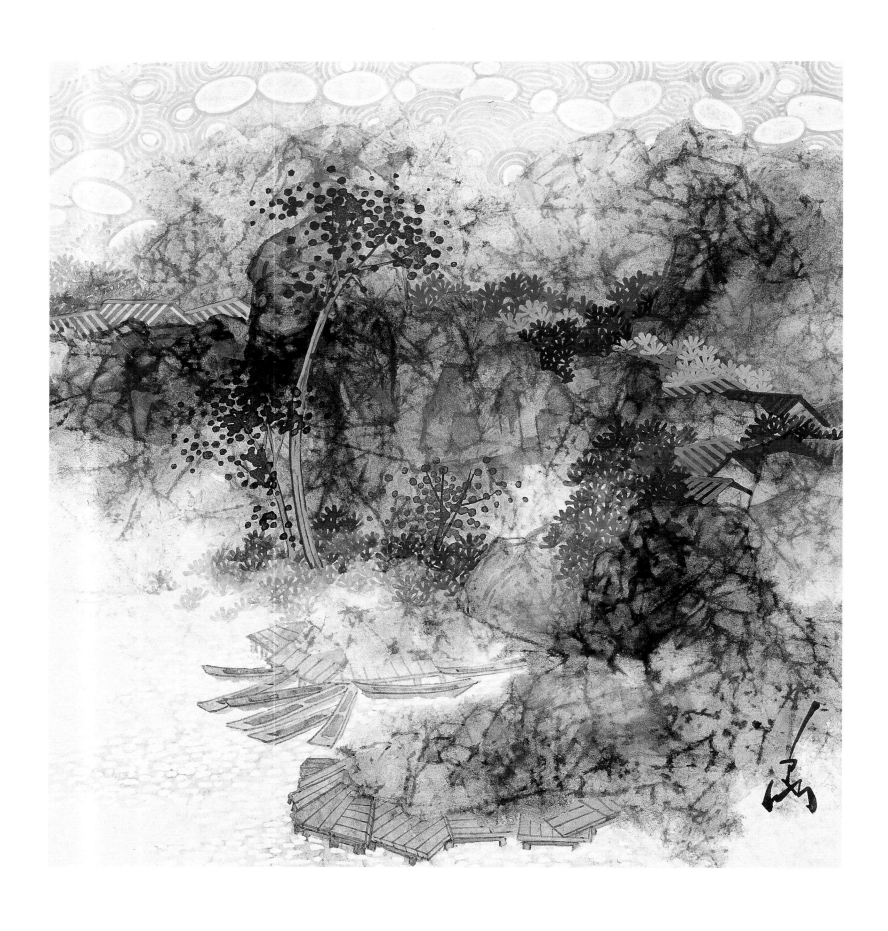

秋林漁家　水彩・紙本　30.3×29.8cm
Fishing Families in Autumn Woods Watercolor on Paper

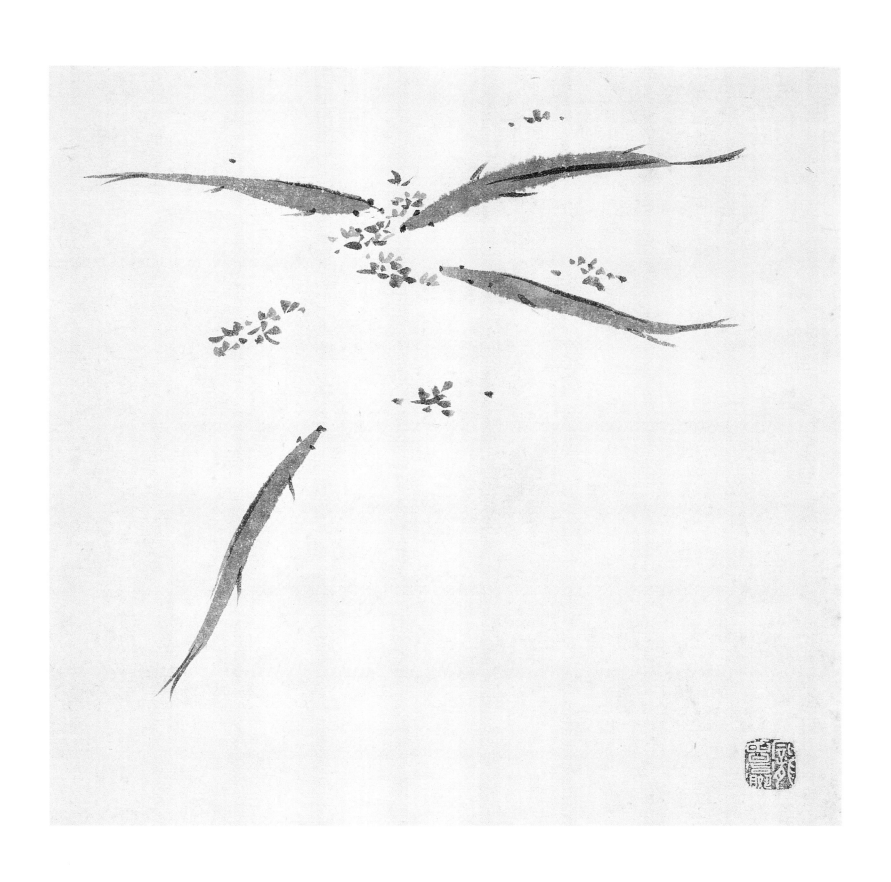

悠游　彩墨・紙　29×29cm
Four Fishes　Ink and Color on Paper

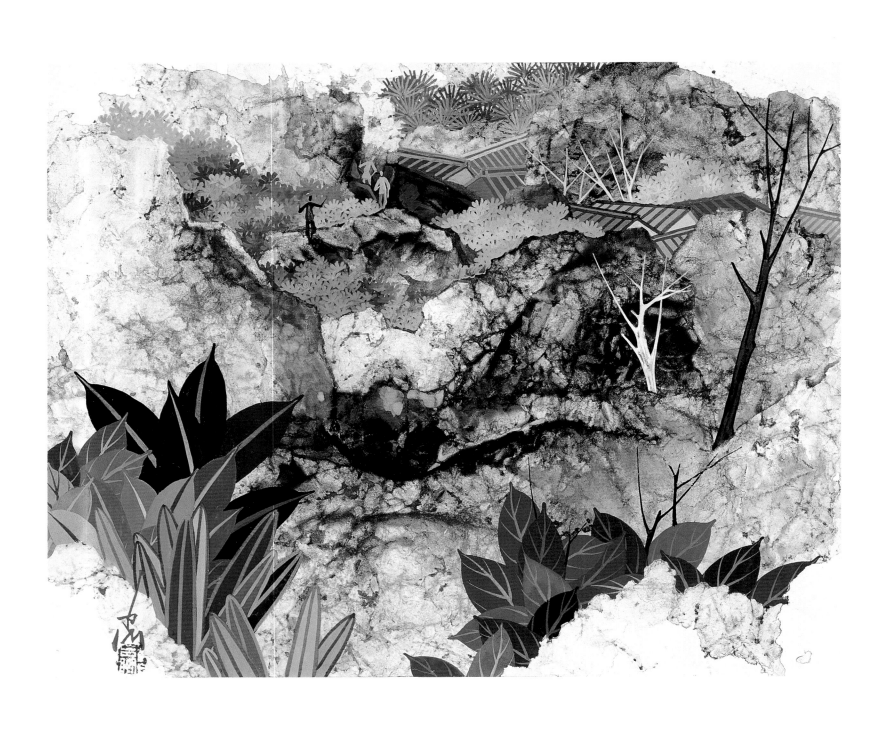

綠樹濃陰繞地雲　水彩・紙本　31×39.3cm
Dense Shades against Hovering Clouds Watercolor on Paper

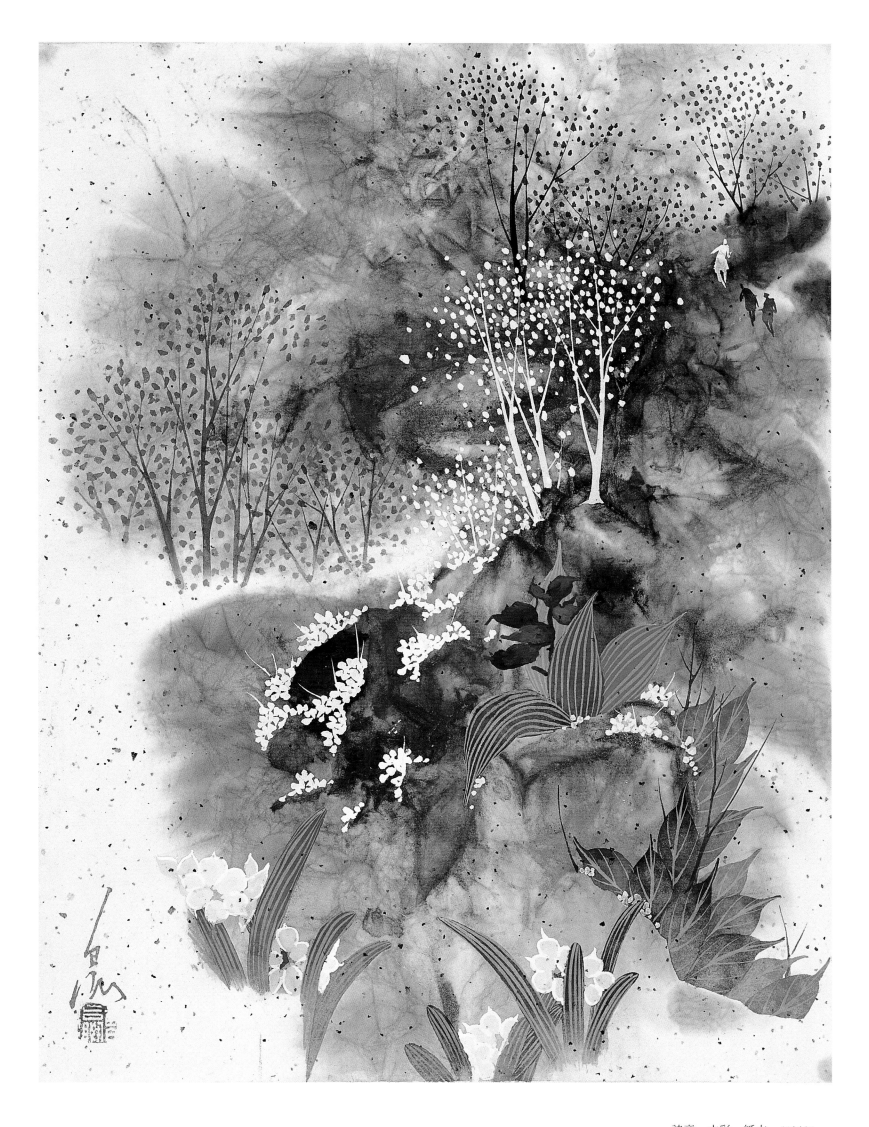

詩意　水彩・紙本　41×31cm
Poetry　Watercolor on Paper

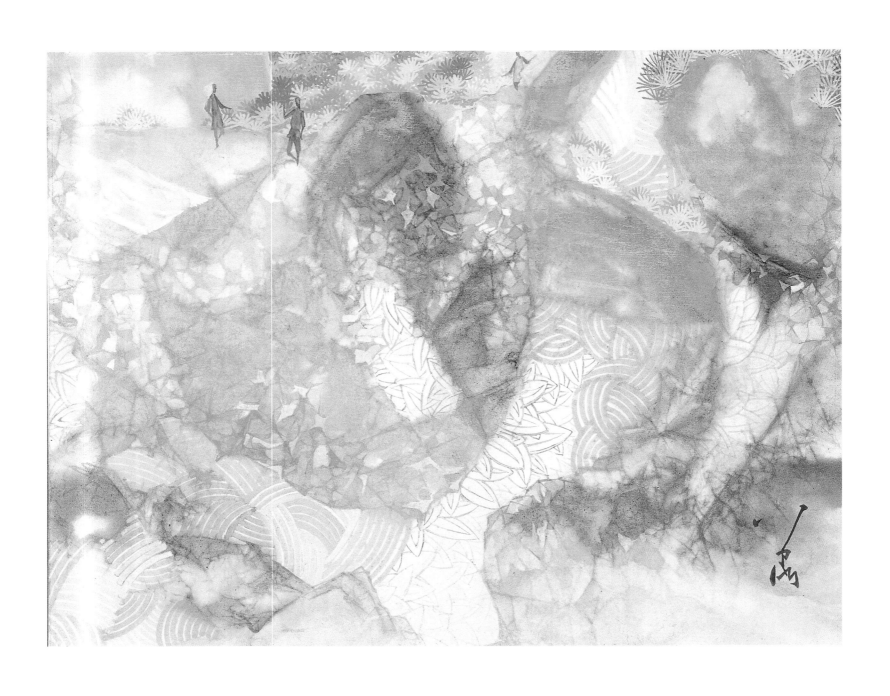

靜　水彩・紙本　32.5×42.5cm
Quietude　Watercolor on Paper

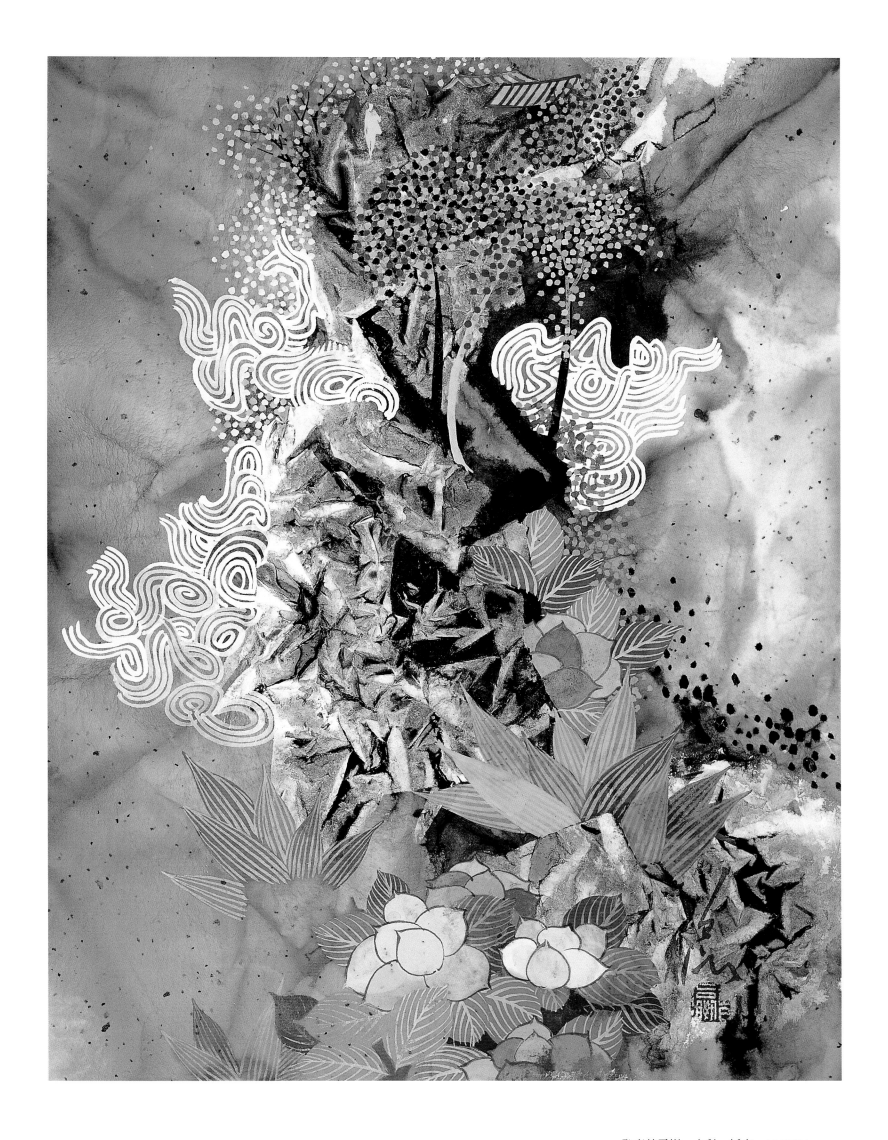

登高望雲樹　水彩・紙本　40.5×31cm
Sky-Reaching Tree　Watercolor on Paper

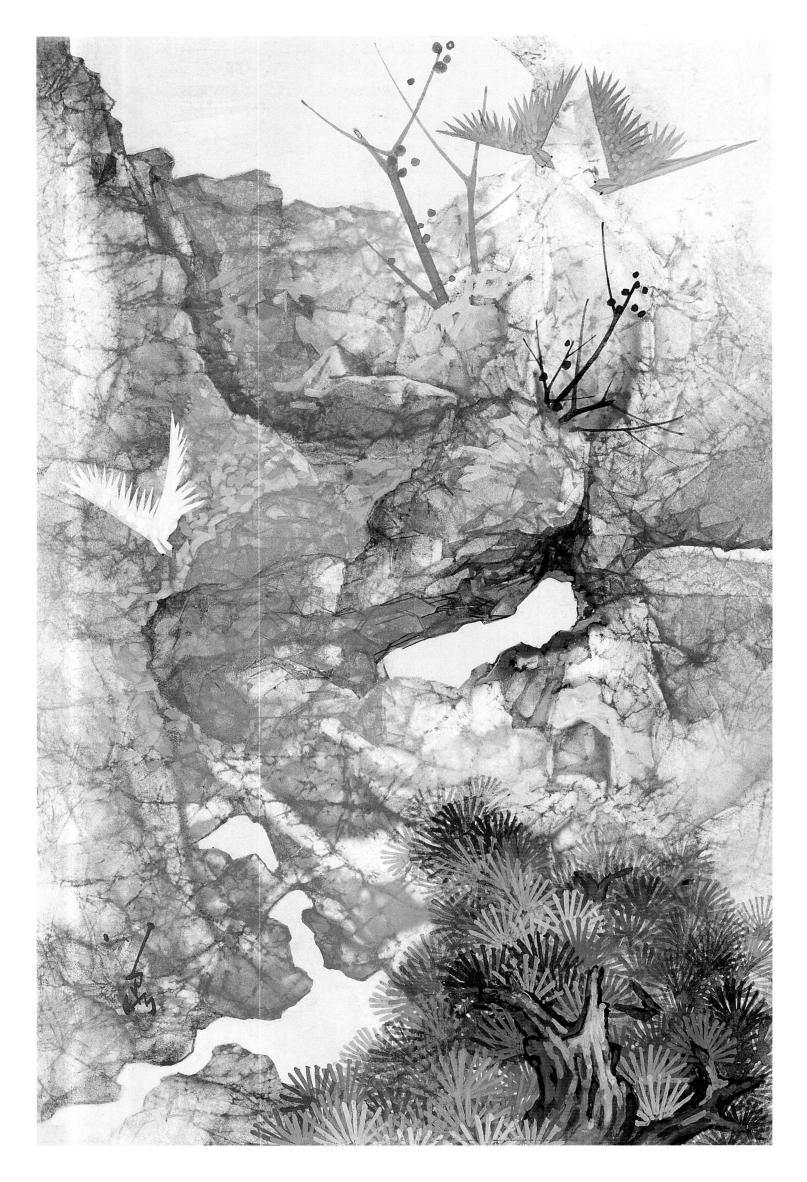

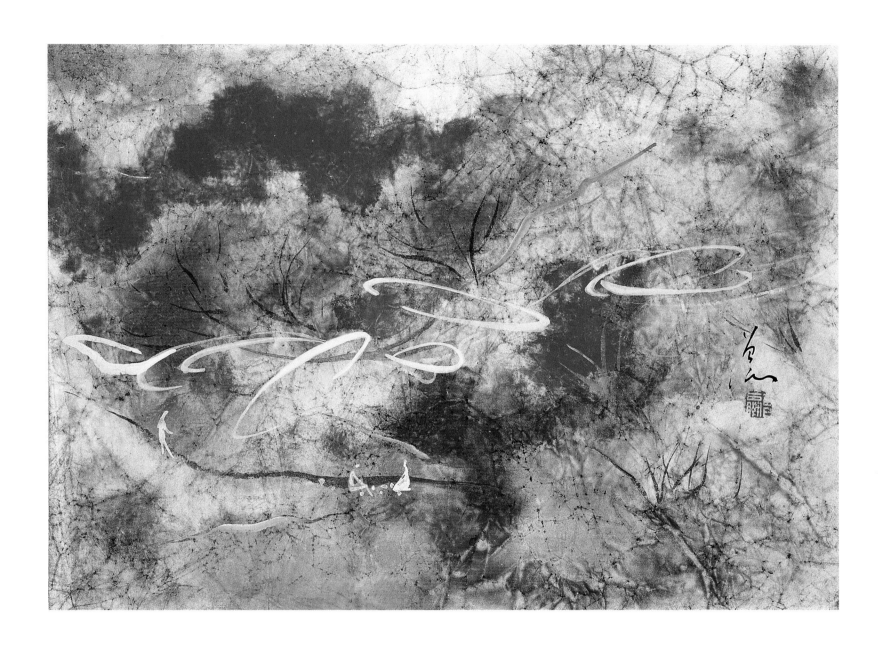

聽風　水彩・紙本　30.5×41.3cm
Above: Listen to the Wind　Watercolor on Paper

飛翔　水彩・紙本　48.5×31.5cm 〈左頁圖〉
Left: Flight　Watercolor on Paper

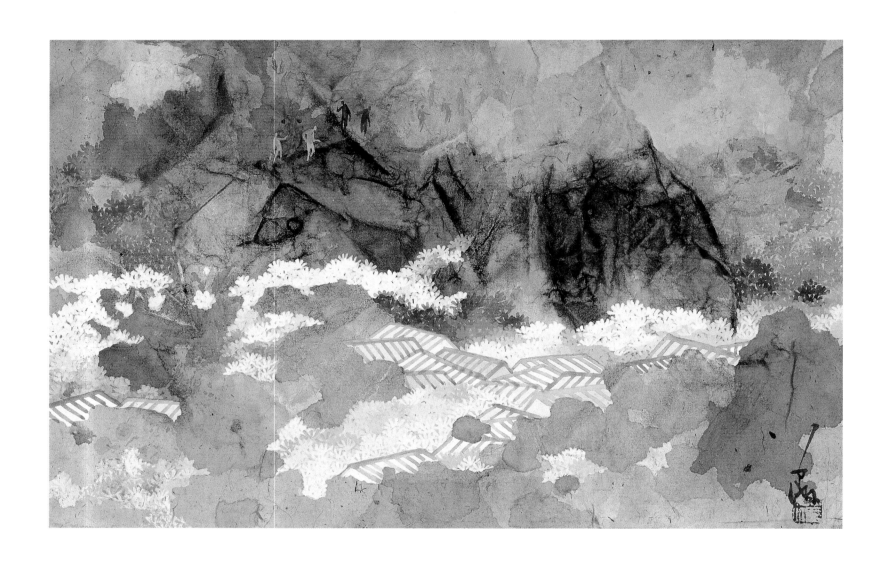

山上（二）　水彩・紙本　25.8×41.2cm
On the Mountain II　Watercolor

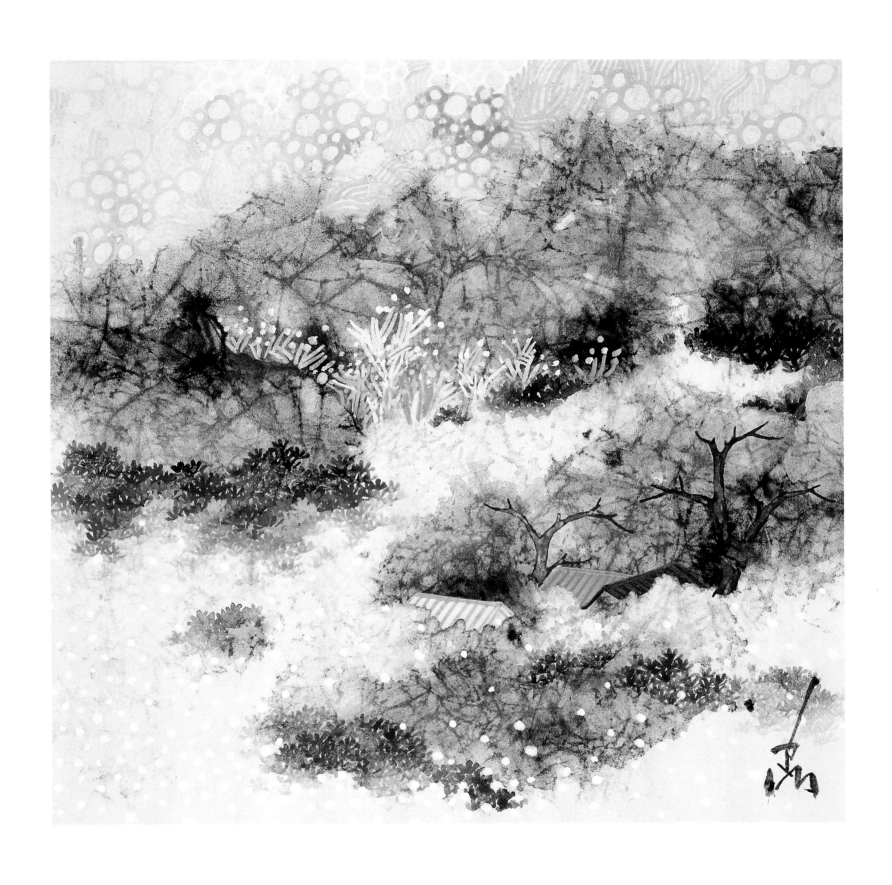

雲氣蒸凝　水彩・紙本　29.5×30.2cm
Steaming Clouds　Watercolor on Paper

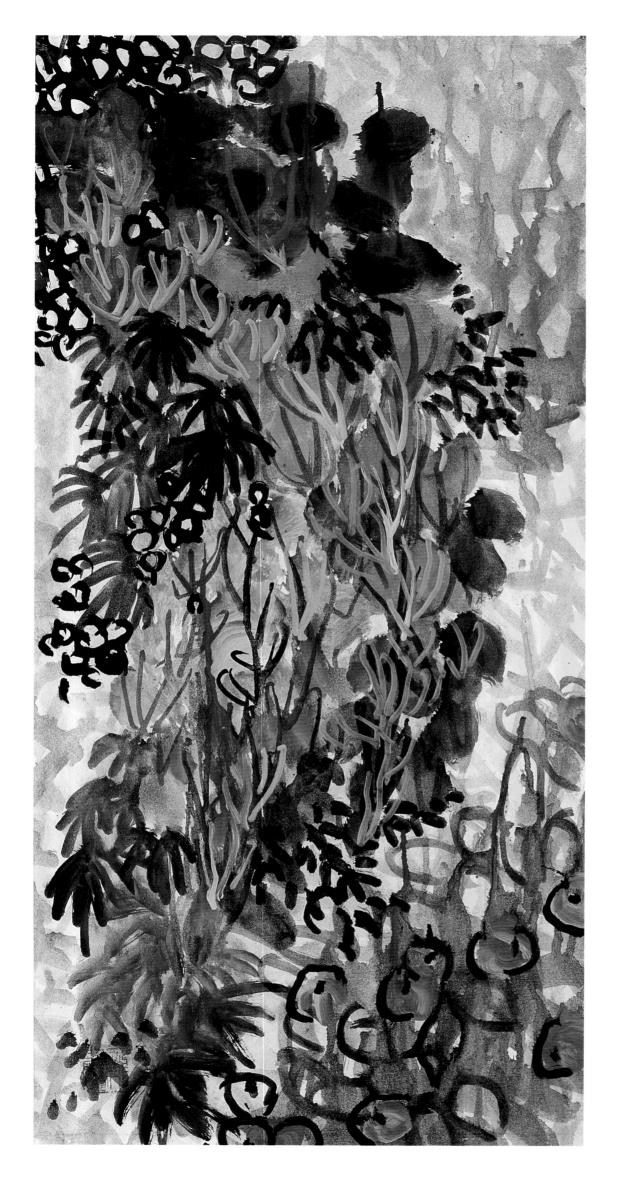

濃
水墨・水彩・紙
54.5×27cm

Trees
Ink and Watercolor on Paper

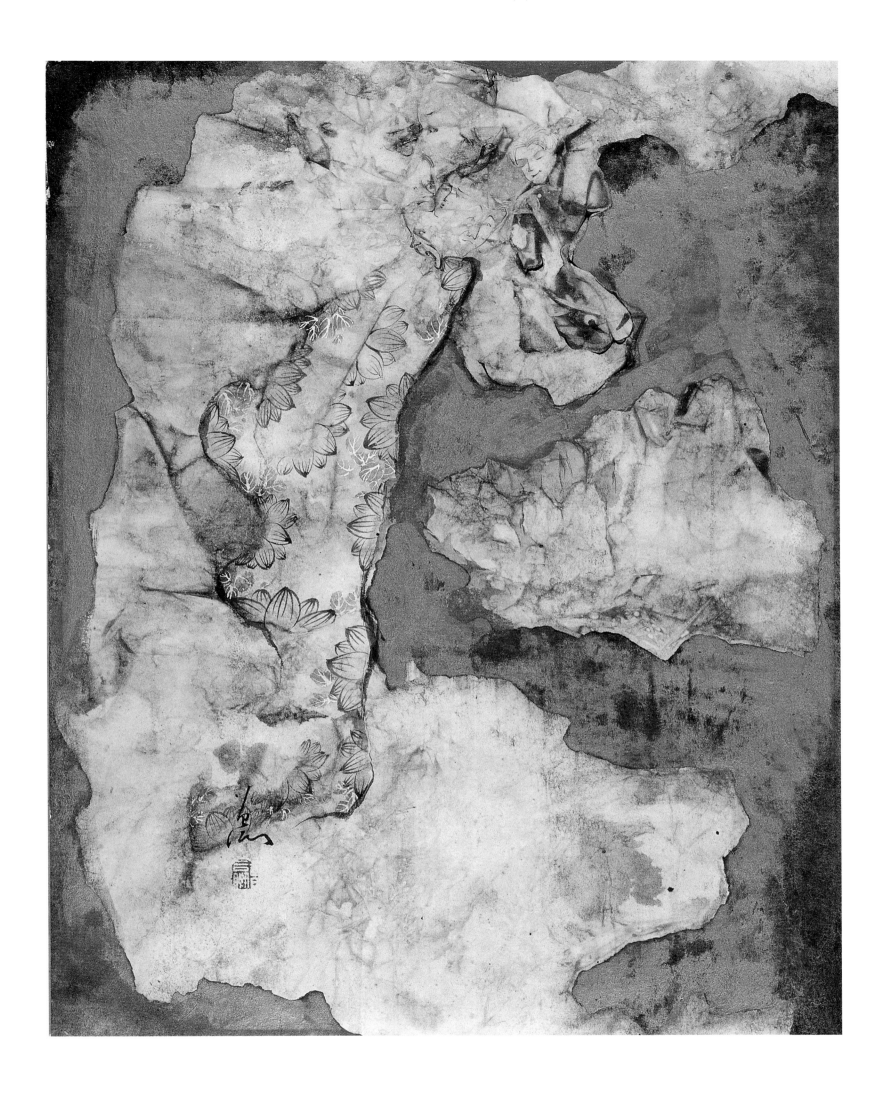

花之憶　水彩・紙本　51.1×41cm
Memory of Flowers　Watercolor on Paper

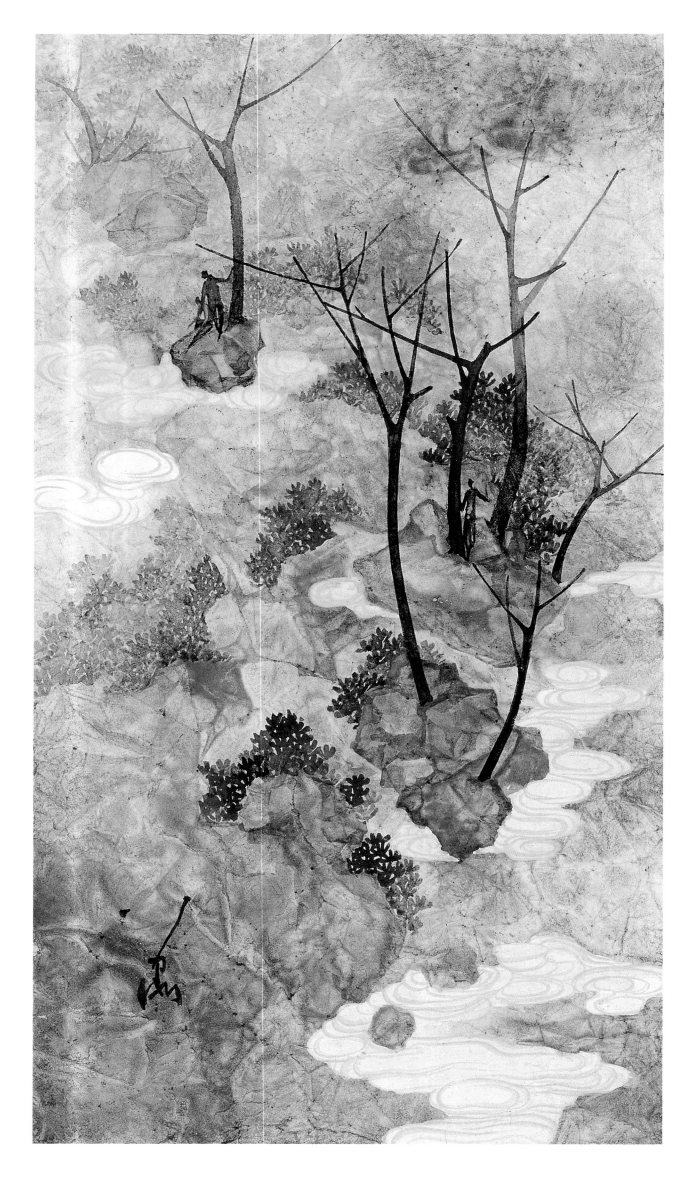

游蹤
水彩・紙本
49.6×28cm

Outing
Watercolor on Paper

124

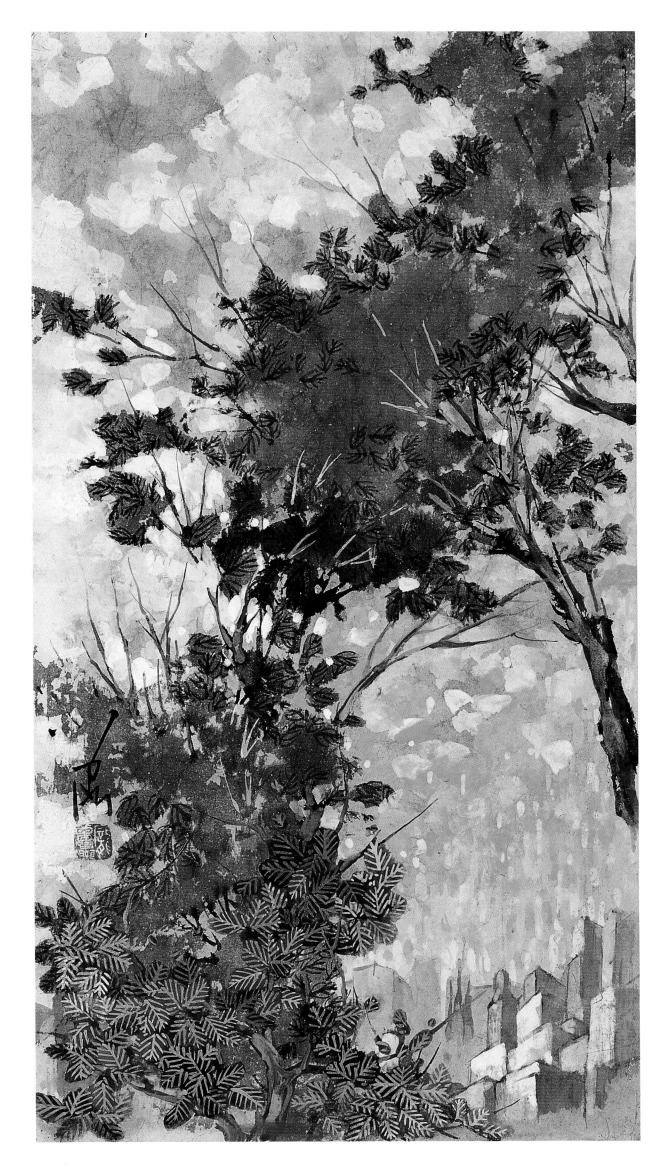

雲和樹
水彩・紙本
57.3×30.8cm

Trees
Watercolor on Paper

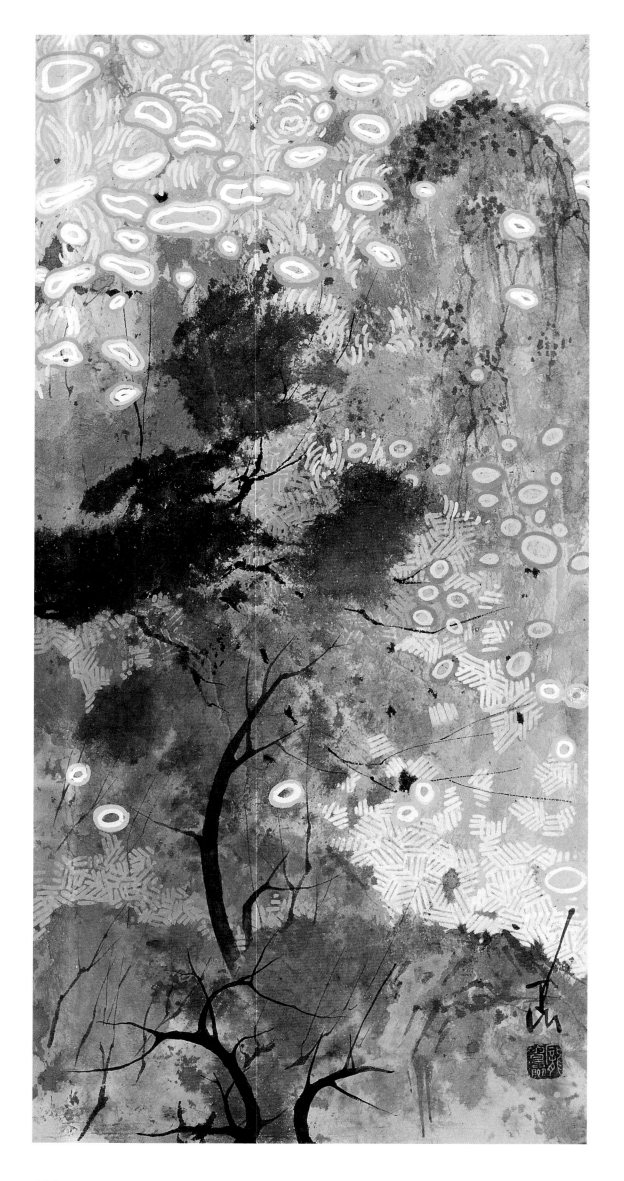

濛濛遙遙
水彩・紙本
61.5×30cm

Cloud-capped Mountain
Watercolor on Paper

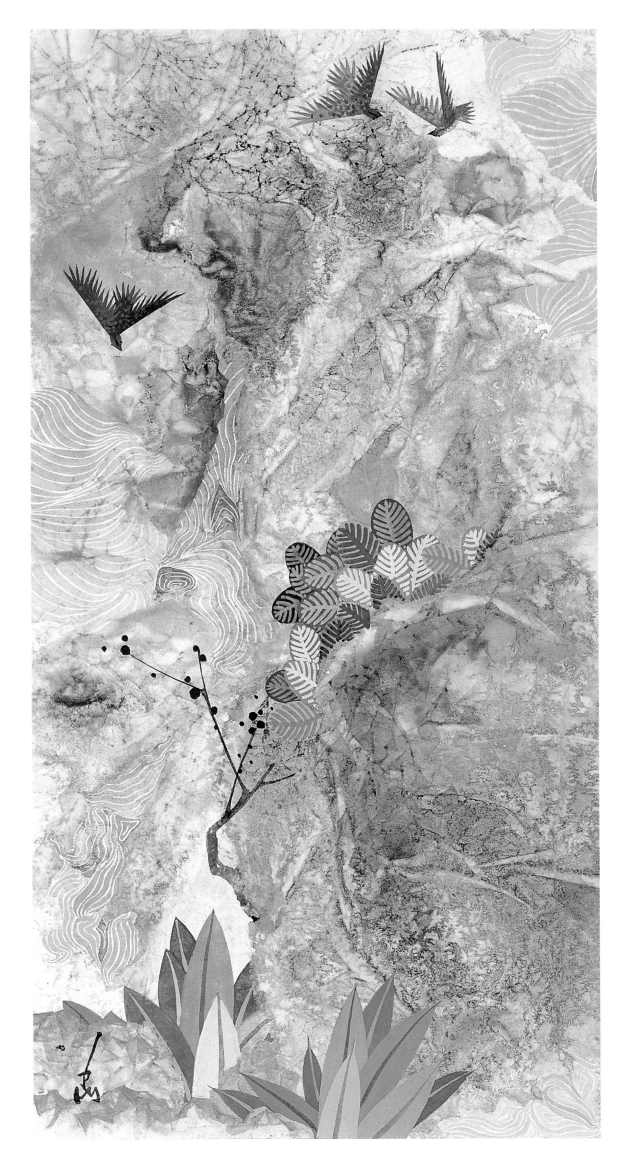

擇木
水彩・紙本
64.8×32.6cm

Brown Birds
Watercolor on Paper

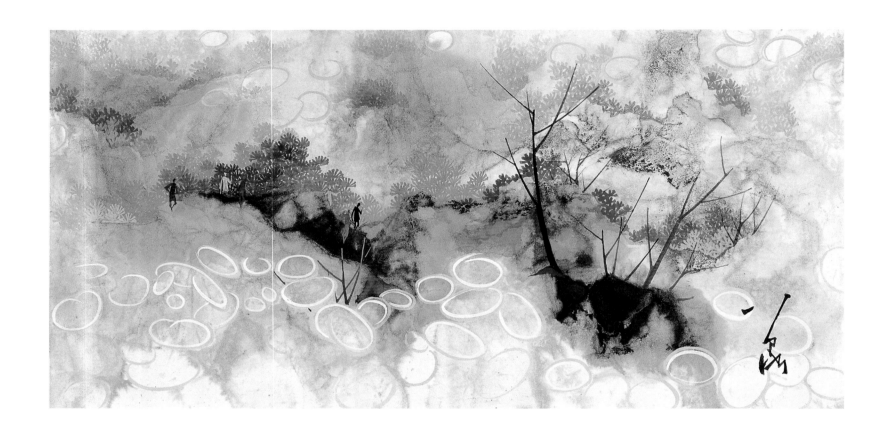

踏青　水彩・紙本　22.7×45.2cm
Outing　Watercolor on Paper

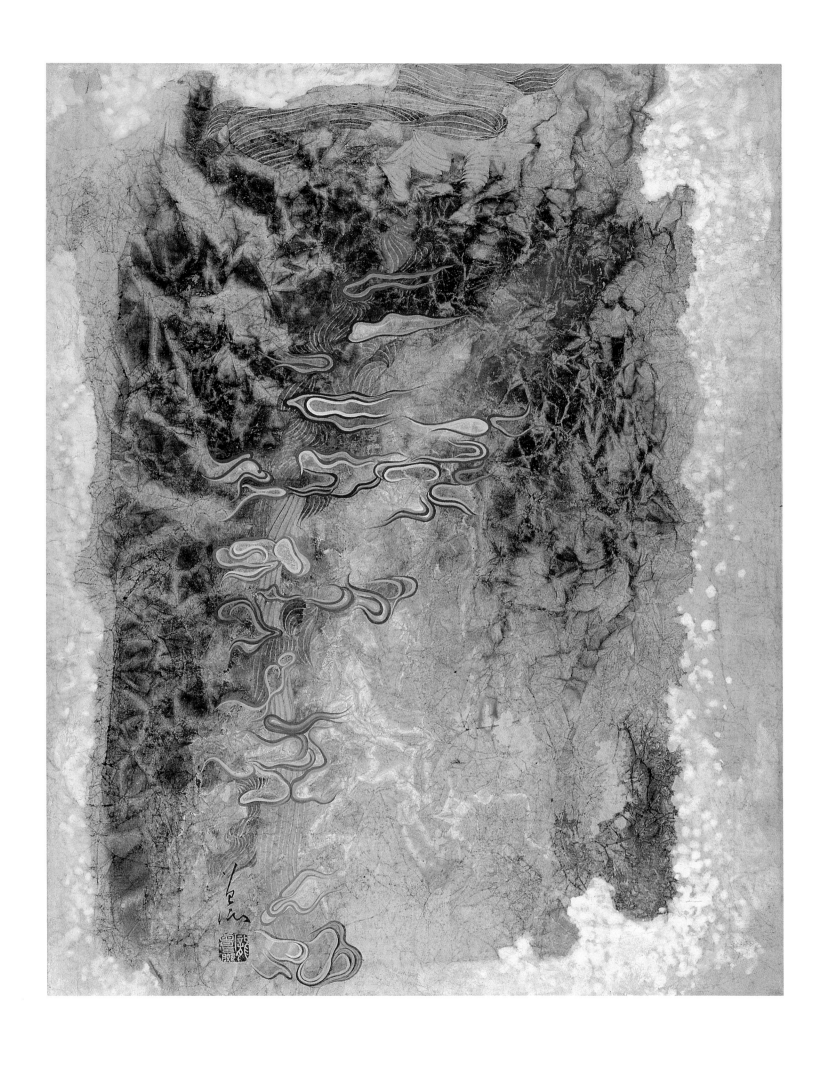

古的象徵　水彩・紙本　60.2×46.2cm
Antiqueness　Watercolor on Paper

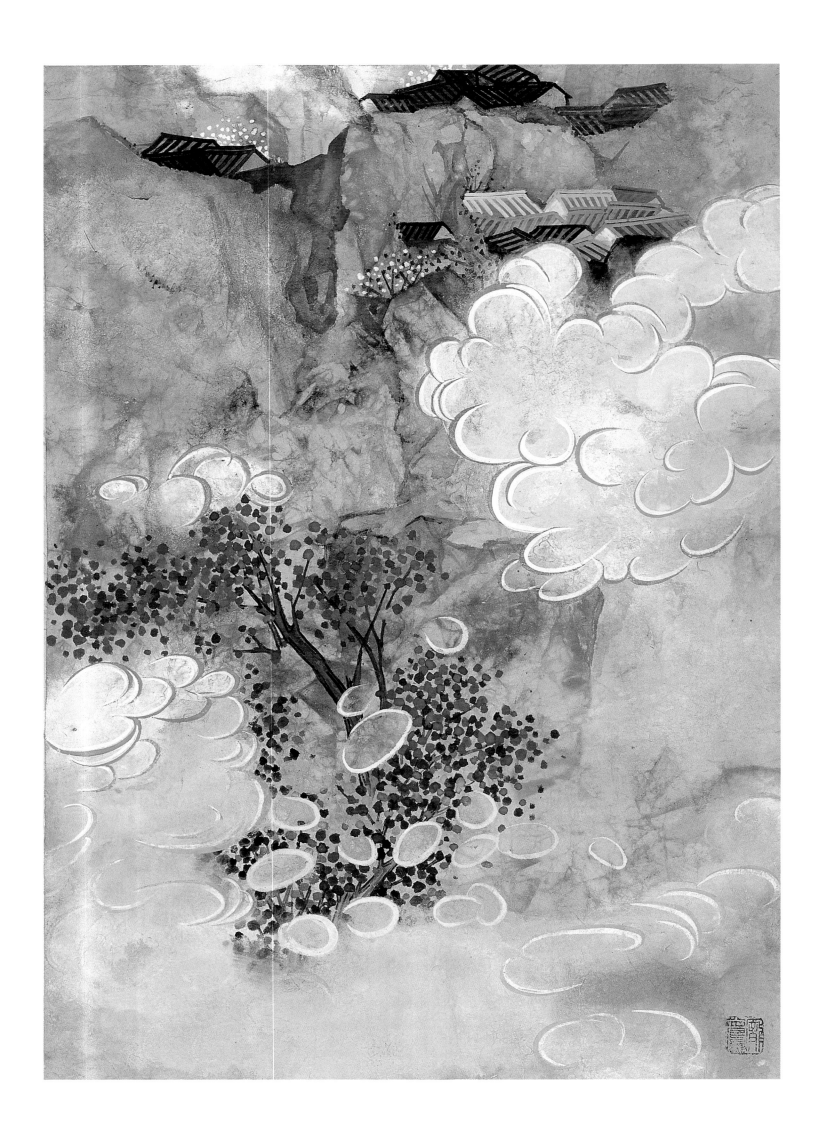

雲開見山家　水彩・紙本　63.9×45.5cm
Houses Looming from Behind the Clouds　Watercolor on Paper

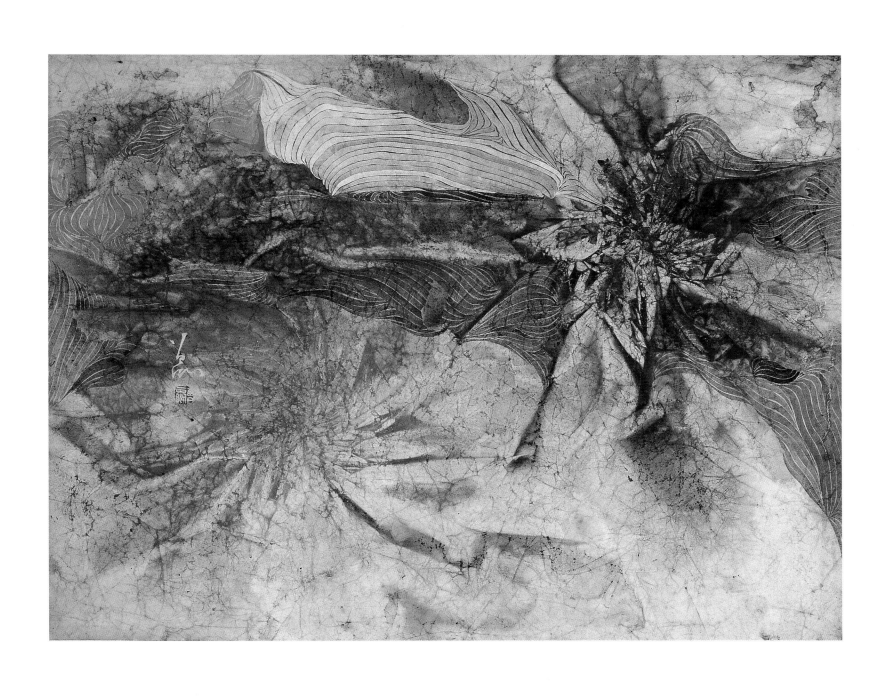

流金歲月　水彩・紙本　46.1×60.5cm
Golden Age　Watercolor on Paper

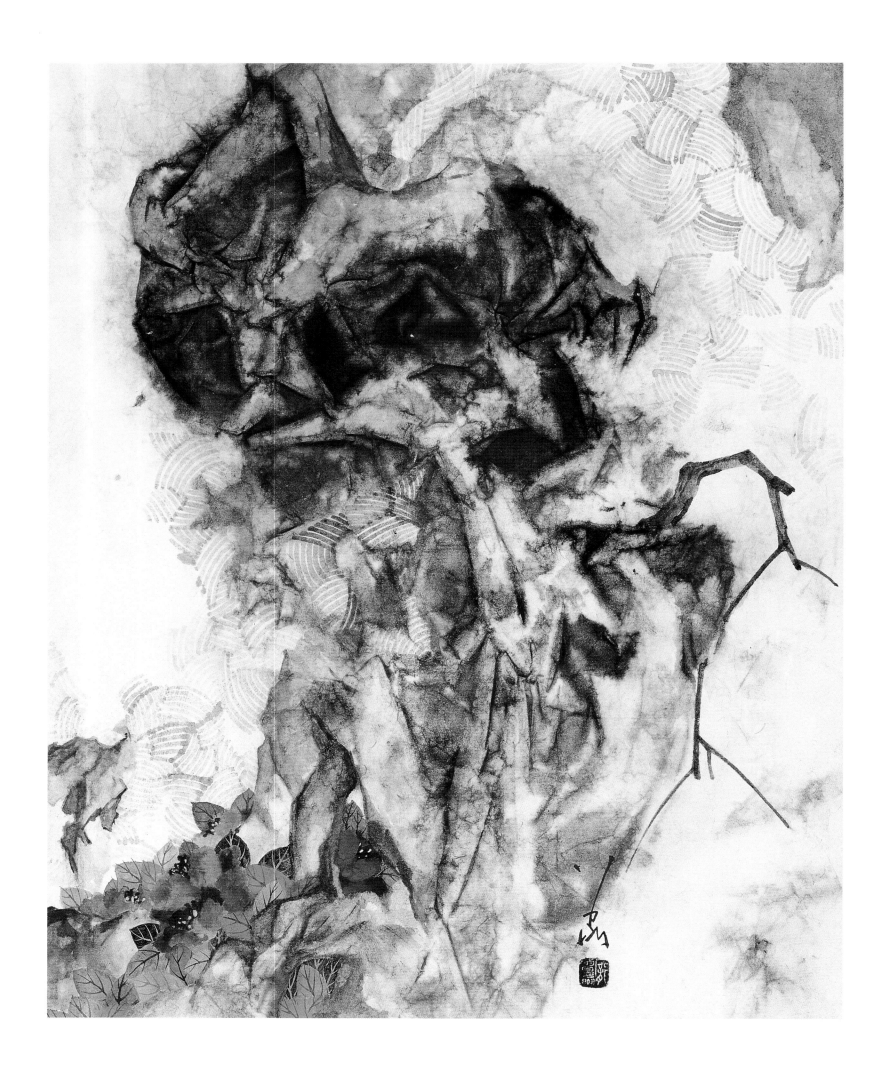

嫣然　水彩・紙本　63×50.6cm
Amorous　Watercolor on Paper

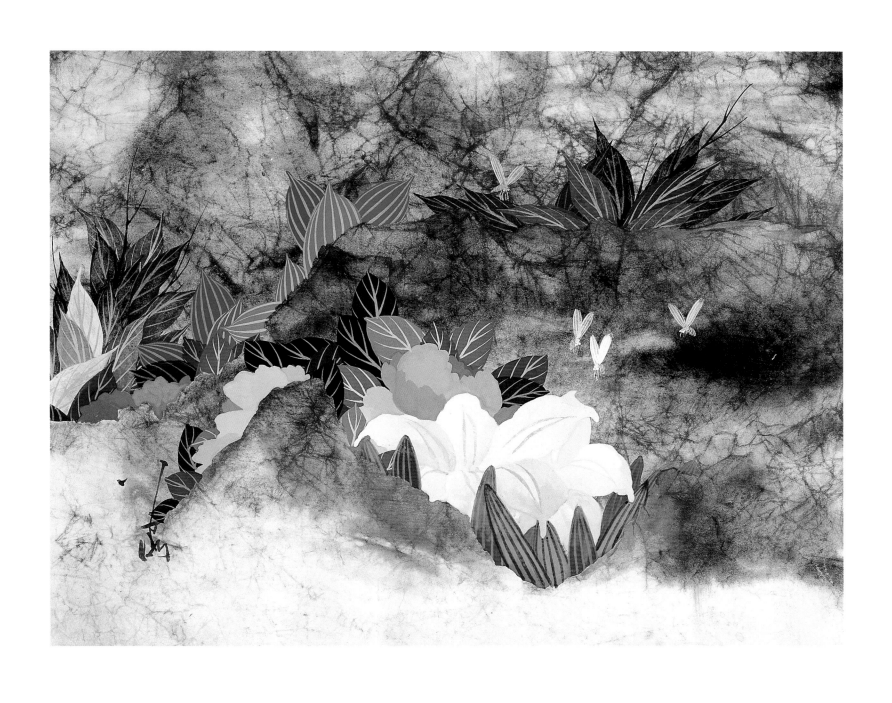

探蜜　水彩・紙本　32×41.8cm
Bees Flies　Watercolor on Paper

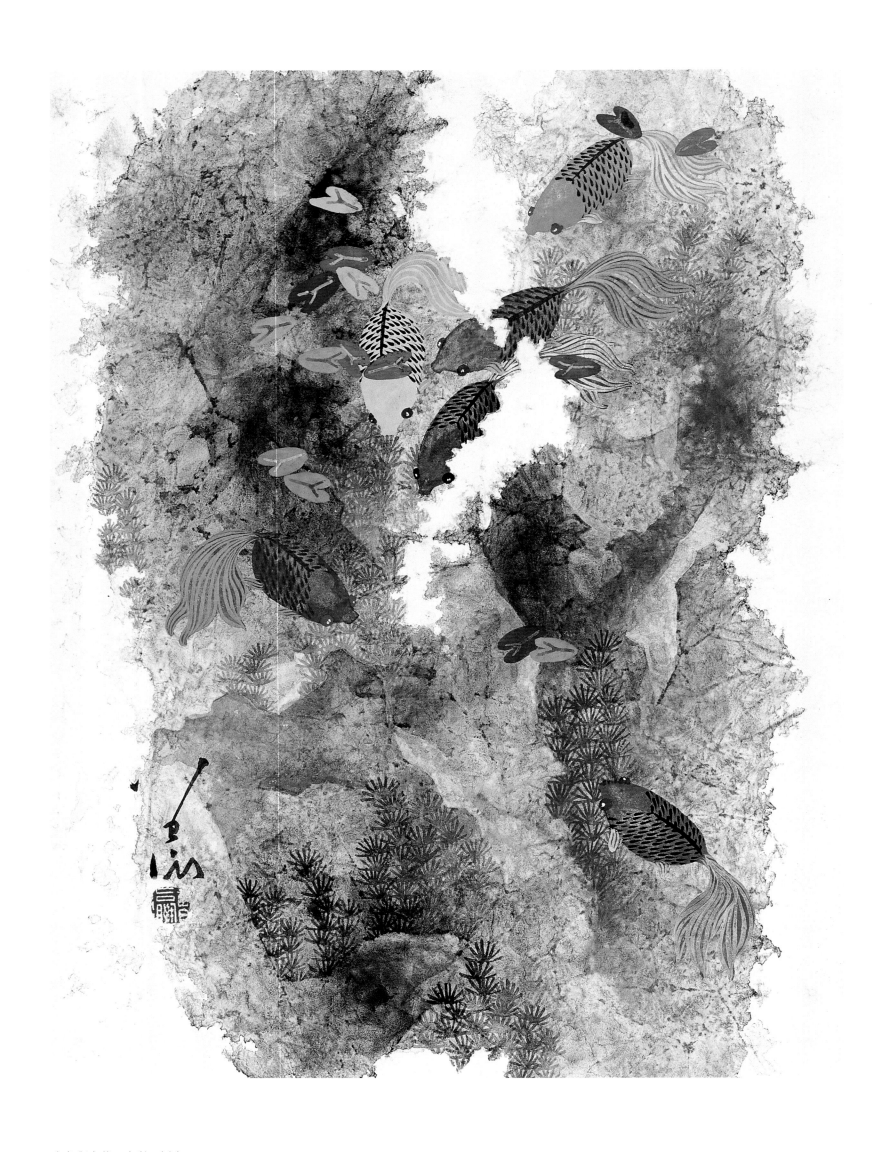

金魚與水草　水彩・紙本　41.8×32.5cm
Goldfishes and Waterweed Watercolor on Paper

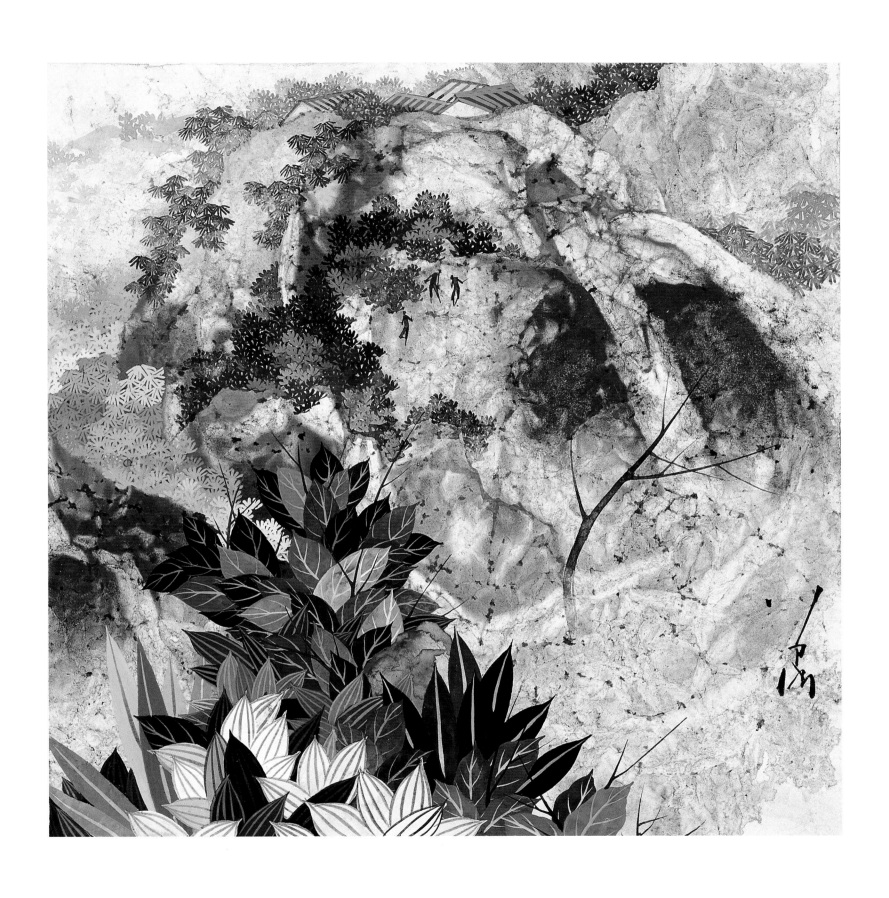

秋高氣爽　水彩・紙本　39.8×40cm
The Cool Autumn Air　Watercolor on Paper

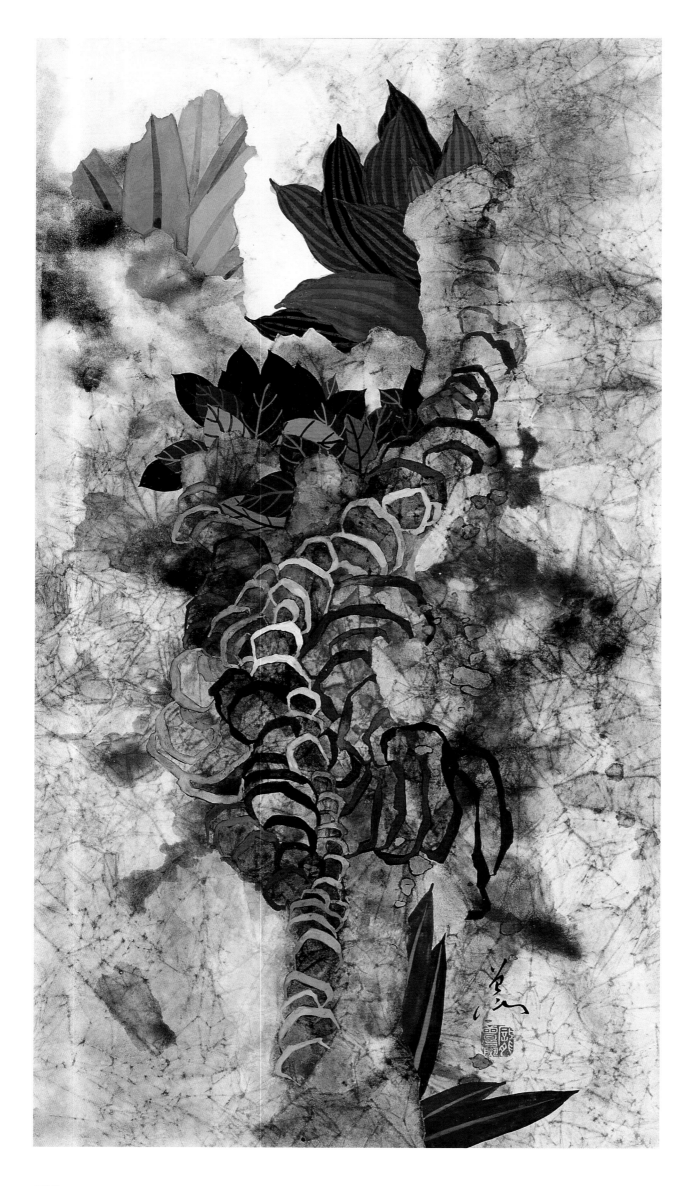

結
水彩・紙本
65.2×36.4cm

Affinity
Watercolor on Paper

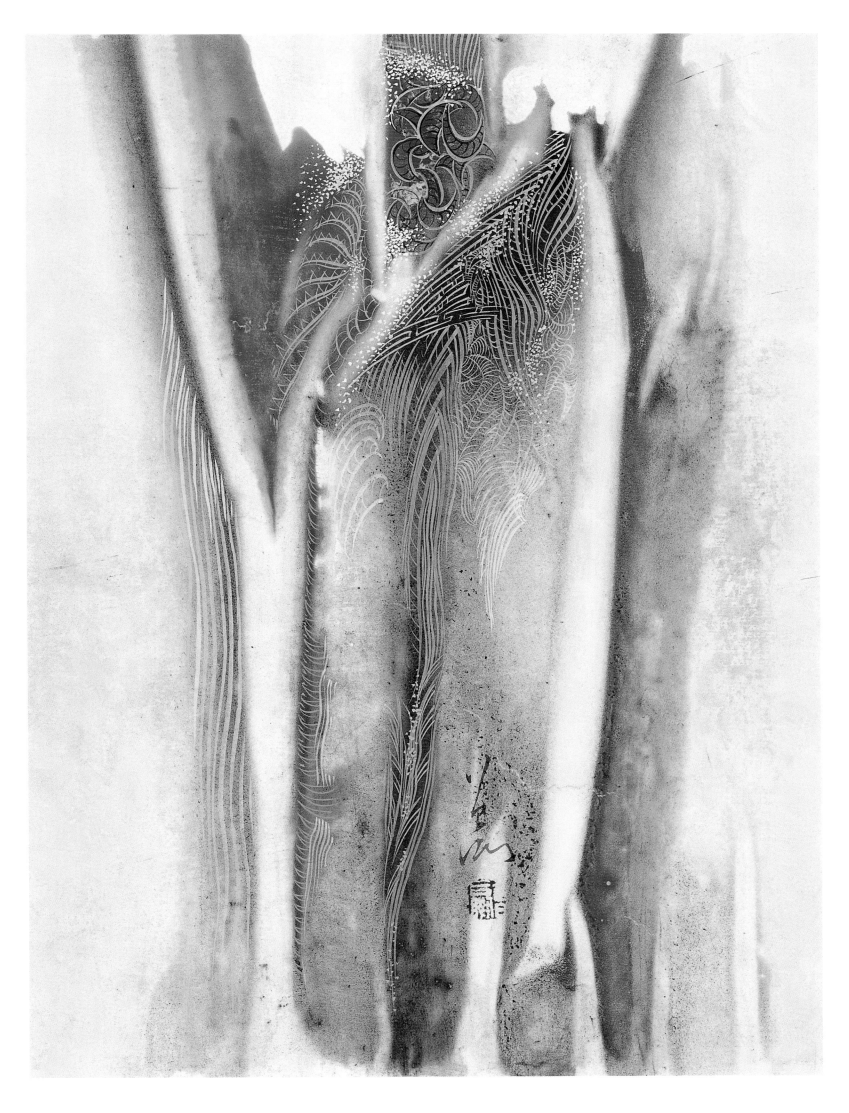

昇　水彩・紙本　40.6×32.2cm
Composition　Watercolor on Paper

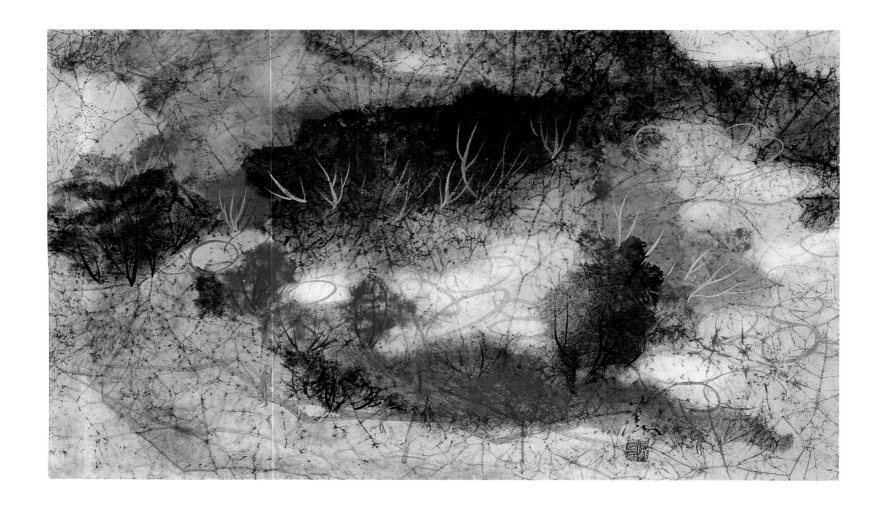

晩風　水彩・紙本　38×64.5cm
Evening Wind Watercolor on Paper

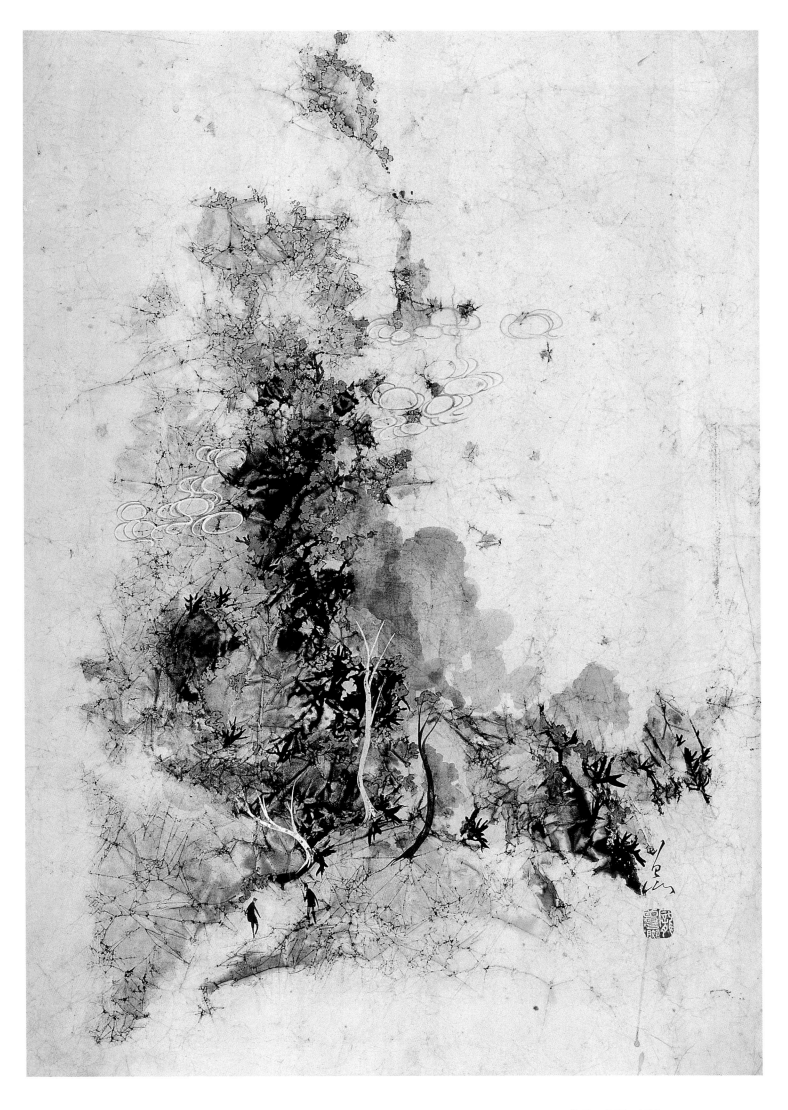

花季　水彩・紙本　66.4×46.2cm
Flower Season Watercolor on Paper

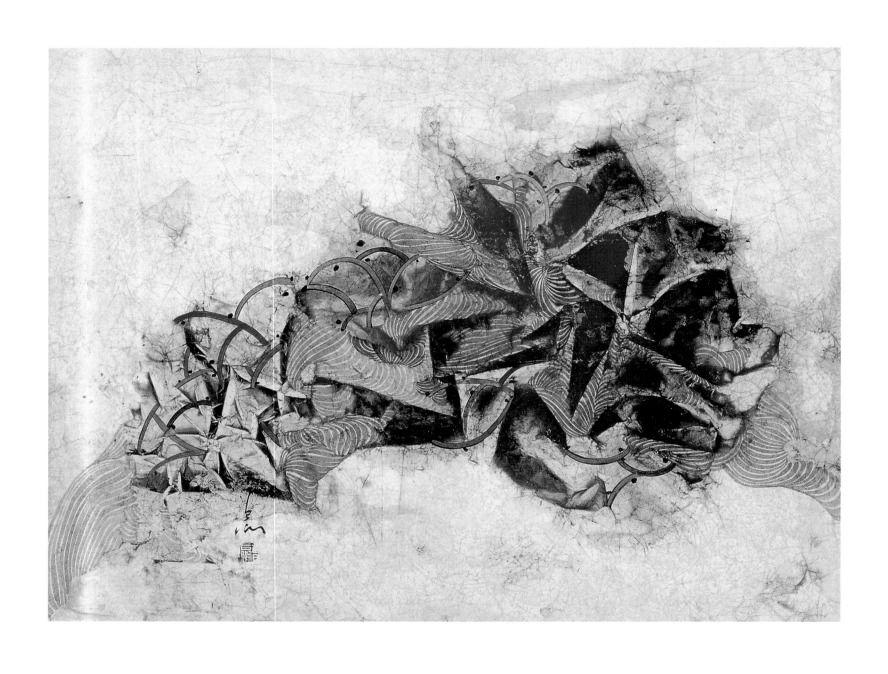

纏　水彩・紙本　46×64cm
Entangled　Watercolor on Paper

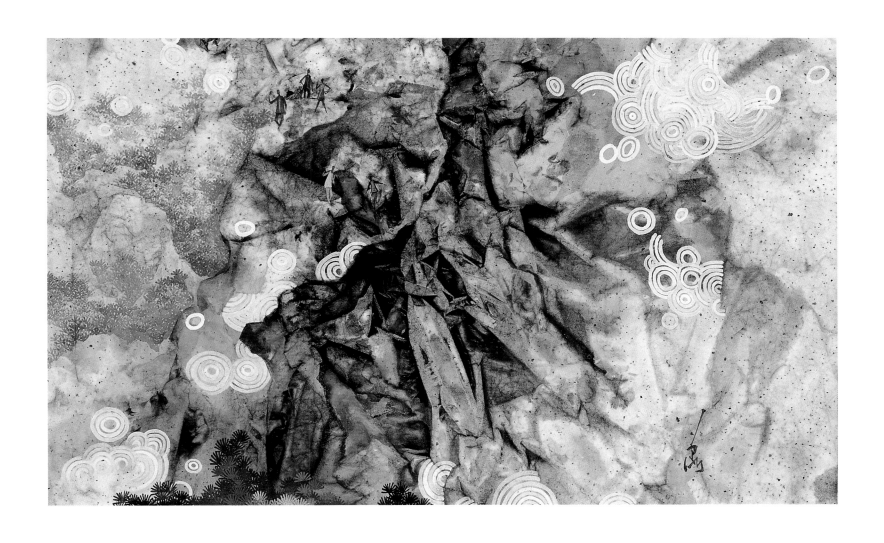

在雲端　水彩・紙本　46×75.5cm
In the Clouds　Watercolor on Paper

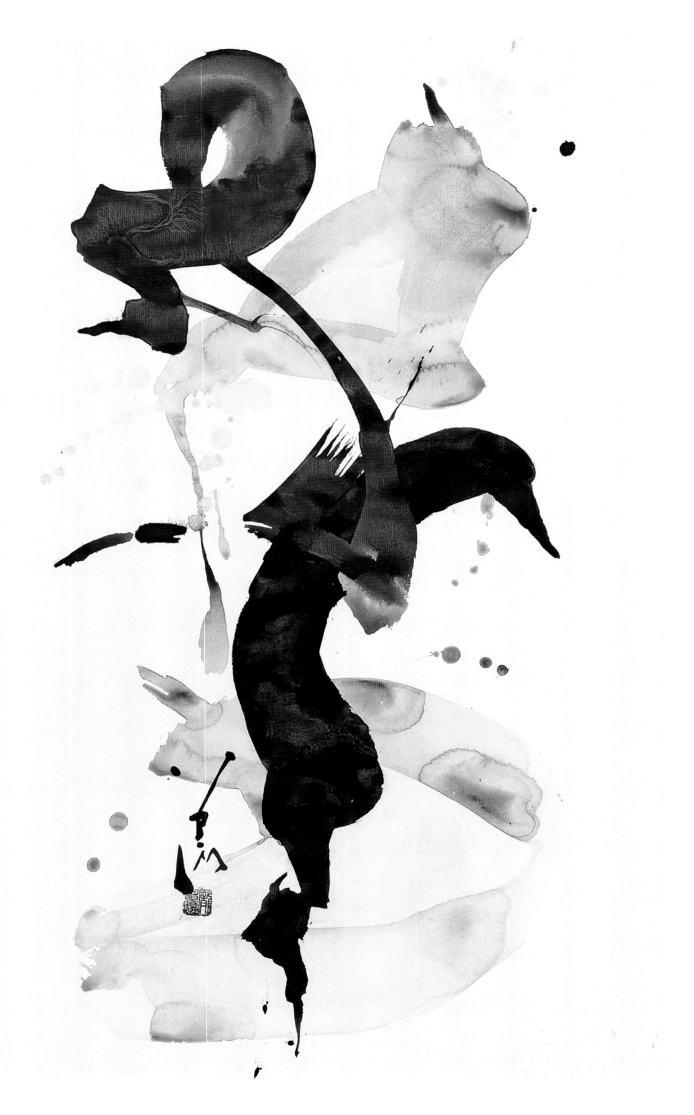

抽象 水彩・紙本 90×58.7cm
Abstract Watercolor on Paper

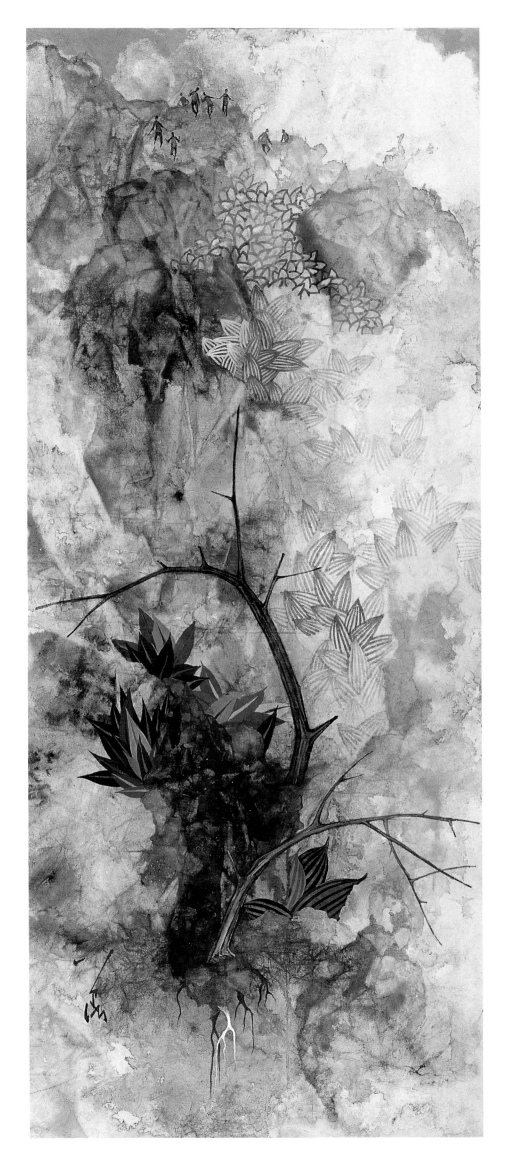

花間集
水彩・紙本
91×37cm

Bloom
Watercolor on Paper

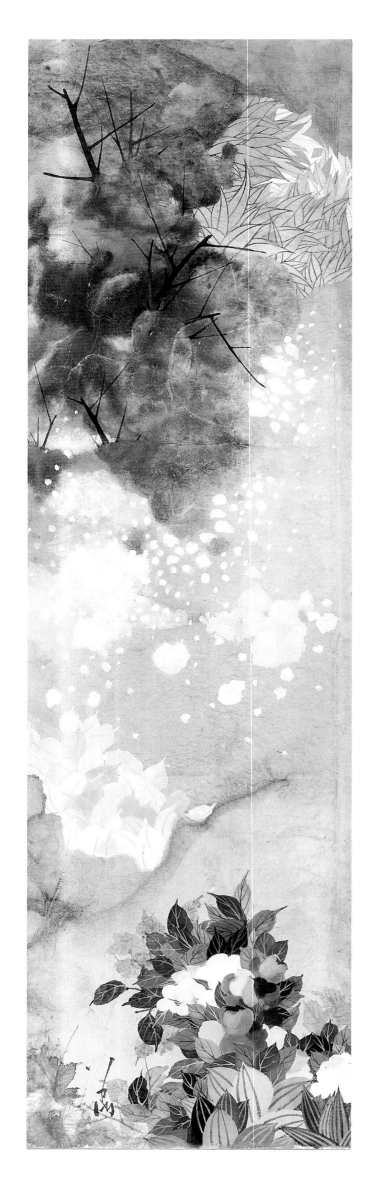

秀
水彩・紙本
92.3×27cm

Flowers
Watercolor on Paper

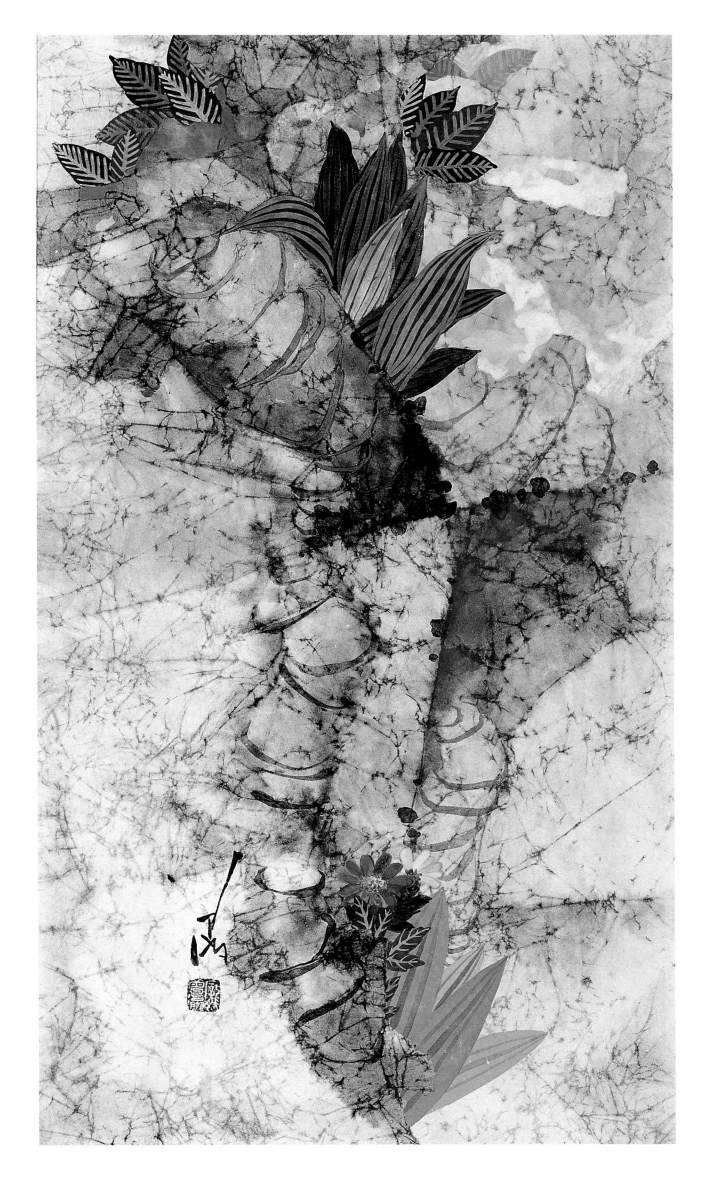

雛菊
水彩・紙本
65×36.8cm

Daisies
Watercolor on Paper

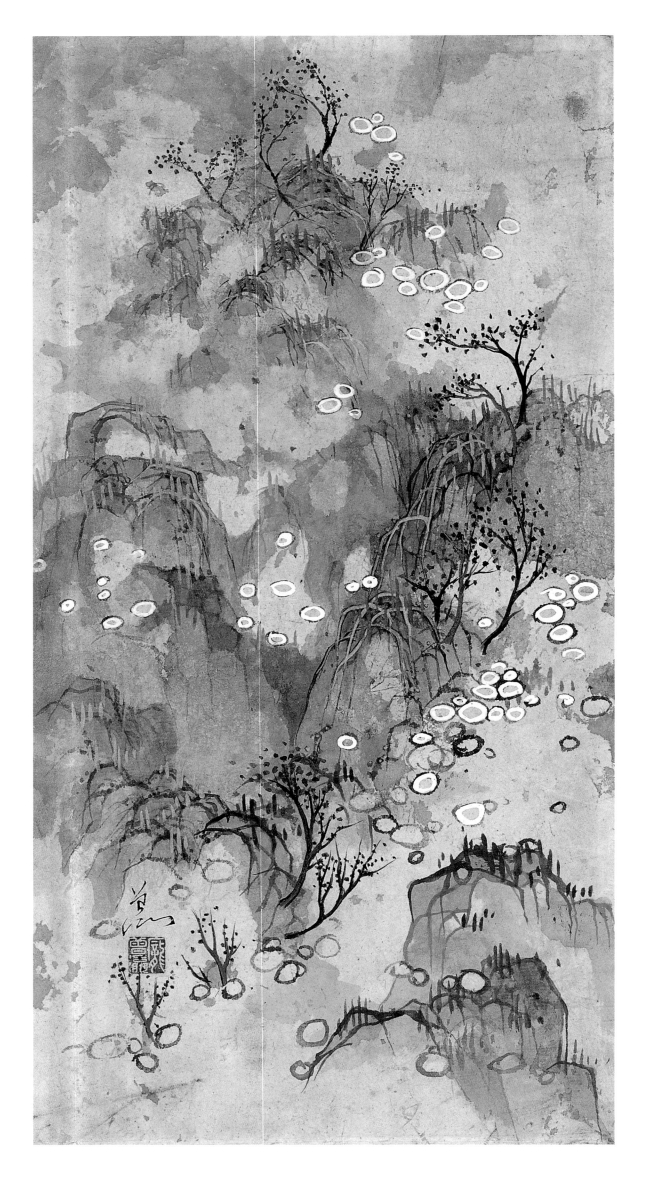

翠嶺煙雲
水彩・紙本
57.9×30.6cm

Ethereal Peaks
Watercolor on Paper

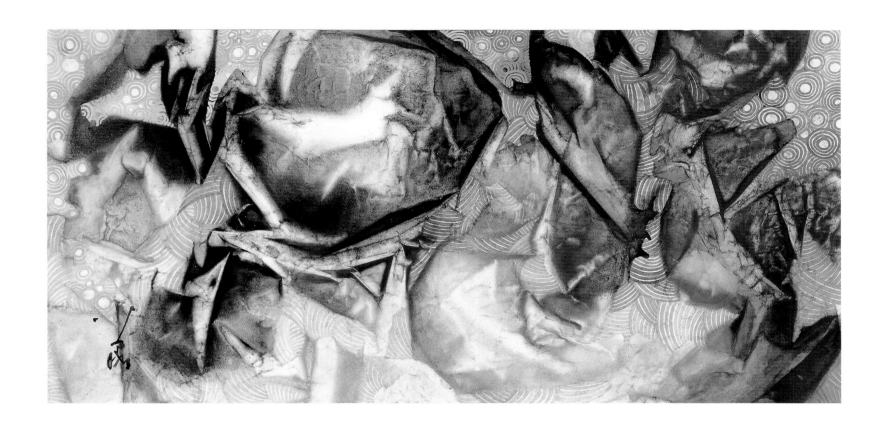

夢　水彩・紙本　31.5×65cm
Dream　Watercolor on Paper

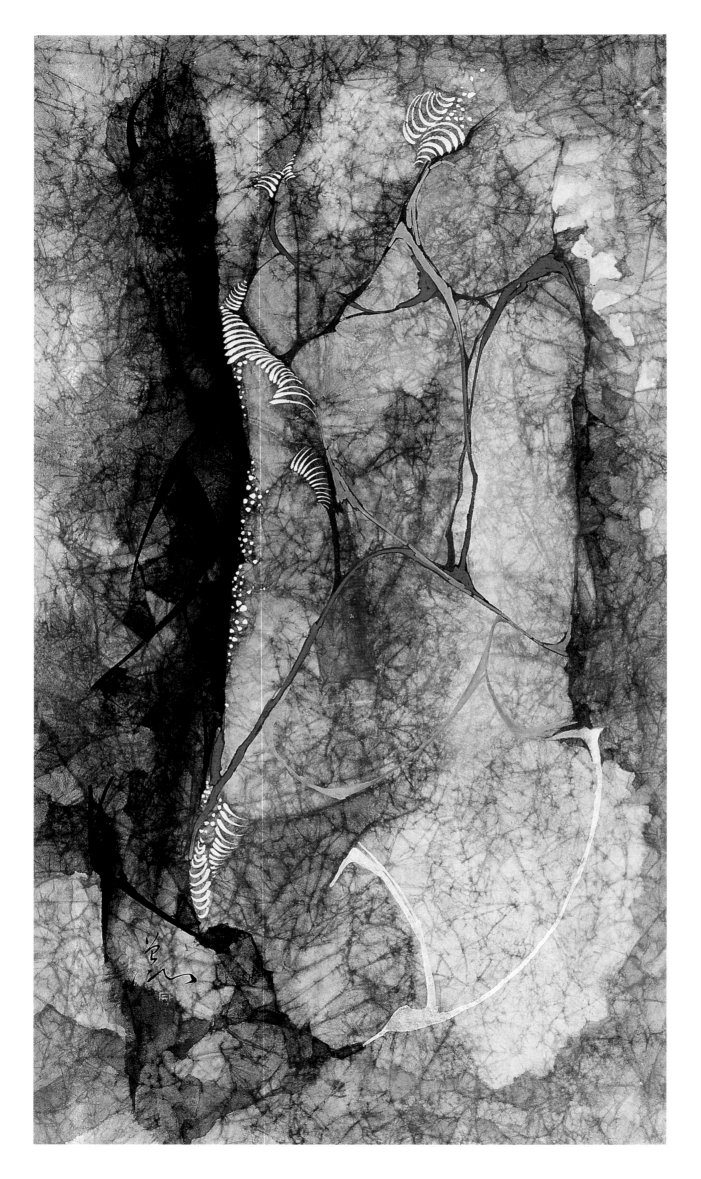

紋
水彩・紙本
65.2×36.4cm

Streaked
Watercolor on Paper

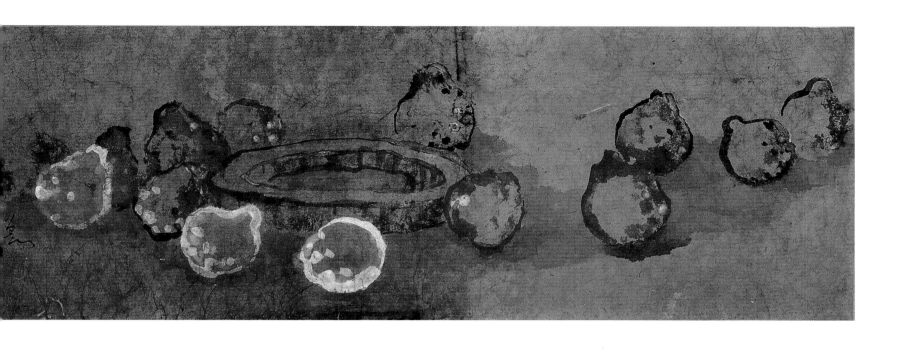

水果靜物　水彩・紙本　28×82.5cm
Still Life with Fruits Watercolor on Paper

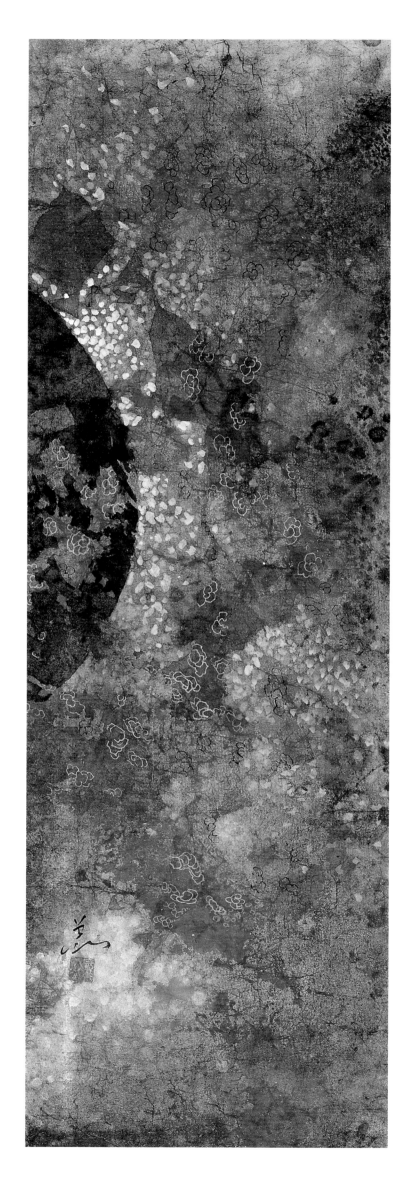

飛光圖
水彩・紙本
97.2×37.5cm

Light
Watercolor on Paper

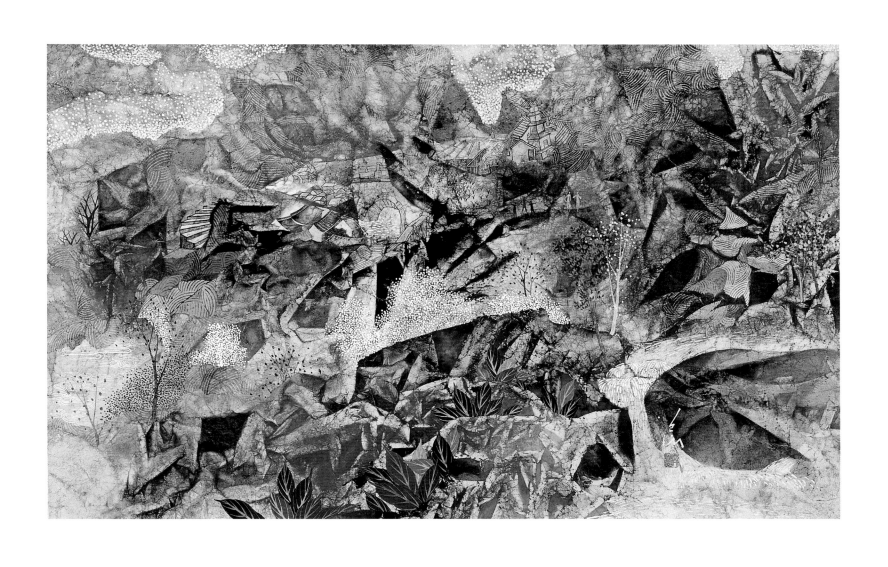

尋幽訪勝　水彩・紙本　78×126cm
In Pursuit of Splendor Watercolor on Paper

輕（三聯作）
水彩・紙本
124.8×36cm

Featheriness (triptych)
Watercolor on Paper

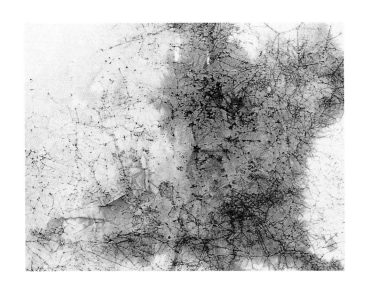

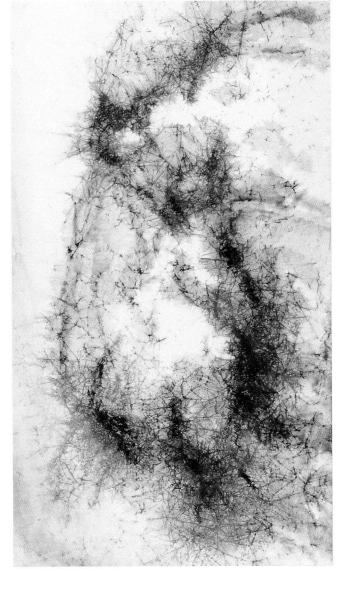

柔（三聯作）
水彩・紙本
124×35cm

Softness (triptych)
Watercolor on Paper

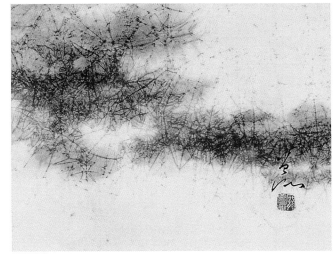

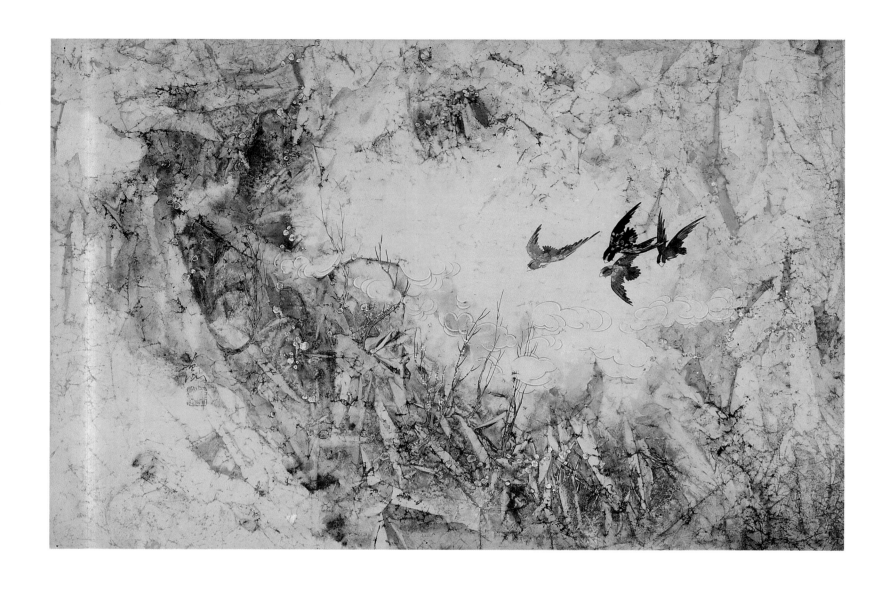

扁羽扁羽　水彩・紙・裱於木板　61×91.5cm
Birds in Flight Watercolor on Paper, Mounted on Wood

龐曾瀛生平大事記
Chronology

年　代	龐曾瀛生平大事記
1916	・三月七日出生，時值父母旅居日本東京期間。數年後，家人遷回中國。 ・原籍江蘇蘇州。 ・母親也是畫家，發現龐曾瀛有繪畫天分。 Born in March 7, during his parents' residence in Tokyo, Japan, and moved with family to Soochow, China. His mother, a painter in her own right, discovered in his childhood his natural talent for painting.
1927	・十一歲，開始學習國畫，逐漸嶄露頭角。 At the age of eleven he began to master traditional Chinese painting.
1932	・就學於當時隸屬於國立北平大學的京師大學學校藝術學院（即國立北京藝術專科學校的前身）。 ・畢業後任京師大學學校藝術學院助教。 Pursued the study of oil painting at the Chunghua College of Art in Beijing and on graduation as an assistant.
1936	・負笈日本，進入日本大學藝術學部研究科深造。 ・在此獲其碩士學位。 ・曾獲頒 Dokuritsu Group 獎項。 Went to Japan in 1936; got his MA from Nihon University College of Art, Japan, and

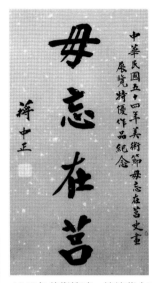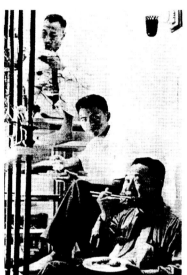

1965年美術節時，總統蔣中正頒發親筆「毋忘在莒」史畫展覽特優作品紀念獎狀給龐曾瀛。〈左圖〉
Left: The ex-president Chiang Kai-shek awarded Pang with calligraphy in his handwriting 'Wu Wang Tsai Chu' on an exhibition of Chinese paintings during the Fine Arts Festival in 1965.

1966年，畫家們在中國水彩畫會歡快地聚餐。人太多了，劉其偉、何政廣、龐曾瀛（由上至下）、三位被擠得坐在樓梯上大嚼。〈右圖〉
Right: From top to bottom: Liu Che-Wei, Ho Cheng-Kuang and Pang Tseng-ying, 1966.

1969年在紐約龐家的一次聚會留影。後立：李明煌（右一）、趙春翔（右二）、龐曾瀛（左四）、戚維義（左三）、張宏（左二）、于兆漪（左一），前坐：沈元美（中排右三）、唐寶雲（前排右三）、于茵茵（中）。
In a party at Pang's home in New York, 1969: Yu Chao-yi, Chang Hung, Chi Wei-yi, Pang Tseng-ying, Chao Chun-hsiang, and Li Ming-huang (from left to right in the back row); Shen Yuan-mei (third on the right in the middle row); Tang Bao-yun (third on the right in the front row); Yu Yin-yin (seated in the middle).

年　代	龐曾瀛生平大事記
1936	received a prize from the Dokuritsu Group.
1940～1945	・返回中國，任職於母校北京（平）藝術專科學校。 ・與來自台灣的畫家郭柏川為同事，交情甚篤。 ・龐曾瀛不久後受邀至西安師範學院任藝術系主任，並擔任此同一職務至二次大戰結束。 Returned to China and instructed at the Peiping Academy of Art, China, during the period of which became acquainted with Kuo Po-chuan, a Taiwanese painter. Not long after, he was invited by Husien Normal College in Sian as head of art department. He remained in the post until World War II ended.
1944	・三月三十日結婚，妻沈元美女士亦是畫家。 March 30, married artist Shen Yuan-mei.
1946～1949	・在中國東北的瀋陽和青州教授繪畫三年。 Taught painting at Shenyang and Chinchou, China.
1949	・遷居台灣。 Moved to and worked in Taiwan until 1965.
1954	・落腳於台灣左營，任教高雄市立一中。 Resided in Tso-ying, Kaohsiung and taught at

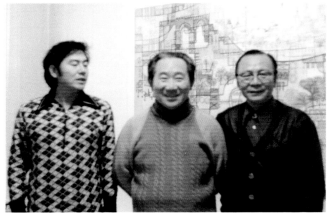

約1970年代，馮鍾睿（右二）、龐曾瀛（中）、孫瑛（左二）在紐約合影。〈上圖〉
Above: Pang Tseng-ying (middle), Fong Chung-ray (second on the right), and Sun Ying (second on the left) in the 1970s New York.

1976年於馬里蘭州的畫室，方何（右）、龐曾瀛（中）、于兆漪三人合影。〈下圖〉
Below: At the studio in Maryland, 1976 (from left to right): Yu Chao-yi, Pang Tseng-ying, and Fang Ho.

年　代	龐曾瀛生平大事記
1954	Kaohsiung First Senior High School.
1957	・先後任教於國立藝術專科學校和復興美術工藝學校。 Taught at the National Taiwan College of Arts and the Fu Hsing Trade and Arts School, Taiwan.
1959	・任教台北省立第一女子中學，以及國立藝術專科學校。 Taught at the Taipei Provincial First Girls' Senior High School and National Taiwan College of Arts.
1961	・「中國畫學會」成立，龐曾瀛獲選任事首屆理事之一，其他理事包括有：李梅樹、黃君璧、楊三郎、李石樵、楊英風等多人。 ・中國畫學會設立「金鼎獎」，每年選拔優秀的美術創作者。 ・龐曾瀛、張道林、劉煜、李德、劉予迪五人合組成「集象畫會」。 Chinese Painting Association was founded, and Pang, together with Lee Mei-shu, Huang Jun-bi, Yang San-lang, Lee Shih-chiao, Yu Yu Yang, etc., was elected the first board members. The association established Golden Tripod Award to encourage talented artists. Chi Hsiang Studio was founded by Pang Tseng-ying, Chang Tao-lin, Liu Yu, Read Lee

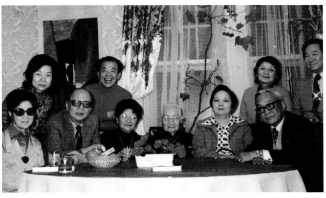

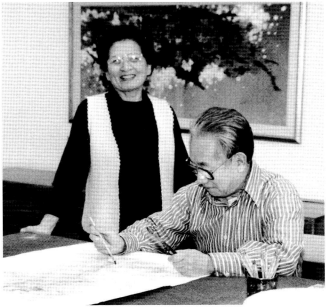

1976年，龐曾瀛夫婦（右站立）與薛光前夫婦（右坐）、馬白水夫婦（左站立）、王季遷夫婦（左坐）等合影。〈上圖〉

Above: The C. C. Wang couple (seated on the left), the Ma Pai-sui couple (standing on the left), the Hsueh Kuang-chien couple (seated on the right), and the Pang couple (standing on the right) in 1976.

1978年，龐曾瀛作畫，夫人沈元美在一旁欣賞，開懷地留下這張相片。〈下圖〉

Below: The 1978 photo shows Pang at work, with his wife Shen Yuan-mei joyfully stood by his side.

年　代	龐曾瀛生平大事記
1961	and Liu Yu-ti.
1965	・在國立歷史博物館展覽，獲頒「總統獎」。 Won the President's Award in the competition "Remember Chu!" held by National Museum of History.
1966～1974	・透過亞洲協會的資助，龐曾瀛舉家遷居美國。 ・期間，龐曾瀛先在紐約生活及創作，而後定居馬里蘭州。 Went to the U.S.A. on the grant from the Asia Foundation. Moved to Englewood, New Jersey. Lived and worked in New York from 1966 to 1974 and then resided in Maryland, U.S.A.
1983	・媒體稱龐曾瀛為「紐澤西州十大畫家之一」。 Entitled one of the ten most remarkable painters in New Jersey.
1990	・九〇年代，被譽為「東方水彩畫大師」。 Named "Watercolor Master of the East."
1997	・二月逝世於紐約。 Died in New York.

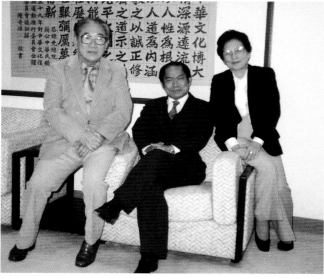

1980年龐曾瀛獲佛州龐帕諾比奇市長頒發市鑰。〈上圖〉
Above: Pang received the 'Key of the City' from the mayor of Pompano Beach, Florida, in 1980.

1983年龐曾瀛夫婦訪台時與當時文建會主委陳奇祿（坐者）合影。〈下圖〉
Below: The Pang couple and Chen Chi-lu(middle), the first minister of the Council for Cultural Affairs, during the couple's visit to Taiwan in 1983.

龐曾瀛代表性個展
Selected Solo Exhibitions

年　代	龐曾瀛代表性個展
1940～1944	・多次在北平及西安等地舉行個展，以及參加聯展等。 Solo and group exhibitions in Beijing, Sian and other large cities of China.
1954	・應美國全國婦女藝術協會之邀，在紐約「靄琴畫廊」舉辦「龐曾瀛油畫展覽」之個展，展出中國大陸、台灣和東京期間油畫三十幅，如〈昏之舞〉、〈靜默中的不融洽〉等。 Solo exhibition of 30 oil paintings, including *Dance of Twilight* and *The Recluse*, produced in China, Taiwan, and Tokyo, in Argent Gallery, under the sponsorship of the National Association of Women Artists in New York, U.S.A.
1959	・於台北市衡陽街「新聞大樓」展出，作品包括〈雲海〉、〈狂舞〉、〈憤怒的鬍子〉及〈風景A〉等三十八幅。 Solo exhibition in the Press Building. Among the 38 exhibited works were *Sea of Clouds*, *Delirious Dance*, *Angry Bristles*, and *Landscape A*, etc.
1966	・於泰納夫萊市「露辛達畫廊」展出。 Lucinda Gallery, Tenafly, New Jersey. ・於紐約州白平原市「斯汶畫廊」展出。 Swain Gallery, White Plains, New York
1967	・於紐約州揚克市「哈德遜河博物館」展出。 Hudson River Museum, Yonkers, New York ・紐約市聯合國教會中心舉行「華人藝術家龐曾瀛繪畫展」。 Painting by the Chinese Artist Tseng-Ying Pang, Dag Hammarskjold Lounge in the

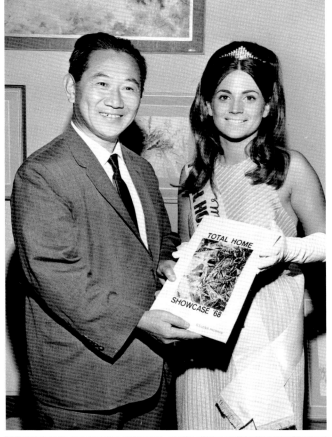

1968年紐約市圓廠「全家陳列窗」，龐曾瀛設計聯展目錄封面。〈上圖〉
Above: Pang's design of catalogue cover for the exhibition in the Total Home Showcase in New York, 1968.

1970年李紹琨神父邀請龐曾瀛個展。〈下圖〉
Below: Pang was invited by Father Li Shao-kun(left) to hold a solo exhibition in Warren, Pennsylvania, in 1970.

年　代	龐曾瀛代表性個展
	Church Center of the United Nations, New York
	・於密西根州底特律市「田野畫廊」展出。 Field Gallery, Detroit, Southfield, Michigan
1968	・於紐澤西州提恩尼克校園「費爾萊・狄克遜大學」展出十九件紙上畫作。 Fairleigh Dickinson University, Teaneck Campus, New Jersey ・於紐約市圓廠「全家陳列窗」展出。 Total Home Showcase, Coliseum, New York ・於紐澤西州梅塔城市「六藝廊」展出。 Theatre Six Gallery, Metuchen, New Jersey
1969	・於維吉尼亞州海灘市「藝術之窗」展出。 Artist Showcase, Virginia Beach, Virginia ・於紐澤西州遠山市「地氈戲劇畫廊」展出。 Carpet Drama Gallery, Far Hills, New Jersey ・於紐約州白原市「斯汶畫廊」展出。 Swain Gallery, White Plains, New York ・於達拉威「里荷波斯藝術聯盟」展出。 Rehoboth Art League, Rehoboth Beach, Delaware ・於紐澤西州李汶斯頓市「十二畫廊」展出。 Gallery 12, Livingston, New Jersey ・於新罕布什爾州湖克西提市「龍畫廊」展出。 Dragon Gallery, Hooksett, New Hampshire ・於康乃狄克州哈爾提弗德市「杜畫廊」展出。 Doo Gallery, Hartford, Connecticut
1970	・於猶他州洛甘市「猶他州立大學大學畫廊」展出。 Utah State University, Logan, Utah

 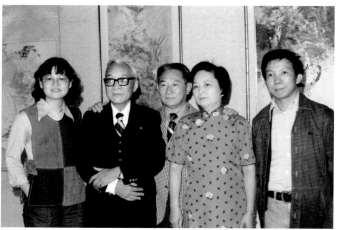

1976年龐曾瀛（左二）受邀在紐約州牙買加市「聖若望大學中正美術廳」展出，夏功權大使夫婦、薛光前（右二）、沈元美（左）合影。〈左圖〉
Left: On the exhibition in Chung Chan Gallery, St. John's University, Jamaica, New York, 1976 (from left to right): Shen Yuan-mei, Pang Tseng-ying, the wife of the ambassador Hsia Kung-chuan, Hseuh Kuang-chien, and Hsia Kung-chuan.

1976年龐曾瀛（中）在「聖若望大學」展出時，畫家何懷碩（右一）與薛光前夫人（右二）、董陽孜（左一）、薛光前（左二）合影。〈右圖〉
Right: On the exhibition in Chung Chan Galley of St. John's University (from left to right): Tong Yang-tze, Hseuh Kuang-chien, Pang Tseng-ying, Hseuh's wife, and Ho Huai-shuo.

年　代	龐曾瀛代表性個展
	・於紐澤西州紐華克市「紐華克畫廊」展出。 Newark Gallery, Newark, New Jersey ・於猶他州普洛沃市「布瑞罕青年大學」展出。 Brigham Young University, Provo, Utah ・於北卡羅萊納州格陵斯波羅市「北卡羅萊納農業工業大學」展出。 North Carolina A and T State University, Greensboro, North Carolina
1971	・於麻州荷利約克市「荷利約克市自然及歷史博物館」展出。 Holyoke Natural and History Museum, Holyoke, Massachusetts ・於北卡羅萊納州瑞利市「小藝術畫廊」展出。 Ruth Green's Little Art Gallery, Raleigh, North Carolina ・於馬里蘭州哈格斯鎮「華盛頓郡立美術館」展出。 Washington County Museum of Fine Arts, Hagerstown, Maryland ・於喬治亞哥倫布市「哥倫布工藝及美術博物館」展出。 Columbus Museum of Arts and Crafts, Columbus, Georgia ・於喬治亞州阿爾巴尼克市南喬治亞藝術協會「班克・海利畫廊」展出。 The Bank Haley Gallery, Southwest Georgia Art Association, Albany, Georgia ・於瑞士伯恩市「豪登遜休爾德及勞休爾藝術畫廊」展出。 Kunst Galeria Haudensenschild and Laubscher, Bern, Switzerland ・於紐澤西州「南橘及梅白爾藝術畫廊」展出。 Art Gallery of South Orange and Maplewood, New Jersey ・於紐約州羅美市「羅美藝術及社團中心」展出。 Rome Art and Community Center, Rome, New York ・於賓州西鎮市「西鎮學校」展出。 Westtown School, Westtown, Pennsylvania
1972	・於紐澤西州麥迪遜市「費爾萊・狄克遜大學」展出。 Fairleigh Dickinson University, Madison, New Jersey ・於委內瑞拉卡拉卡斯市「文學藝術協會畫廊」展出。 Galeria Bellas Arts in La Castellana, Caracas, Venezuela ・於紐澤西州「李汶斯頓三藝術協會」展出。 Art 3 Association of Livingston Inc., New Jersey
1973	・於北卡羅萊納州瑞利市「小藝術畫廊」展出。 Ruth Green's Little Art Gallery, Raleigh, North Carolina ・於紐澤西州普林斯頓市IBM展出。 IBM, Princeton, New Jersey
1974	・於麻州省鎮「泰勒畫廊」展出。 Taylor Gallery, Provincetown, Massachusetts
1976	・於紐約州牙買加市「聖若望大學中正美術廳」展出。

年　代	龐曾瀛代表性個展
	Chung-Chan Gallery, St. John's University, Jamaica, New York
1977	·於華盛頓特區「國際藝術博覽會」展出。 International Art Expo, Washington, D.C.
1978	·於紐約州紐約市「蓋德畫廊」展出。 Guild Gallery, New York, New York
1979	·於紐約州紐約市「蓋德畫廊」展出。 Guild Gallery, New York, New York ·於華盛頓特區「維納伯·內斯納畫廊」展出。 Venable Neslage Gallery, Washington, D.C. ·於維吉尼亞州亞力山卓「舊城波多馬克畫廊」展出。 Potomac Gallery of Old Town, Alexandria, Virginia
1980	·於紐約州紐約市「蓋德畫廊」展出。 Guild Gallery, New York, New York ·於佛羅里達州那不勒斯「史迪夫·羅桑達爾畫廊」展出。 Steven Rosendahl Gallery, Naples, Florida ·於佛羅里達州彭帕諾海灘「普沃德畫廊」展出。 Broward Gallery, Pompano Beach, Florida
1981	·於賓州費城「羅德傑·拉培爾畫廊」展出。 Rodger LaPelle Gallery, Philadelphia, Pennsylvania ·於華盛頓特區國際藝術博覽會展出。 International Art Expo, Washington, D.C. ·於加州杜思登「藝術之眼畫廊」展出。 Artistic Eye Gallery, Tuston, California ·於紐約州白平原市「斯汶畫廊」展出。 Swain Gallery, White Plains, New York
1982	·於維吉尼亞州亞力山卓「朱麗安畫廊」展出。 Julian Gallery, Alexandria, Virginia ·於加州舊金山國際藝術博覽會展出。 International Art Expo, San Francisco, California ·於紐約市紐約國際藝術博覽會展出。 International Art Expo, New York, New York ·於佛羅里達州冬園市「哈特萊畫廊」水彩畫個展展出。 Hartley Gallery, Winter Park, Florida
1983	·於佛羅里達州冬園市「哈特萊畫廊」展出。 Hartley Gallery, Winter Park, Florida ·台北國立歷史博物館國家畫廊展出「旅美畫家龐曾瀛畫展」，係其回國第一次個展，展出水

年　代	龐曾瀛代表性個展
	彩作品四十件。 National Museum of History, Taipei, Taiwan. As the first solo exhibition of Pang after he returned to Taiwan, it exhibited 40 of Pang's watercolor works.
1984	·於康乃狄克州布魯克林市「新英格蘭當代藝術中心」展出。 New England Center for Contemporary Art, Brooklyn, Connecticut ·於維吉尼亞州亞力山卓「朱麗安畫廊」展出。 Julian Gallery, Alexandria, Virginia
1985	·於賓州費城「羅德傑·拉培爾畫廊」展出。 Rodger LaPelle Gallery, Philadelphia, Pennsylvania ·於賓州匹茲堡「龐德街畫廊」展出。 Bond Street Gallery, Pittsburgh, Pennsylvania
1986	·於紐約市南漢普頓「佩里肯尼斯畫廊」展出。 Peri-Kenneth Renneth Gallery, South Hampton, New York ·於紐約州揚克市「哈德遜河博物館」展出。 Hudson River Museum, Yonkers, New York ·於密西根州底特律市「田野畫廊」展出。 Field Gallery, Detroit, Michigan ·於紐澤西州「費爾萊·狄克遜大學」展出。 Fairleigh Dickson University, New Jersey ·於猶他州洛甘市「猶他州立大學畫廊」展出。 Utah State University, Logan, Utah ·於麻州荷利約克市「荷利約克市自然及歷史博物館」展出。 Holyoke Natural and History Museum, Holyoke, Massachusetts ·於北卡羅萊納州「小藝術畫廊」展出。 Ruth Green's Little Art Gallery, North Carolina ·於華盛頓「郡立美術館」展出。

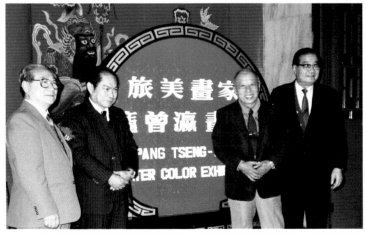

1983年台北國立歷史博物館國家畫廊展出「旅美畫家龐曾瀛畫展」，係其回國首次個展，右起：何浩天、郭明橋、陳奇祿、龐曾瀛四人合影。〈左圖〉
Left: On the first solo exhibition in the national gallery of the National Museum of History in Taiwan, 1983 (from left to right): Pang Tseng-ying, Chen Chi-lu, Kuo Ming-chiao, and Ho Hao-tien.

1989年，美國賓州戶外的龐曾瀛個展告示牌〈右圖〉
Right: A signpost to one of Pang's solo exhibitions in Pennsylvania in 1989.

年　代	龐曾瀛代表性個展
	Washington County Museum of Fine Arts, MD
	．於紐澤西州普林斯頓市IBM展出。 IBM, Princeton, New Jersey
	．於瑞士伯恩市「豪登遜休爾德及勞休爾藝術畫廊」展出。 Kunst Galerie Haudensenschild and Laubscher, Bern, Switzerland
	．於委內瑞拉卡拉卡斯市「文學藝術協會畫廊」展出。 Galeria Bellas Arts in La Castellana, Caracas, Venezuela
1987	．維吉尼亞州亞力山卓「朱麗安畫廊」舉辦「龐曾瀛個展」，同時有英文畫冊《龐曾瀛畫集－－二十年回顧選》出版。 *Pang Tseng-ying*, Julian Gallery, Alexandria, Virginia, along with the publication of an English catalogue *Pang Tseng-ying: 20 Years of Art.*
1988	．於維吉尼亞州亞力山卓「朱麗安畫廊」展出。 Julian Gallery, Alexandria, Virginia ．於紐澤西州法蘭克林湖市「白色畫廊」展出。 White Gallery, Franklin Lakes, New Jersey
1989	．於賓州艾斯頓「二畫廊」展出。 Gallery II, Eston, Pennsylvania ．於馬里蘭州哥倫比亞市「哥倫比亞藝術中心」展出。 Columbia Arts Center, Columbia, Maryland ．於紐澤西州「克里斯‧詹姆斯畫廊」展出。 Christian James Gallery, Summit, New Jersey
1990	．馬里蘭州陶森大學「亞洲藝術中心」舉辦「龐曾瀛水彩畫三十年回顧展」，本展展出龐曾瀛1944年至1989年間的作品。 *30 Years Retrospective - Watercolors by Pang Tseng-Ying*, Towson State University, Asian Arts Center, Towson, Maryland, which selected Pang's works produced between 1944 and 1989. ．於賓州匹茲堡「龐德街畫廊」展出。 Bond Street Gallery, Pittsburgh, Pennsylvania
1991	．參加華盛頓特區「美國年度展覽」。 *Junior of Awards for the Sumi-e Society of America's Annual Exhibition*, Washington, D.C.
2000	．台北「大未來畫廊」舉辦「龐曾瀛——繪畫六十」個展，並出版畫冊。 *Pang Tseng-ying, - 60 Years in Painting*, Lin & Keng Gallery, Taipei, Taiwan, along with a catalogue.
2005	．台北「大未來畫廊」舉辦「龐曾瀛」個展。 *Pang Tseng-ying*, Lin & Keng Gallery, Taipei, Taiwan
2006	．台北「大未來畫廊」舉辦「龐曾瀛」個展。 *Pang Tseng-ying*, Lin & Keng Gallery, Taipei, Taiwan

龐曾瀛代表性聯展
Selected Group Exhibitions

年　代	龐曾瀛代表性聯展
1954	・高雄「華南銀行」舉行「友聯中西畫展」。參展者包括：蘇仲民、龐曾瀛、王瑞琮、鄭劍英、劉庸、沈元美及胡奇中。龐曾瀛展出〈故鄉之菩提樹〉等約三十餘幅油畫作品。 3 days from Aug. 21, Hwa Nan Commercial Bank, Kaohsiung, Taiwan. The exhibited artists included Su Zhueng-mien, Wang Ruei-cueng, Zheng Jian-ieng, Liu Ueng, Shen Yuan-mei, Hu Qi-zhueng, and Pang Tseng-ying who dedcated more than 30 oil paintings, including *Bo Tree of Hometown*. ・紐約「米舟畫廊」開幕第三組合展，陳其寬、龐曾瀛等十二位藝術家聯展。龐曾瀛展出〈妻像〉和〈風景〉兩項作品。 Group exhibition of 12 artists including Chen Ci-kwan and Pang Tseng-ying, Mi Chou Gallery, New York. Pang's works *Portrait of My Wife* and *Landscape* were exhibited.
1958	・北平藝專四十週年紀念「旅台校友美展」，假台北市衡陽路的「新聞大樓」舉行；其他參展者尚包括：孫多慈、劉予迪、黃君璧、溥心畬等人。龐曾瀛以〈幻影〉、〈畫像〉等作品參展。 *The Peiping Academy of Arts 40th Anniversary Memorial Exhibition Graduates in Taiwan Art Exhibition* was held in the Press Building on Hengyang Rd., Besides Pang, whose exhibited works included *Illusion and A Portrait*, the other participants were Sun Tuotsu, Liu Yu-ti, Huang Jun-bi, Pu Xin-yu, etc.
1959	・於台北國立台灣藝術館舉行的「聯合西畫展」，水彩部分參展者有楊英風、藍蔭鼎；油畫部分有陳武順、李元佳、吳昊、席德進、陳道明、廖繼春、鄭世璠、劉國松、歐陽文苑、龐曾瀛、顧福生、胡奇中等人。龐曾瀛以〈苦修者〉、〈疲途〉等五件作品參展。 *Joint Exhibition of Modern Paintings by Chinese Painters*, National Taiwan Art Center, Taipei. Pang had 5 paintings exhibited, including *Benevolent and A Weary Way*. The other works were dedicated by Yu Yu Yang and LanYin-ding in watercolor; Chen Wu-shun, Li Yuan-chia, Wu Hao, Shi Te-chin, Chen Dao-ming, Liao Ji-chun, Cheng Shih-fan, Liu Kuo-sung, Ouyang Wen-yuan, Ku Fu-sheng, and Hu Qi-zhueng in oil.
1961	・「集象畫會」首次畫展，在台北的「新聞大樓」展出，包括龐曾瀛、劉煜、李德、張道林及劉予迪等人，共展出三十餘幅作品。 *The 1st Chi Hsiang Group Exhibition* at the Press Building, Taipei, Taiwan, April 28-30. It exhibited more than 30 works of artists inlcuding Pang Tseng-ying, Liu Yu, Read Lee, Chang Tao-lin, and Liu Yu-ti.
1962	・參加「長島中華協會」舉辦的國畫展，展出藝術家包括：鄭月波、靳懷倫、劉業昭、龐曾

年　代	龐曾瀛代表性聯展
	瀛、王子豪、吳退伯、吳文彬等。 *Exhibition of Chinese Painting* with artists Chen Yueh-Po, Chin Huai-Lun, Liu Yeh-Tsao, Pang Tseng-Ying, Wang Tsu-Hao, Wu Tui-Pe and Wu Wen-Pin at the Chinese Center on Long Island, Inc., West Hempstead, L. I., New York. Pang exhibited works *Flowers, Several Flowers, Trees and Vines, A Lone Tree, Winter and Birds in the Moonlight.* ‧參加在台北衡陽路第十信用合作社禮堂舉行的「聯合水彩畫展」。 *Joint Exhibition of Watercolor Paintings*, Hall of the Tenth Credit Cooperative Hengyang Rd., Taipei, Taiwan. ‧參加於紐澤西州「小藝術畫廊」舉辦的「九位中國藝術家聯展」。 *Joint Exhibition of 9 Chinese Painters*, Petite Galerie, Englewood, New Jersey. ‧參加在紐約「柏根中心」展覽廳舉辦的「自由中國八位畫家展」，共展出百餘幅水墨作品。 *Paintings by 8 Contemporary Chinese Artists Residing in the Republic of China (Taiwan)*, Bergen Mall's Exhibition Hall, Paramus, New Jersey. ‧「集象畫會」第二屆聯展在台北「國立台灣藝術館」展出，參展藝術家包括：龐曾瀛、劉煜、李德、張道林、劉予迪、吳廷標及胡笳等七位，共展出油畫、粉畫、水彩畫及素描作品四十三件。 *The 2nd Chi Hsiang Group Exhibition*, with 43 paintings of oil, pastel, and watercolor, and drawings by the artists Pang Tseng-ying, Liu Yu, Read Lee, Chang Tao-lin, Liu Yu-ti, Wu Tieng-piow, and Hu Chia, Taiwan National Art Gallery, Taipei, Taiwan, Dec. 15-23 ‧「現代畫家具象畫展」在台北市「中山堂」展出，此展提倡文藝研究，義賣展出作品，由五月畫會、四海畫會、長風畫會、集象畫會、藝友畫會、今日畫會、東方畫會、現代版畫會、散沙畫會、台南美術會等聯合舉辦。 *Contemperary Figuratine Artists Exhibition*, contributed by Fifth Moon Association, Four Seas Association, Wildwind Association, Chi Hsiang Art Studio, Art Friends Club, Le Salon du Jour, The East Association, Modern Printmaking Association, Loose Sand Association, and Tainan Art Association, was held in Zhongshan Hall, Taipei, to promote study in art and culture.
1963	‧第三屆「集象畫會」畫展在「國立台灣藝術館」展出，參展畫家包括：胡笳、龐曾瀛、吳廷標、張道林、李德、劉煜、劉予迪等七位。 *The 3rd Chi Hsiang Group Exhibition* in National Taiwan Art Center with artists Hu Chia, Pang Tseng-ying, Wu Tien-piow, Chang Tao-lin, Read Lee, Liu Yu, and Liu Yu-ti.
1964	‧參加中華民國赴菲文化友好訪問團書畫展，展出作品〈高山〉。 *Exhibition of Painting and Calligraphy* with Pang's work *High Mountain* at the Cultural Goodwill Mission of the Republic of China to Africa.
1965	‧胡笳、龐曾瀛於「國際畫廊」聯展，展出胡笳水彩作品十二件，及龐曾瀛油畫作品十三件。 *Associated Exhibition of Watercolor & Oil Paintings by Hu Chia and Pang Tseng-Ying* at the International Art Gallery, Taipei, Taiwan, April 15-24
1966	‧參加於「國立台灣藝術館」舉辦的「集象畫會」畫展，參展藝術家包含：李德、劉煜、劉予迪、龐曾瀛等九位藝術家。 *Chi Hsiang Group Exhibition*, National Taiwan Art Center, Taipei, with artists Read Lee,

年　代	龐曾瀛代表性聯展
	Liu Yu, Liu Yu-ti, Pang Tseng-ying, etc.
1966～1967	・參加紐約「美國水彩協會」年度展覽。 American Watercolor Society Annual, New York
1967～1968	・參加紐約州普奇斯比「安得麗安斯博物館」聯展。 Adriance Museum, Poughkeepsie, New York
1968～1970	・參加紐約市「美國藝術家聯盟」年度展覽。 Allied Artists of America, New York, annual exhibition
1970	・參加紐澤西州西橘郡「廣場經典藝術」聯展。 *Art Classic on the Plaza*, West Orange, New Jersey ・參加華盛頓特區一九七〇年首屆「藝術博覽會」邀請展。 *Expo of the Arts*, First Invitation Art Show 1970, The Fine Arts Committee, Washington, D.C. ・參加華盛頓特區「國際金融基金」聯展。 Joint Exhibition by International Monetary Fund, Washington, D.C. ・參加麻州伯克頓市「伯克頓藝術中心」聯展。 Brockton Arts Center, Brockton, Massachusetts ・參加麻州「波克夏博物館」聯展。 Berkshire Museum, Massachusetts ・參加紐澤西州紐澤西市「紐澤西市立博物館」聯展。 Jersey City Museum, Jersey City, New Jersey ・參加紐澤西州蒙克列爾市「蒙克列爾博物館」聯展。 Montclair Museum, Montclair, New Jersey ・參加紐澤西州紐華克「紐華克博物館」聯展。 Newark Museum, Newark, New Jersey ・參加康乃狄克州「新英格蘭年度展覽」。 New England Annual Exhibition, Connecticut
1971	・作品〈秋〉入選三月中華民國第六屆「全國美術展覽會」。 *The 6th Art Exhibition of the Republic of China*, National Taiwan Art Center, Taipei, with the work *Autumn*.
1972	・參加紐澤西州提恩尼克校園「費爾萊・狄克遜大學」聯展。 Friendship Library, Madison Campus of Fairleigh Dickson University, New Jersey
1972～1974	・參加奧都邦藝術家聯展。 Audubon Artists, annual exhibition
1979～1981, 1983～1986	・參加紐約州紐約市「國際藝術博覽會」。 *International Art Expo*, New York, New York

年　代	龐曾瀛代表性聯展
1979～1980	・參加華盛頓特區「國際藝術博覽會」。 *International Art Expo*, Washington, D.C. ・參加紐澤西州特錢頓市「紐澤西州立博物館」聯展。 New Jersey State Museum, Trenton, New Jersey ・參加紐約州白平原市「維徹斯特藝術協會年度聯展」。 *Westchester Art Society Annual Juried Exhibition*, White Plains, New York ・參加紐約州布魯克林市「布魯克林博物館」聯展。 Brooklyn Museum, Brooklyn, New York ・參加紐澤西州「紐澤西畫家與雕塑家協會」聯展。 Painters' and Sculptors' Society of New Jersey, New Jersey
1984	・參加「現代華裔畫家作品聯展」，在曼哈坦蘇活區西百老匯「李氏畫廊」展出，由紐約當代藝術中心與華美藝術協會聯合主辦。 *Joint Exhibition of Modern Chinese Painters*, sponsored by New York Center of Contemporary Chinese - American Painter's Group Exhibition, Lee's Gallery, Soho of Manhattan.
1985	・參加紐澤西州科技研究所「當代華人畫展」。 *Contemporary Chinese Art Exhibition* with artists Lee Mao-C, Pang Tseng-Ying and Yu Heshi, Institute of Technology, New Jersey. ・「華裔藝術家聯展」在曼哈頓中城社區Community畫廊展出，由美華藝術中心贊助，展出作品包括油畫、水彩畫、雕刻、陶藝及攝影等。 *Modern Chinese Paintings* with works of oil, watercolor, sculpture, ceramics, and photography of Chinese painters, sponsored by Chinese American Art Center, Downtown Community Center, Manhattan.
1987	・參加首屆「紐約中國名藝術家聯展」，在紐約聖若望大學中山堂中正美術館展出，展出囊括紐約區二十五位中國著名藝術家的作品，展出油畫、水彩、版畫、陶藝、中國畫與書法等六項作品，約五十件。 *Renowned Chinese Painters in New York*, with 50 works of oil, watercolor, print, ceramics, Chinese painting, and calligraphy of 25 Chinese painters in New York, St. John's University Gallery, Jamaica, New York ・參加台灣國立師範大學美術系「歐美地區中國畫家聯展」，參展作品為〈古的象徵〉。 *Art of Overseas Chinese Painters*, National Normal University, Taipei, Taiwan. Pang participated with the work Antiqueness.
1997	・參加由虞曾富美策劃的「北美華裔前輩藝術家聯展」，在紐約台北藝廊展出，參展者係旅美之八十歲以上的華裔藝術家，包括程及、邱潤銀、曾景文、馬白水、龐曾瀛、王季遷等。 ・在美國過世，享年八十二歲。 *Artists: 80 Plus And Going Strong*, curated by Marlene Tseng Yu with nine participating artists Leon Long-yien Chang, Chen Chi, Jen-yin Chiu, Dong Kingman, Pai-sui Ma, Tseng-ying Pang, C.C. Wang, Fang-yu Wang and Ling-wen Wang, Taipei Gallery, McGraw-Hill Building, New York ・Died at 82 in the united states.

龐曾瀛作品收藏主要記錄
Selected Collections

· 美國紐約州靄琴畫廊 Argent Gallery of the Hotel Delmonico, New York

· 美國加州棕櫚泉沙漠博物館 Desert Museum, Palm Springs, California

· 美國印第安納州印第安納博物館 Indiana Museum, Indiana

· 美國康乃狄克州新英格蘭當代藝術中心 New England Center for Contemporary Art, Connecticut

· 美國紐澤西州西橘郡西橘鎮 Town of West Orange, West Orange, New Jersey

· 美國紐澤西州莫里斯郡立學院 County College of Morris, Dover, New Jersey

· 美國賓州費城費城自由圖書館 Free Library of Philadelphia, Philadelphia, Pennsylvania

· 美國麻州波克夏博物館 Berkshire Museum, Massachusetts

· 美國紐澤西州紐華克博物館 Newark Museum, Newark, New Jersey

· 美國紐澤西州紐澤西州立博物館 New Jersey State Museum, Trenton, New Jersey

· 美國紐約布魯克林博物館 Brooklyn Museum, Brooklyn, New York

· 美國猶他州普洛沃市布瑞罕青年大學 Brigham Young University, Provo, Utah

· 美國猶他州洛甘市猶他州立大學 Utah State University, Logan, Utah

· 台灣台北國立歷史博物館 National Museum of History, Taipei, Taiwan

· 台灣台北國立台灣藝術館 National Taiwan Art Center, Taipei, Taiwan

龐曾瀛作品索引
Index

I. 油畫作品　Oil Paintings

II. 紙上作品 Watercolor and Ink Paintings

國家圖書館出版品預行編目資料

龐曾瀛
Pang Tseng-ying

／龐曾瀛等著
--臺北市：藝術家，民96，25.5 X 34公分

ISBN13 978-986-7034-40-3（平裝）
1.油畫－作品集　2.水彩畫－作品集　2.水墨畫－作品集

947.5　　　　　　　　　　　　　　96004636

龐　曾　瀛
Pang Tseng-ying

發行人　／　何政廣
主編　／　王庭玫
文字編輯　／　謝汝萱・王雅玲
英文翻譯　／　黃敏裕・謝汝萱
美術設計　／　苑美如

策劃出版　／　大未來畫廊
編輯印製　／　藝術家出版社
法律顧問 ／ 蕭雄淋
台北市重慶南路一段147號6樓
TEL：（02）2371-9692～3
FAX：（02）2331-7096
郵政劃撥：01044798 藝術家雜誌社帳戶

總經銷　／　時報文化出版企業股份有限公司
倉庫：台北縣中和市連城路134巷16號
TEL：（02）2306-6842

南部區域代理　／　台南市西門路一段223巷10弄26號
TEL：（06）261-7268
FAX：（06）263-7698

製版印刷　／　欣佑彩色製版印刷股份有限公司
初版 ／ 2007年7月
定價 ／ 新台幣800元
ISBN-13　　978-986-7034-40-3（精裝）